BRICKWORK

A BIOGRAPHY OF

THE ARCHES

DAVID BRATCHPIECE & KIRSTIN INNES

Salamander Street

First published in 2021 by Salamander Street Ltd.
(info@salamanderstreet.com)

Brickwork: A Biography of The Arches © David Bratchpiece and Kirstin Innes, 2021

ISBN: 9781913630980

10 9 8 7 6 5 4 3 2 1

*Dedicated to everyone who worked at The Arches,
everyone who played at The Arches,
and most of all to Andy Arnold*

Introduction: Glasgow's Glasgow's Glasgow xi

1. Fuck It; Let's Just Keep Going (1990-1991) 1

2. And Then On Friday Night, We Went Through To The Arches (1991-93) 13

3. Here We Fucking Go (1993-1999) 43

4. Drop The Pressure (1999-2008) 91

5. It's All Allowed (2008-2013) 137

6. How Can You Have A Day Without A Night? (2013-2015) 171

7. Bits And Pieces 197

Appendix One (More Tune) 206

Authors' Note

When trying to work out how to tell The Arches' story, we kept coming back to the people who made it what it was. As former employees who had their lives changed by the venue, both of us were aware, from the moment we started our very different roles, of the many, varying things the place meant to so many. This is a 'biography', because we're not just telling the story of bricks and mortar, or of an arts venue, but of an organisation that seemed to have its own soul. People may or may not 'make Glasgow', as the current city marketing slogan would have it, but they definitely made The Arches. So we've tried where possible to have this story told verbatim, in the words of the people who were there at the time: the founders and directors, the club impresarios and DJs, the theatre makers and performers, the clubbers, the bar, door and cloakroom staff, and the audiences. Of course, this book is really only scraping the surface. The Arches was the sort of place that almost everyone it touched has a story about: here are as many as we could cram in.

David Bratchpiece and Kirstin Innes.

Dramatis Personae

ANDY ARNOLD: Arches founder and artistic director, 1991–2008

LORI FRATER: First Arches general manager, 1991–1996

KEITH BRUCE: Former arts editor, *The Herald*

DAVE CLARKE: Director of Soma Records and promoter of Slam and Pressure (active in The Arches 1992–2015)

COLIN McCREDIE: Actor

STEPHEN McCOLE: Actor/DJ

GARY GILLIES: Co-founder, *Alien War* (active in The Arches 1992, 2008, 2012)

AL SEED: First Arches artist-in-residence, 2005–2008

DAVID BRATCHPIECE: Co-author of *Brickwork*. Arches cloakroom and usher (1998–1999), box office assistant (1999–2006), duty manager (2006–2010), front of house manager (2010–2013)

BLAIR SUTHERLAND: Longest serving Arches employee (1992–2015: bar staff, bar supervisor, bars and catering manager, director of operations)

STUART McMILLAN: DJ & producer, Slam

ANGIE DIGHT: Co-founder, Mischief La-Bas

ORDE MEIKLE: DJ & producer, Slam

FIONA SHEPHERD: Arts journalist

JULIE WARDLAW: Work placement (1994), front of house staff, press and publicity manager (1994–2000)

JOYCE McMILLAN: Theatre critic

CORA BISSETT: Actor, writer, director

NIKKI MILICAN: Artistic director, National Review of Live Art

GRAEME THOMPSON: Promoter, Love Boutique (active in The Arches 1993–1999)

NIALL WALKER: Designer, then marketing and design manager, 2000–2014

GERI O'DONOHOE: Television producer. Arches box office assistant 1998–1999, box office manager 1999–2001

RICKY MAGOWAN: Promoter, Streetrave and Colours (active in The Arches 1995–2015)

IAIN 'BONEY' CLARK: DJ, Streetrave and Colours (active in The Arches 1995–2015)

JULIE McEWAN: Promoter, Streetrave and Colours (active in The Arches 1995– 2015)

DUNCAN REID: Founder of Breastfed Records, promoter of Inside Out and Freefall (active in The Arches 1995–2011)

SIMON FOY: DJ and promoter, Inside Out and Freefall (active in The Arches 1995–2011)

ANDY MACKENZIE: Arches staff 1999–2006 (bar staff, duty manager, front of house manager, operations manager)

CARL COX: DJ/producer, Arches patron 2006–2015

JUDGE JULES: DJ/producer

SARAH WELLS: General manager then executive director, 1996–2002

ANDREW O'HAGAN: Journalist and novelist

WILLIAM DANIEL: DJ, Inside Out and Freefall (active in The Arches 2000–2015)

ROB WATSON: Technician, then technical manager, 1997–2015

TAMSIN AUSTIN: Music programmer, 1999–2003

BARRY ESSON: Arches refurbishment project assistant (1999–2000), then curator of Instal Festival (active in The Arches 2001–2009)

LYNDA FORBES: Commercial and corporate events manager, 2000–2006

LJ FINDLAY-WALSH: Arts administrator then arts programmer, 2005–2015

NINA MILLER: Steward then joint head of security, 2000–2015

KIRSTIN INNES: Co-author of *Brickwork*. Arches press and publicity manager, 2004–2006

NIC GREEN: Actor and theatre-maker

JACQUI REID: Death Disco PR staff 2004–2011, arts intern 2006, co-promoter of Nightwalk 2010

JACKIE WYLIE: Fundraising officer 2004–2005, arts programmer 2005–2008, artistic director and co-chief executive officer 2008–2015

MARK ANDERSON: Executive director 2003–2015

MARK FISHER: Journalist

KIERAN HURLEY: Playwright, Arches front of house staff 2006–2009

TIM CROUCH: Playwright, theatre director, actor

ROBERT SOFTLEY-GALE: Artistic director, Birds of Paradise Theatre Company

RICHARD GADD: Actor, writer, director

KIRSTIN McLEAN: Actor, Arches Award for Stage Directors winner 2004

NESHLA CAPLAN: Actor, Arches box office assistant then manager, 2006–2009

GEORGE MACKENNEY: Front of house staff, duty manager, operations manager 2005–2015

BRIAN REYNOLDS: Music programme manager, 2008–2012

KIRSTIN BAILLIE: Front of house staff, 2009–2015

LYN GARDNER: Theatre critic

LISA DUNIGAN: Steward, then joint head of security, 2003–2015

JOSEPH BLYTHE: Press officer, 2013–2014

NATALIE O'DONOGHUE: Writer, theatre critic, Arches events bar staff 2008–2015

NEIL BRATCHPIECE: Comedian, actor, writer, Arches events bar staff 2000–2007

MIRANDA RALSTON: Arches PR 2005, finance assistant 2005–2011

EDDIE CASSIDY: Comedian, Arches clubber

RONA PROUDFOOT: Arches clubber

LOUISE STEWART: Actor, writer, director, Arches box office and front of house staff, 2008–2015

CAT HEPBURN: Poet/writer, Arches box office and cafe bar staff, 2010–2015

ANGIE KOORBANALLY: Arches bar, front of house and box office staff, 2004–2009, founder of Nightwalk 2010

SCOTT McDONALD: Lighting and visuals freelancer (active in the Arches 1991–2015

IAN SMITH: Co-founder, Mischief La-Bas

Glasgow's Glasgow's Glasgow

Were you there?

Did you scream at the original *Alien War*? Did you witness the night Banksy painted the walls, or the time a young lad yet to rename himself Calvin Harris got his first warm-up shot on the decks? Were you at the National Review of Live Art when Franco B performed his bloodletting piece? Did you see Daft Punk? Or Massive Attack? Or Irvine Welsh? Or the Chemical Brothers? The original production of Nic Green's Trilogy? The night Ann Liv Young got naked at Death Disco? Were you there the night the first-ever crowd started chanting, 'Here we, here we, here we fucking go'?

From 1991–2015, if you wanted to feel the beating pulse of Glasgow, you had to go underground; to the cavernous space below Glasgow's Central Station, held up by six red brick arches, which on any given day-into-night might play host to a children's puppet show, an art exhibition, a lunch meeting, a poetry reading, a fashion show, a boozy dinner, an experimental piece of performance art, an awards ceremony, a groundbreaking theatre show, a rock gig, or one of the biggest techno club nights in Europe. The Arches was where Glasgow came to play, and the stories about it are legendary.

To understand The Arches, it's important to understand that it could only ever have existed in one city. In 1899, Glasgow was revelling in its honorary title as the Second City of the Empire. More steel and smoke than 'dear green place', over half of the British tobacco trade was concentrated on the River Clyde. Shipbuilding was thriving and the city's culture and industry were reaping the benefits

of its merchants' vested interests in the slave trade in the Americas and Caribbean. Every city on the up needs a transport hub, of course, and an actual stone's throw away from the river was Glasgow Central Station, constructed in 1879. An impressive cathedral to progress: glass, riveted steel, and brickwork, refracting the occasional bursts of golden sunlight.

Two decades on and Glasgow had expanded its industries into textiles, garment making, carpets, leather... you name it, the Weegies were doing it. With this rise came more people. Central Station had become too small for purpose, and also needed expansion, in the form of an extra platform, supported by a large series of arches. Red-bricked. Functional. Unaware of what was to come. Imagine the men who built those arches – dirty, sweating, drinking, smoking, sparring verbally (yer famously sarcastic Glaswegian sense of humour, there), and all completely unaware that around a century later their great-grandchildren would be doing pretty much the same things in that same space, for very different reasons.

The extra rail tracks ran over Argyle Street (an area dubbed the 'Hielanman's Umbrella' as the pubs there were frequented by the Highlanders who came to the city to work), then over Midland Street before heading south above the Clyde, boxing a section of the city centre away from daylight for good.

Perhaps it was all that money flowing in, but the city's artists were developing a certain swagger. Inspired by the brave new industrial world, James Kay painted the Clydeside shipyards, with their delicate light and heavy smoggy industry, on huge canvases. Up the hill at the Art School, Charles Rennie Mackintosh led a revolution with sky-scraping iron and roses, the subversive Glasgow Boys made ordinary working-class people the subjects of their paintings; meanwhile the work of the Glasgow Girls foregrounded style, design and fashion. From then on, Glasgow's cultural and working lives were in confluence.

The city kept its cynical spirits up through the two World Wars, even surviving its shipyards being bombed in the Second, but as the production bases of its key manufacturing industries moved further east to Europe and Japan in the post-war period, it began to see a long

period of economic and social decline. Poverty, alcoholism and gang culture grew like spores, creating a reputation the city still hasn't quite managed to shift today. Dirty. Hard. Poor. Dangerous.

The city council turned to marketing. They came up with the slogan 'Glasgow's Miles Better', and pinned the giant smiling face of the Roger Hargreaves character Mr Happy on a gas tower over the M8 motorway, trying to lure tourists and the emergent technology industries into the city and its satellite towns.

All that industry, further decimated by Thatcherism in the 1980s, had left a lot of big, empty spaces behind it, spaces which could be rented cheaply. Warehouses, old shipyard docks, and railway arches. As the city bosses looked to culture to regenerate the city – opening the Tron Theatre in 1981, investing in Gorbals mainstay The Citizens Theatre – those spaces began to fill up again. Artists were attracted by the city's dangerous reputation; by its combination of cheap rents, derelict spaces and beautiful old architecture, and by all that golden light. In 1983, a group of Art School graduates opened Transmission, an experimental and internationally reaching gallery space. In 1988, 4.3 million people visited the 120-acre site formerly and shamefully known as Plantation Quay, once the largest dock on the River Clyde, for the Glasgow Garden Festival, an exciting, colourful, celebratory mishmash of exhibits, miniature railways, performance art and a great big rollercoaster. The city loved it and grew in confidence once more; that same year also saw the first large-scale theatrical performance in a former municipal tram depot in Pollokshields, renamed Tramway. By the late 1980s, Glasgow was well and truly back, baby.

Elsewhere around the country, something was stirring in youth culture. Something loud, messy and led by a series of repetitive beats. Loud and repetitive enough to terrify authorities. Illegal raves and the acid house movement had Britain in its sweaty palm, fuelled by a new sense of optimism and unity in the country's youth, which itself was fuelled by a powerful new 'love drug', nicknamed Ecstasy. It was a phenomenon, and it was beginning to move indoors – to warehouses and derelict spaces. In the centre of Glasgow, halfway down Jamaica Street, a former jazz club which had hosted the likes

of Louis Armstrong and Ella Fitzgerald had reopened in 1987 as The Sub Club, a dark basement breeding ground for a new generation of Glasgow dance DJs. Right around the corner, underneath the Central Station bridge on gloomy, unloved Midland Street, a huge derelict space, untouched for decades, was lying in wait.

By 1990 the city's new-found confidence crystallised as it took up the mantle of European City of Culture – the first non-capital city to hold the title. It was dubbed 'Glasgow's Year in the Sun' (figurative title only – we didn't get the weather). International festivals were established. Huge open air music performances. Luciano Pavarotti and Frank Sinatra both visited the city; the Queen and Jacques Chirac presided over the handover ceremony in the Kings Theatre.

'It was such a powerful example of what we now know as arts-led, or culture-led, regeneration for cities,' said Bob Palmer, leader of the team behind the City of Culture celebrations, speaking to Glasgow's *Evening Times* in 2015. 'At the end of the day, leading Glasgow 1990 European Capital of Culture was something like managing a volcano, overflowing with the hottest talent and the most incredible excitement that could be imagined at that time. That creative volcano continues to erupt even now, and perhaps evermore.'

He added that it was never going to be considered a quick fix or a short-term celebration… it was always intended to spearhead a new legacy of physical change and increased civic confidence. Part of that physical change was to use spaces around the city, some unused for many years, for performances and exhibitions.

One of those exhibitions was called 'Glasgow's Glasgow' – a multimedia nod to an event called 'Berlin Berlin', a city with an underground music and arts scene not dissimilar to Glasgow's. The exhibition was a look back at Glasgow's history. The ships, the art, the people. The rise and fall and rise again. And what better place to host it than those derelict archways underneath Central Station?

1

1990-1991

Fuck It; Let's Just Keep Going.

'It all started with a love of theatre, not commerce. No other venue has achieved or maintained credibility in the same way. Andy Arnold has a safe pair of hands, but he's not scared to look, listen, or hand over the reins to the mad people on a regular basis.'

(Ian Smith, co-director of veteran performing arts troupe Mischief La Bas) [Interviewed in The List, Issue 559, 2006]

ANDY ARNOLD *(Arches founder and artistic director 1991–2008)*
In 1989 I was running the Bloomsbury Theatre in London, and wanting to come back to Scotland. I was feeling disillusioned with London.

I knew about the European City of Culture. Bob Palmer was running the whole thing, he was my predecessor at [Andy's previous venue] Theatre Workshop in Edinburgh. I rang him up, and asked, 'Is there anything I can get involved with?'

He said, 'Well, there's two things – the Tramway is being run by a technical person but they need an artistic person there to run that place and also, they're setting up this exhibition under the railway station, and they're wanting some sort of street theatre activity going on.'

And I thought, well I don't want to run street theatre really, but I'll come up and visit. I went to the Tramway first and suddenly realised it's not what I want to get involved with. Partly because its being run by the council, and secondly because during my time in London I had

constantly gone to small spaces all the time; I was running a 600-seat theatre, and I didn't like big theatres, I really liked little ones, and the Tramway was a big space.

Then I went to visit The Arches, and they were just cleaning the place out, and it looked amazing. And I thought, 'Jeez, this is fantastic. One of these would make an amazing theatre space.'

And the guy setting the whole thing up, this guy Doug Clelland, he was an architect. He was a Glasgow guy but he ran his business in Berlin, and he was setting up what was then called The Words and the Stones, and they had an office separate from it, further along Argyle Street, a sort of warehouse.

He was a very dynamic bloke, you know, you could tell. And he said, 'Look, we need a street theatre team to be going around this exhibition, but also, there could be a theatre space there that you could use after that.'

That sounded quite exciting, and I liked him, so I thought, 'Yeah, I'll go along with that.'

So round about the Spring of '89 I joined and went on the payroll there – setting up a street theatre team, and deciding to have this sort of travelling minstrel thing: an old cart, a wooden cart my good friend designed for me. Andrew Dallmeyer, my old acting friend, was going to write some scripts for it. I worked it out, we had eight performers, actor and musician types, and I deliberately went for people I had never met before. Andrew wrote these little sketches, that were ten-minute pieces, one was about Saint Mungo – his birth to death in fifteen minutes, there was the Glasgow Grave Robbers, Shackleton's Expedition to the Antarctic, and Great Glasgow Inventors.

It was a great learning experience actually, making little bits of theatre around these things. The idea was that when this exhibition was built, we would come out three times a day and do our little theatre show. We'd wheel our little cart down through the central spine, as it were, and do our show. And then when they built the exhibition, it was The Arches as we know them, but also the main entrance was from Jamaica Street, through a big glass partition; the whole thing was partitioned off.

So you'd go in, into a big dome thing which gave you an idea of what you were going to see, and you could either go into the bottom arches on the other side of Midland Street, or into the main arches – The Arches as we know it. And one of those arches was a little studio theatre space.

We had dressing rooms there, and the idea was we would trundle out this cart every day, seven days a week – it wasn't always with eight people, sometimes it would be five and so on, so we managed to do it seven days, and we'd do this show.

The original idea was that in every different arch there would be a part of Glasgow. It was like we had a different theatre set in every arch – the docks in one arch, The Gorbals in another, the tenements with people shouting across. Doug Clelland got a whole load of different architects to design each arch, and I'll never forget… in the office there was this massive great model of all these arches, which was as exactly as he described it and it sounded very exciting. But Doug Clelland himself, he liked to be a very adventurous, 'way out' architect, and he said, 'No, these are far too naturalistic, I want you to do things that are far more abstract and metaphorical and so on.'

They were all abandoned and then replaced with things that meant nothing to anybody. There were great big 'swoops'… representing something or other, and masses and masses of model boats and bits of engineering, which excites architects but didn't excite people at all.

So the content of Glasgow's Glasgow really was very controversial, especially because it was getting all this money compared to People's Palace, which was getting nothing.

You also had to pay to get in, and there was no exhibition in Glasgow that ever had paid entrance.

And the crime was… there was these sound cones driven by this massive computer, which was very novel at the time. In every arch, you'd listen to things about things, and this was switched on, before the thing started. I said to Doug Clelland, 'This is far too loud, it's a cacophony of sound, it's a nightmare. We can't do our show with that.'

So they arranged that for three times a day, for twenty minutes, the sound would be shut off and we could trundle our cart out and do our little show.

It was then that people could actually relax and wander around the exhibits because it was so fucking noisy otherwise, with all these bloody awful sound cones everywhere.

KEITH BRUCE (*Former arts editor, The Herald*)
Covering the opening of the Glasgow's Glasgow exhibition as one of the flagship events of the city's year as European City of Culture 1990, *The Herald*'s reporter was sarcastic about the metres of ruched fabric that had been used to prettify Midland Street. That reporter was myself. In years to come the late Alasdair Gray would be especially tickled that the show was originally to be entitled 'The Words And The Stones', until someone spotted the unfortunate acronym.

LORI FRATER (*First general manager of The Arches, 1991–1996*)
'The Words and The Stones', as they were then, was the organisation that were responsible for setting up Glasgow's Glasgow. And that's when they refurbished the building itself, to make it a public space. Glasgow's Glasgow were looking for a press officer. So that's how I started out. A publicity and a press officer – working with Andy, who had set up what was the little theatre inside the building, and the theatre company.

I won't even go into the stories of Glasgow's Glasgow… they were a bit of a nightmare… but one important thing was that Glasgow's Glasgow lost, what was it, £4.8 million. And effectively, we ran The Arches for years on probably less than that.

DAVE CLARKE (*Director of Soma Records and promoter of DJ duo Slam, The Arches' first regular club night*)
'Glasgow's Glasgow' was an exhibition which completely flopped! No one really went to it, but they'd already cleaned out the building. You know, it already had the corridor, it already had the toilets. So although it felt like you were going into an almost grotty, underground arches…

it was kind of habitable, although everyone's shoes always used to get filthy! But it was pretty clean.

ANDY ARNOLD

When it was being set up, before they built the wall for it in the studio... the floor was all cobbled. And a lot of the arches were cobbled, because I think they had been used for drayhorses and so on. Breweries and whatever. It was derelict for sixty years before it was converted for the exhibition in 1990. In fact, Jimmy Boyle, who I was a pal of in those days, said that in his gangster days, in his younger days, they'd go down the arches to be dealing in various things. Because it was a very dark, empty space, you know.

I thought the cobbles were great, actually. And I remember almost the horror... as they concreted the whole lot. But it had to be, I suppose. Apparently, there was horse manure between the cavities.

DAVE CLARKE

But I don't know, it definitely had a special atmosphere. I heard that when they were getting it ready for Glasgow's Glasgow, they had so many rats in the place that they couldn't possibly poison them all, so they actually hired marksmen, and they had people in shooting the rats, before they could do work on it!

ANDY ARNOLD

So [what we were putting on] was lovely bits of theatre... Saint Mungo's journey of birth to death and so on... and they were hugely popular because the whole exhibition was so mechanical and alienating in some ways. And here was something human, you know. And so people gathered round... they loved it.

The exhibition was incredibly controversial and the likes of [Booker Prize-winning Glasgow author James Kelman] made massive complaints about it. But because we had our own little theatre thing, and also in the studio theatre we were programming little bits of theatre – and we called that The Arches Theatre, because I said, 'Look,

it needs to have a name of its own' – we were then regarded separately, so we weren't under the same criticism as the rest of the thing.

We got a bit of money to do our theatre show. I got Andrew to write this script, so we also did this play – *Rudolf Hess, Glasgow to Glasnost* – as a piece of theatre which we staged there. That's when I first met [long-time Arches Theatre Company collaborator] Benny Young, because we cast him as Hess. And Juliet Cadzow and Andrew Dallmeyer, they were in that. Graham Hunter, the guy that designed it all, was pivotal in getting The Arches going after that.

So we had these visiting companies – Elaine C. Smith was on stage at the very beginning there, loads of interesting little things – and our bit of it worked very well.

Now, Doug Clelland had said, 'This is going to be a massive success, you're going to have a permanent theatre at the end of this.' And that's one reason I committed to it.

But then, the whole thing went… It abandoned having a box office, and became free after a while, and lost a massive amount of money, millions. So what happened was, at the end of December 1990, after seven months, it was closed down, everything was ripped out of there. I was on the dole for the first time in my life, I had a young family and all the rest of it, we'd moved up to Glasgow… and everything was just ripped out.

I got on the phone to Bob Palmer, I said, 'Whatever you do, leave those seats in that studio theatre space.' It was bank seating, 100 seats. I said, 'You won't get any money for it, but there's no other small scale theatre in the middle of Glasgow. There's nowhere else, and it would be a great space for theatre companies to come and perform in the middle of Glasgow. Give me a chance to see what I can do with it.'

He agreed, but they took all the lights out and the technical stuff, and they stored them up at Tramway. So I had a feeling we might be able to get a hold of them.

That was agreed, but everything else was ripped out – even things like fire alarm systems, everything. There was a journey of trucks going up to the waste ground next to Tramway. There was a great big bonfire.

It's almost like the Garden Festival... there's always this intention that it will carry on, and Bob Palmer kept saying, you know, the Year of Culture thing, it will carry on. And of course it completely transformed the image of Glasgow, but nothing carried on. Everything was ripped out, and The Arches was all boarded up, and I was on the dole.

LORI FRATER

When Glasgow's Glasgow came to an end, I moved back to Mayfest, but Andy and the theatre company then went on to do a play called *Noise and Smokey Breath*, for what was then the Third Eye Centre, and they called themselves 'The Arches Theatre Company'. And that's where the kernel of all of this started.

At that point Andy had managed to talk to British Rail, as they were then – to actually use the arches themselves, for Mayfest the following year.

ANDY ARNOLD

I went to British Rail, and I said 'Look, I'd love to run a little theatre event in Mayfest.' Just like you would at, like, a Fringe venue in Edinburgh. Just have a venue which you take on for the festival. And it was a short-term thing but I thought it would be great just to do that for then.

They were happy to have us in there to turn the lights on and so on, and be in the place while they were showing people around but, you know, long term they were looking for a commercial tenant. I was completely on my own, so I went to Community Service Volunteers, who had an office on the Clyde, and persuaded them to give me a couple of people to work with me on setting it up.

Anyway, I went to [Blackfriars Bar manager] Alan Cunningham because I was going to try and set this up for Mayfest, and asked him if I could use his bar licence, to run a bar, so we had a bar. And I also asked Bob Palmer if we could get the lights back from the Tramway. The place, the Arches, was completely empty, there was nothing there. What was good, what enabled me to do stuff, was the fact that there

was the toilets and the fire exits and so on, but otherwise it was just an empty space.

So my original idea actually was to have an entrance in the lane [Midland Lane] into the studio theatre, and have our own little theatre space – so somebody could rent out the rest of the place and we could use the little theatre space. But there was obviously the entrance on Midland Street.

Alan came and made a temporary bar, just for Mayfest really... What else? We went up to the Tramway to get our lights back, and they gave us our stuff, then we went back to get more stuff and there was nobody there at the time and there was all this furniture lying about... mad stuff. There was a massive great sort of structure, which was like a long seat with a huge great back to it... a sort of sculpture thing. And I said, 'This is great, there's all this stuff... chairs and everything.' We had this van so we just filled it up and took it all back down. So we had a bit of furniture, you know. We thought, we've got to have some furniture in the place, for people to sit outside the theatre.

LORI FRATER

We had to give him time to get a programme together so that it could go into the Mayfest brochure. So because I worked for Mayfest working on the press, [I said], '...I don't know, I just somehow managed to lose the brochure copy!' ...and just 'found' it when finally Andy had managed to get a programme together! So, you know, miraculously his programme was able then to be included in the Mayfest brochure!

I kept popping down [there], and I mean, honestly, there was nothing... What had happened was, because Glasgow's Glasgow lost so much money, the Tramway bought the entire equipment of the theatre. So it was a shell of a building. But the Tramway then lent back the actual theatre equipment and it all went back in again, so that it could be used for the three weeks of Mayfest.

ANDY ARNOLD

We were rehearsing *Noise and Smokey Breath* and *Sexual Perversity in Chicago* the week before we were due to open, and then I got

a phone call to say my dad had died, quite unexpectedly. Well, he was seventy-five but he suddenly had a heart attack, and that was it. And my immediate thought was, 'God, I'm trying to get these shows ready', and so on… It was awful – as much as I was fond of my dad… I couldn't think, you know. It was only when I was sitting on the plane back down, that I actually suddenly started to think about it – you know, that my dad had died. And the funeral was on the seventh of May 1991. This became a pivotal day in my life, the seventh of May. That was the funeral, that was the day we were meant to be opening The Arches, and that was also my mother's eightieth birthday.

And we had the licence ready from the council, on the basis that we got our fire alarm system sorted out, because they weren't satisfied with what we'd got up there. And the fire company who had set the thing up originally, they had been very helpful in doing it for us for… you know, it was going to cost my own money actually, a couple of grand, which I always hoped I'd get back when I left but I never did *(laughs)* … a couple of grand to get the fire alarm system going – it would have cost a lot more than that to do it commercially.

And so the idea was, as well as our two shows, we also had visiting companies lined up. One of them was this thing called 'Glad', which was the Grassmarket Project, and they were a big hit in Edinburgh. They were all homeless people, 'Glad' was a thing about being homeless, and they were rehearsing in the space as well, and they were ready to run their show in the space. It was life imitating art, really, because they were performing on the stage and you could hear all these other homeless people outside in the lane shouting away, it was crazy.

LORI FRATER
The audiences, everyone who had come to it, were lauding it: 'Ooh, it's great.' And they left the building, and of course we had a soup kitchen next to us, and it was all our homeless people all outside, and suddenly all these people are asking me to call the police to get rid of the homeless people! The irony of those kind of things…

ANDY ARNOLD

I went down to my dad's funeral, with a view to come back that night to The Arches... and of course there was no mobile phones in those days, so I was constantly going to phone boxes and ringing up: 'What's happening about the licence?'

And the fire alarm people even agreed to stand by the bloody fire exit if they [the council] don't think its good enough, but they still wouldn't give the licence, so officially we opened on that night, May the seventh, but actually we didn't open that night, and I arrived there in the evening, back from Southend, and everybody was sitting about looking pissed off, because we weren't allowed to do the show. But we opened the next night. We just managed to do a bit of nonsense, you know, whatever was needed in terms of a fire alarm or whatever. Finally it was approved, and we got the licence. I'll always remember the first time we got a theatre show going at Mayfest. Sitting in that theatre space thinking, 'Fucking hell, we're a theatre!' It was so exciting.

There was no Arches Theatre Ltd then, it was just under my name as sole trader, so it was profit sharing, literally on the back of an envelope dividing up money for us all in terms of ticket sales. And if people wrote a cheque for tickets, it would be to me, Andy Arnold. And it was cloakroom tickets that we were giving to people, as tickets to see shows.

But the shows went really well, and we had a great little Mayfest. And we won a thing called The Spirit of Mayfest Award, from the *Herald*, which was five hundred quid, and you know, five hundred quid back then was like gold. And also Jimmy Boyle, who I knew and had worked with, the ex-gangster but now running the Gateway Trust in Edinburgh – which was like a voluntary youth thing – he had a Trust there with his wife. They gave us five hundred quid as well which, again, was major.

The licence we got was meant to be for the three weeks of Mayfest – but they gave us a licence for twelve months, which was a mistake! But it was a licence, you know. So we were expected to pack up after three weeks, but we thought, 'Fuck it, let's just keep going.'

LORI FRATER

And it was an absolute success. Such a success that the council then said, 'Okay..., here's £10,000.' When you think about the money now it's just ridiculous. 'Here's £10,000.'

ANDY ARNOLD

The then-leader of the council, her husband had died very recently and during Glasgow's Glasgow he had been to The Arches and loved going to the Arches Theatre bit of it. So she wanted to set something up, in memory of him I think. And immediately, what I thought was, 'We need someone to be running this place properly' – you know, financially.

I liked Lori, she was very sharp and organised. So I went to see her at the Mayfest office and said, 'We can pay you a wage, if you come and be general manager at The Arches.' And she said, yes, she'd love to do that.

This caused a bit of a revolt amongst my little team there; they were all with me, these actors, all unemployed, and suddenly... you know, the first time I get a bit of money and I go and pay it to a general manager. And I said, 'Look, we can't possibly exist unless we have somebody financially who's doing everything' – applying for funds for us, sorting out invoices and all the rest of it, because it was all starting to develop. Also, I was trying to set up an independent charitable company, Arches Theatre Ltd, so we could apply for money and so on, because obviously we couldn't do it under my name. In retrospect, if I had kept it under my name, I could have had the nightclub people in straight away and I'd be quids in!

LORI FRATER

My contract ended with Mayfest, and I walked into the building, with Andy and our £10,000, with the grand idea that we were now going to run a building.

There was nothing there, I mean, there really wasn't. It was an absolute shell. Glasgow's Glasgow, when they had left, had ripped

things out. Cables and everything... live wires hadn't even been turned off.

And we had the grand idea then that – this is us, with our £10,000 – we were going to set up The Arches. My job then was actually to set up the company, so I came in and did all the legal aspects of it. Setting up the charity.

KEITH BRUCE

The undisputed highlight of the unloved exhibition [Glasgow's Glasgow] was its troupe of travelling players who animated moments of the city's history, so it was fitting that their director, Andy Arnold, was the man who persisted in animating the venue when the season ended. Network Rail was not entirely unhappy to have a rogue arts organisation in residence under Central Station. After the reinvention of the old transport museum as Tramway, it was the single most important development of Glasgow's cultural reinvention.

2

1991–1993

And Then On Friday Night, We Went Through To The Arches

LORI FRATER

At the heart of it all, every single one of us was working seventeen or eighteen hours a day to keep this place afloat. I was twenty-four, just a kid. And the only thing that got me through, was that I had a business degree. So I knew what had to be done theoretically... I did not know how to do it practically. I don't think I had a holiday in probably two years. I don't think I had a day *off* in two years. There were times when we weren't taking any pay because there just wasn't the money for us to take any wages. If it hadn't been for all of these people literally doing it for the absolute love and belief of doing it, it just wouldn't have been there. Because everyone was against it. Everyone said it was impossible to do. The city council had brought in consultants, originally, to say, 'Could this be turned into a profitable building?' And everyone said no, it couldn't. And we went in and said, 'Yeah. It can be. It can.'

We all learned as we went along. People did things because they wanted to. I remember even with our electricians... they did an entire electrical rewiring of the entire building, but we paid them as and when we were able to, so we paid them whenever there was money to do it. That's the kind of goodwill that can be really difficult to get. And they ended up just being based there themselves, and they let us pay whenever we could. But the entire electrical system was shot, you know? There were bits of the building where the dampness was appalling. It just reeked with dampness. And when we went down to the basement – there were times we were walking in the water, it was that bad.

Most of the time we couldn't have the second bit of arches opened up, because it was just too big. Our electricity bills were crippling us.

I mean, to this day I don't know how we did it. People were working on nothing. The £10,000, hilariously, was basically to give me and Colin Proudfoot, our technician, a pay. All the actors were on a profit share.

COLIN McCREDIE *(Actor and early Arches Theatre performer)*
[Interviewed in The List, issue 559, 2006]
You got no wage as such. Just sixty quid cash in your hand every week. It was up-and-coming? You went because you loved the work. It was Andy Arnold's troupe of different people. But it was a very grubby place. There were no showers. It had a real guerrilla feel which made it very special.

STEPHEN McCOLE *(Actor and DJ)*
I was at Langside College doing a one-year theatre arts course, and we are informed that the class will be going to a competition with the play *Equus*. This is very exciting news, everyone wants a part. Unfortunately the class size is too large so six of us would be loaned out to the Arches Theatre company for their production of *The Ballad of the Sad Café*. Now being young – and let's be honest, rather stupid – this seemed on the face of it to be the booby prize, we wanted to be in the competition! How wrong we were.

It's fair to say I learned more in those five weeks with the Arches Theatre company – from the likes of Martin McCardie, Gordon Munro, Ross Stenhouse, Grant Smeaton, Morag Stark and Andy Arnold – than I did in the whole of the rest of that year. What it was like to be an actor in the real world, how important or not the training we were doing really was, the importance of being involved in the arts from a political standpoint. But most importantly, just how much fun could be had with the right group of people.

LORI FRATER

The one thing I was absolutely adamant about – and I probably put everyone through hell about this – is that I wasn't going to take out a loan from the bank. Because I thought that if we take out a loan from the bank, we will go under. I kept everybody on very, very tight budgets – they weren't getting any money out of me whatsoever! I thought, 'You're artists, go off and be innovative! Find things!'

So our poor set designer, Graham Hunter – he just went hunting around in skips. All of our sets came from skips, you know.

ANDY ARNOLD

Graham was wonderful, actually. He had designed the cart for Glasgow's Glasgow, and the costumes, and all the rest of it, for our little studio theatre shows. He came and helped set everything up, he dressed the place at the beginning of The Arches. We used to call it the Casbah Arch, the one opposite the bar, because Graham got all these rugs from the Barras and hung them on the walls to make it look like a casbah; he got all these lanterns to hang down. And where we had this grey plastic piping coming down, he'd be going round with Hammerite and painting them so they looked like old rusty dripping pipes – he decorated it to make it all look old and atmospheric.

LORI FRATER

We got the break when [large scale animatronic dinosaur exhibition] Dinosaurs Alive came in. Pete Searle, who was running Tramway, recommended us for it, not that long after we'd opened – October 1991. They used the back arches, and suddenly you could now see that the back arches could be something quite special, a really good space to use as well. At that point, because it was so big, so we were only using the front arches. And we franchised out the bar.

ANDY ARNOLD

We'd got a temporary licence to use the back spaces; we had a dinosaur exhibition there in the back arches, and we also had a pop video

exhibition that had been going in the South Bank. Then in early 1992, two very significant things happened. First off, we had this guy Gary and his mate coming along, he was a swimming pool attendant, and his pal was a bit of a designer... They came along and suggested that they wanted to build an alien spaceship.

GARY GILLIES *(Co-creator, Alien War)*
John [Gorman, *Alien War* co-creator] was a good friend, and we both loved the *Alien* movies. And John collected all these photos, and managed to get a hold of Sigourney Weaver's boots from the actual movie – this was before people really started collecting props.

And then we heard that the GFT [local indie cinema Glasgow Film Theatre] were doing a double bill of *Alien* and *Aliens* – a special thing on one night. We contacted them and asked, could we do a wee exhibition, so when people came out, they could go into this other section and see all the photos and stuff. We put all the pictures up, and Sigourney's boots, and all the other bits and pieces. We actually had an alien there, that John had built – similar to the one in the movie. And it was a great success. And everybody left, and John and I were sitting, just before packing up, and we had the alien sort of looming over us. And we thought – wouldn't it be better than objects in a glass case, if things were up and moving about and you could actually take part in the movie, and be part of it. Instead of sitting in your armchair, you get pulled out and you're actually part of it.

ANDY ARNOLD
They got permission to do it from Warner Brothers or whatever, somehow or another. I don't know how they got it.

GARY GILLIES
I contacted 20th Century Fox in London and told them the idea. And they said, 'Well, it's not up to us, it's up to Los Angeles.' And I said, 'Well, who's got the final say in this?' They said, 'A guy called Al Ovadia.' And I said, 'Right, have you got a number for Al?' And they went, 'Yeah, this is the number.'

So one night John was over at mine and he said, 'Ah, just phone him up.' So I phoned up, and I went, 'Hi, Gary Gillies phoning long distance from Scotland. I'd like to talk to Al Ovidia please.' The receptionist put me through to this guy Al, and I told him the whole idea – getting the sets, and the actors and so on. And he said, 'Well, that sounds great. It's never been done before. Can you fax me some designs?' Of course John was amazing at art, he did all the corridors, and then a week later we got a call from 20th Century Fox's London agents, saying, 'Right. Fox love this, and they're going to give you a licence to do it. Whereabouts are you thinking about doing it?' I'd just been to an exhibition at The Arches, it was the one with dinosaurs. I said to John, 'We've got to do this at The Arches, because it's really gloomy and it's got the atmosphere.' And he said, 'Yeah!'

ANDY ARNOLD
They wanted to build it in the back arches.

GARY GILLIES
I knew because it was Glasgow, Scotland, The Arches; it was like the back of beyond to LA. They were thinking, 'If this thing fails, we don't want a big opening in London and then it falls flat.' So that was basically it – and then, when the contracts came through, I looked, and down at the bottom of the contract, Al Ovadia had signed it. And he was the president of 20th Century Fox. I had been talking to the president without knowing it.

We came into The Arches, and we got a carpenter to come in and build all the corridors and sets. We had nothing, absolutely nothing. So John, being John, had to go and get moulds and build aliens and costumes, and sew everything. Everything. He had to do all that, and even the corridors were very basic – just walls painted black. We put up some pipes and grills, and that was it. We built the doorway and everything else. And then I designed the layout of it – worked out how many groups we could get… 'Once this group gets here, the next group can set off,' etc.

We put an ad in the paper, I think it was the *Evening Times* – and we said, 'We're looking for the new Sigourney Weaver.' And that was it. We did an audition and it was literally hundreds of people coming in, and they'd say a couple of lines.

ANDY ARNOLD

So, *Alien War* was set up, and they built that at the back of The Arches, and we helped to find six foot six actors to be alien monsters and so on.

GARY GILLIES

We did have that guy from Franz Ferdinand – Alex Kapranos. He was an alien. He was a skinny sort of guy. I think he was doing it for extra money or something like that.

We did a couple of test runs. We literally went into McDonald's on Argyle Street, and got a couple of groups, said, 'Would you like to go through this thing?' Of course, the reactions were fantastic. And that was it.

I think we got STV, [the BBC's] *Reporting Scotland* and all that, they all came down, because it was such a new thing, and they filmed it. And *The Sun* newspaper. I'll always remember the reporter from *The Sun*. He came in and he said, 'Right, I'm just back from Beirut,' which was a war zone at the time. And he said, 'I'm going to take my camera in, just in case I can get a couple of shots.' They went round, and the screams were great and everything. And I always remember – because I was backstage at the time, and I could look into the lift, where the alien comes in and drags somebody out – when it came in, this reporter was at the back of the lift screaming, and he had his camera out and his finger had jammed on the trigger, and it was going, 'click, click, click.' And he was screaming his head off.

So we thought, 'Oh! We've got a winner here.'

The Saturday it opened, the queue was just… I couldn't believe it. Right along the street, right round to the McDonald's bit. And that was us, off and running. And it was just mayhem after that.

LORI FRATER
Alien War was such an enormous hit. I remember coming down Midland Street, and the queue was just around the building, and around the building, and around, you know. And the people were coming out, and joining the queue again.

GARY GILLIES
We just seemed to hit a nerve with this whole experience.

AL SEED *(Arches artist-in-residence, 2005–2007)*
I took my little brother to the original *Alien War* and gave him nightmares for weeks. The Arches was then on my psychological map.

GARY GILLIES
We didn't want to have tons of special effects, so I said, 'Look, let's just plant the seed in everyone's head, because the most terrifying thing in this world is your own imagination. We'll plant seeds, and the easiest way to do that is to build up a story, and then the lights go out. And you're in the dark. And there's something in the room.' Simple. And it worked.

It was just so perfect. And also the fact that when trains went across the bridge, the whole place rumbled. And people were like, 'How did you get that effect?' And we'd be like, 'Ah, large speakers we've got.' Ha! Surround sound.

DAVID BRATCHPIECE *(Employee, 1998–2013, various roles inc. cloakroom, box office, front of house manager)*
Alien War was the first time I was introduced to The Arches. The first run, in 1992, my friend phoned me – he had heard about it – and he said, 'There's this thing called *Alien War*, licenced from the films. The aliens chase you about, it's a scare attraction thing. It's in this place in the centre of Glasgow called The Arches.' I was a nerdy kid, and a huge fan of the films, so immediately I was like, 'Yeah, we're going.'

GARY GILLIES

From then on, word got out. We had *Time* magazine over, did a full page. CNN were over filming it, their London branch came up and filmed. It just seemed to explode. And it was great that it happened in Glasgow. We got, I think, about 103 or 104,000 people through in the six months. Which was good for a small city like Glasgow. It just went ballistic.

John and I went out to meet 20th Century Fox in LA, and while we were out there, we knew Michael Jackson was coming to Glasgow. And Fox managed to give us Michael's agent. And we started to communicate with them, and we said, 'Look. We really want Michael to come along to The Arches and go through *Alien War*.' And we got word back that they were going to consider it.

It was literally the day of the concert – we had just opened up for the day – and somebody radioed me to say, 'There's people down here from Michael Jackson's entourage, they want to talk to you.' And I was like, 'Ooh, this is it, this is brilliant.'

I went down, and it was your classic big, heavy guys – obviously his bodyguards. They were like, 'We are here to go through the show and make sure it's okay for Mr Jackson.' And I went, 'No problem at all.'

So word went out to the marines: 'Right, I want the best show ever. All the marines running in, gunfire going off, everything.' They went into the base, and I was listening – all the screams and all that sort of stuff. Then halfway through the show, the emergency exit opened up. And I was like, 'Ohhh.' Thinking one of them had banged their head or something's happened. And they all came out.

I said to the marine, 'Was something wrong?' And he said, 'No. They couldn't take anymore. They asked to be let out.' These big guys, the bodyguards! And I'm like, 'Right, okay.' And they were like, 'Thank you', and off they went.

And then we heard word back that Michael Jackson wouldn't be coming, because it was too scary.

But funnily enough, we had a marine that started working for us – his name was Michael Jackson. So I said, 'Right, John, we're going

to get a quote.' I said to Michael, 'What do you think of the show?' He said, "Fantastic." So, there you go: '"Fantastic" – Michael Jackson.'

And then, when it finished… Aberdeen Exhibition Centre had come down to see it at The Arches, and Bournemouth Exhibition Centre came up and saw it at The Arches, so they said 'Right, when you're finished, bring it up.' And we had to dismantle all the sets and bring it there, and do stuff like that.

It was 1993, it was in London. Sigourney Weaver and Lance Henriksen attended, and a few of the marines as well. London was massive, because by that time, Fox's eyes were wide open.

There's a Facebook site, Alien War Veterans… and we've had people that have travelled to every one – Aberdeen, Bournemouth, London. And all say the same thing – Glasgow was the best. In London we had all the sets from *Aliens*, all the original pieces, everything, even down to stickers. We had the original moulds of the armour, we had pulse rifles made by Bapty, the same company that made the weapons, everything was mind-blowing. We had a lift that actually moved – it went up on hydraulics and then dropped down. We had an EEV – Emergency Escape Vehicle – that everybody went in. We had facehuggers coming down. All this stuff.

The Arches was the best. I think it was just because it was so basic and the atmosphere was just right – it has this creepy element.

BLAIR SUTHERLAND (*Bar staff, bar manager, eventual director of operations, 1992–2015*)
I was a qualified stockbroker, but I chucked it to focus on my band. And when you focused on being in a band in those days, you got an independent record deal – there was no funds coming in, you only got funds from sponsorship for tours and so on. Anyway, I went to *Alien War*. My mate was one of the… whatever the 'gun guys' were at *Alien War*. We went to see it one Saturday afternoon or something like that – it was brilliant – on the ground floor and middle bar and all that. I went, 'Oh, I could do with a bit of a job', just to pay for the petrol money for the gigs and all that. Asked the bar, which in those days was a white plastic bar, three Bud fridges in the back bar and

these white Formica kitchen units – and I'm not kidding, they were kitchen units. They said, 'Yeah, give us your number', so I gave them my number. Eight weeks later, the assistant manager left – I got the assistant manager role. Fast forward a couple of years, the manager of the bar left and I was the bar manager!

ANDY ARNOLD

The other thing that happened was that same month [when *Alien War* launched]: Pete Irvine, who was then just finishing running Regular Music, had this idea. He was fed up with all the clubbing going on in Glasgow, he thought that something a bit more interesting could happen in Glasgow. We'd already had a couple of club nights. The first club event was run by Angus Farquhar, who went on to run [large-scale public art organisation] NVA. I had no idea that our theatre licence was only for the theatre bit and was only till midnight… we used the whole building till six in the morning, it was thick with smoke everywhere, you couldn't see anything.

So we'd already had a club night, and Pete Irvine had heard about it, so he came along with Dave [Clarke] and Pedro [McShane] from Slam. They were running Slam at The Sub Club in those days, and they wanted a bigger space.

DAVE CLARKE

I went in to see The Arches and thought, 'This would be a great space.' Because I'd gone in to see it, it was stuck in my head. And then there was one event that predated us persuading Andy Arnold to let us do a club in there… a one-off by Pussypower – Jason and Terry, a couple of crusty techno DJs with Castlemilk connections. We did our first night there in '92, and I was twenty-five, Stuart [McMillan, one half of DJ duo Slam] was twenty-six, Orde [Meikle, the other half of Slam] probably twenty-seven. We had been doing clubs and events since 1988 – we probably thought we were veterans but we were pretty young! And mega enthusiastic, for sure. I don't think Andy took a lot of convincing. I think once he met us he could see that we were enthusiastic and we knew what we doing. We'd already done some

big all-nighter events with Regular Music at Strathclyde Park and SEC, the Scottish Exhibition Centre. So much had happened in that initial acid house period in the first few years, and then the raves and stuff... We were doing the trendy Sub Club, and I think he thought we had a passion for it... and we also liked the idea of what the theatre could bring to the club as much as what the club could bring to the space. We'd got this idea to do Slam on the Friday but have something altogether more theatrical on the Saturday, with Andy having a bit of programming.

STUART McMILLAN *(DJ/producer, Slam)*
I think the whole thing with The Arches was, because of its theatre background, this kind of nightclub thing and the theatre productions made sense together. So Pete came to us and we sat down and we talked through all the ideas.

ANDY ARNOLD
Friday night would be a proper clubbing night, run by Slam, and Saturday would be a more sort of mad theatrical thing, that Pete Irvine wanted. I came up with the name Café Loco. The format would be that we had mad actors dressed up in costumes – as bouncers, or whatever... sailors, and daft things... as people came in. And there would be a piano playing in the corner, and then there would be a few cabaret things going on, and I was the maître d' going around. And we had a mad band going on of some sort. The first band was called The Gods of Glam, we had the Scottish Sex Pistols, bands like that. And then it would be a DJ for the rest of the night, who would play a range of music, not just house music... disco classics as well.

ANGIE DIGHT *(Co-founder, Mischief La-Bas)*
In March '92 Andy Arnold got in touch with Ian [the late Ian Smith – Angie Dight's partner and the founder of anarchic performance troupe Mischief La-Bas] to ask if we were interested in doing something at his new club Café Loco which was going to be launching in a couple of weeks. We'd been working with the French circus Archaos, but they'd gone bust in '91 and we'd returned to Glasgow with our bank account

frozen due to the poll tax; we were living just then in a tiny caravan on Glasgow Green.

That very same week I had been sacked (unfairly) from my job at Blackfriars so it was a bad week that turned good, although Blackfriars also ran the bar at The Arches, which I wasn't really okay about. I was sacked for stealing out of the till, which I hadn't done – and giving a staff member free drink, which I had. Andy said he didn't care, he'd nicked a jacket out of Flip recently, which I was a bit shocked about, since he was a proper grown-up.

ANDY ARNOLD

Then, with about a month to go, Pete Irvine said, 'I've been commissioned to write this book, *Scotland the Best*.' He said he had to travel round the country writing it, so he said, 'I can't do this.' I said, 'Well, I can't do it.' And he said, 'Well, you're already setting up the theatre side of things; I'll get you the DJs, and you're fine.' And obviously the Slam guys could help with that as well – they knew what they were doing.

STUART McMILLAN

Pete's vision was very 'Berlin' – kind of old school nightclub, curtains… quite decadent.

DAVE CLARKE

It was 'shabby chic', wasn't it. It was looking decadent but on a shoestring budget.

STUART McMILLAN

So we got all these second-hand couches…

DAVE CLARKE

I remember Lori trying to set them on fire to prove we'd fireproofed them properly!

STUART McMILLAN

Yeah, we just did things back then that you wouldn't have done now… With that many people, you would think about putting potentially hazardous couches in…

DAVE CLARKE

But they weren't hazardous! We covered them and sprayed them, and they were definitely fireproofed, and she was like strict with the rules – although she hadn't worked in nightlife before, it was coming from a theatre background. So she had a lighter out, trying to burn the couches, she's like, 'You have to show that with a naked flame, nothing will happen!'

LORI FRATER

Oh crikey, yeah, Because that was a massive thing with *Alien War*. *Alien War* had been postponed because we couldn't get it licenced, because it wouldn't meet the fire specs. They had chosen the wrong wood and it was too expensive for them to replace it with wood that the licencing would have accepted, so we had to go through a whole process. We had to send off to Germany to get some form of spray retardant. And we had to send it off, literally bits of wood, to all of these labs, to get it tested. And we had to go through all these different testings, and we had spent a fortune getting all of this flame retardant. But yeah, Dave's right, I did go around spraying sofas! I was always very legal! And the massive curtains for Café Loco – we had to use spray retardants on all of it it. Yeah, there was definitely a lawyer in me even then…

ANDY ARNOLD

And so we did. We ran it ourselves, and it was massively successful. It was hugely popular – it was a mixture of young clubbers coming and this very trendy set – theatre people, film people like Robert Carlyle, you know, famous musicians… we'd get a lot of famous people coming along. And there were mad things going on all night. Mischief La-Bas were there doing installations and performance stuff.

STUART McMILLAN

So the first night was us just DJing the whole night – Mischief La-Bas were peeling carrots from a…

ORDE MEIKLE *(DJ/producer, Slam)*

…An Obelisk!

DAVE CLARKE

I think it was potatoes, Stu! And making necklaces. Ian Smith was sitting on top of this plinth, which was another theatre prop – it was probably about ten foot high – peeling potatoes and making them into necklaces. The whole night!

ANGIE DIGHT

We were really into the Circus Archaos/European street theatre performance vibe and we planned to do a weird durational performance, which we decided would be three hours long… and that we would only speak in French, which considering our French wasn't that amazing was ambitious.

The first gig at the launch we enlisted Rachel Mimiec and Archaos' Irish chef Eddie Keane. We found a big ten-foot plinth in the Arches somewhere. Ian and Eddie, as chefs, sat on top of the plinth, while Rachel and myself as the KP chefs sat at the bottom. We sent buckets of potatoes and carrots up to Ian and Eddie (who gave up after twenty minutes), who then peeled them over us and the floor. We picked the peelings up and made them into garlands which we put over the heads of any willing punters. Rachel didn't speak any French at all, so we chatted for the whole three hours in gobbledegook language, to ourselves and to the punters. Punters came up all the time, with all our performances, and wanted to know what we were doing, we were super friendly, but still spoke in gobbledegook or cod-French – or French people trying to speak a bit of English was how it really worked out. As English people, people liked us a lot more when they thought we were French. It wasn't the reason we started in the first place, but was definitely the

reason we continued. I'd never met Rachel before but we became firm friends that night and still are today.

DAVE CLARKE
Usually the performance stuff was just something that was done as a sideshow and then one night Mischief La-Bas managed to persuade Orde – they said, 'We've got a good idea, we're going to be cutting about dressed as French people and we're going to have these signs for Maurice Chevalier. We're going to be Maurice Chevalier fans. And at a pre-arranged time we'll run into the dancefloor and we'll chant, "Maurice, Maurice." And you have to stop and play "Thank Heaven for Little Girls", the Maurice Chevalier track.' And we went along with it. Why not! I guess everybody just had to be versatile… I remember for the DJ box, before one was built, we had this kind of wagon, like you would have a horse in front of, that was used for some theatre production or play and we just kind of rolled that over and got it sitting stably and put the decks on it.

ANGIE DIGHT
Every week we created a new manifestation… at least for the first year and a half (when we started to resurrect some older ones). On a good week, the idea would be in the bag by Monday; on a couple of bad weeks, we were still struggling to come up with something decent by Thursday. We would need to get any props and costume and whatever else together… often a trawl round the charity shops.

BLAIR SUTHERLAND
It was the cool, new up and coming place, so to speak. It was a little bit different. Friday night was Slam and it was cutting edge, leading the techno scene at the time.

STEPHEN McCOLE
It's fair to say that my first Slam night – even though I was working on the bar – the tunes that came pounding through from the dance floor and the people who were there set me on a path that would change my

life. I'll be honest, I spent more time 'clearing glasses and bottles' from the dance floor than I spent behind the bar.

DAVE CLARKE

It was six years, exactly and precisely to the date, first weekend of April, when we stopped the weekly Friday Slam at The Arches. Orde's wife Jackie used to do the front door, the cash desk, every week for the entire first six years.

Orde and Stuart played pretty much as the residents every week. And then we had a few local guys that would fill in every now and again, at first, and I think we kind of maybe started doing guests every six weeks or so, it wasn't a big part of it. Early guests would have been people like Andrew Weatherall, Laurent Garnier... Green Velvet, definitely. Underworld played, they closed it one night – a live set in their early days, when it was just a six or seven hundred people venue. And obviously Daft Punk as DJs. It wasn't about the guests, you know, but it became a good occasional thing to do. But I think that was the beauty of it – it had Café Loco which was a different crowd, and more for people connected to the place as a theatre, and Slam on the Friday, and there was no other club night so I guess the thing that made it special is that it was something you don't really get as much, or even at all, now – where it was this kind of weekly congregation of people from different walks of life that went along, and quite often wouldn't be socialising with one another or know each other, apart from on a Friday night at the club... So it was a club, as in a *club*, where people felt like they belonged and came along no matter what was on. And very often it was just Slam playing all night.

STUART McMILLAN

I think people grow fond of a space. I think The Arches just had a warmth and people instantly enjoyed being in that space. It had a big club, big room atmosphere, but with a small room connection. So even though there was a lot of people there, it wasn't like you were in a massive arena. You could see people's eyes, you could see people's

faces. The connection between you and the public was fantastic. And you weren't miles away from people, so that's what I mean by it having a kind of small club intimacy.

ORDE MEIKLE
And it was so central, wasn't it… the location was so central, do you know what I mean? It was very easy to get to.

STUART McMILLAN
I mean you would drive up and just see that queue going right up… unique because it's underneath the bridge and everybody queued right up to the back and round the corner…

ORDE MEIKLE
And then back down the other side of the street.

STUART McMILLAN
Yeah, you'd just see that queue… as a punter, getting towards those big metal doors, and hearing that music – 'boom, boom, boom' – coming… that anticipation must have been amazing.

ORDE MEIKLE
And all the smoke, and the heat coming out through the open doors, I remember that. It was very anthemic.

DAVE CLARKE
And then the steam off everybody's bodies when they're…

ORDE MEIKLE
Coming back out, aye.

STUART McMILLAN
And because we were always working with Dave Pringle and continually tweaking [the sound system] the sound was second to none.

It was adventurous, The Arches. It was all these different little areas and rooms and corridors – all these different areas to explore, that just made it an exciting place, a) to play in, but b) as a punter, to go to. It wasn't just one room and that was it. You could get lost in there.

BLAIR SUTHERLAND
And when you went down on a Saturday night, you'd come in to this big club, and those curtains to the dance arch were closed, then Andy would give a speech and then Mischief La-Bas and all these guys would do all this mad stuff running about in Arch 6. And people were, let's just say, coming up on whatever was happening… be it the love of The Arches… not knowing what was going on.

I remember Mischief La-Bas' kazoos. They'd have one guy jumping onto the wall, and then a guy going 'bzzzz' with a kazoo. The guy was dressed as a fly, so he's running about as a fly with a kazoo and the other guy's chasing him with a fly swat.

ANDY ARNOLD
The famous one was Ian Smith dressed up as a chef, chasing Ange through a crowded dancefloor with a chainsaw, and then about half an hour later coming out spattered in blood giving out jam sandwiches to everybody.

ANGIE DIGHT
We realised that people [Glaswegians] absolutely loved freebies. We were nearly always giving stuff away, and whatever old rubbish it was, people would want it because it was free. The first Halloween gig we did, it was a thin idea, but basically we rushed through the bar area, Ian with a chainsaw (no blade – an Archaos trick) running after someone. We went back to the dressing room and made two sliced loaves' worth of some sliced brown meat and beetroot sandwiches with added juice – they were disgusting-looking – went back in and offered them round, they were gone in a couple of minutes, and people actually ate them. I was gobsmacked and horrified, but it was also hilarious and we loved it – that 'Yes' attitude that was/is so Glasgow.

BLAIR SUTHERLAND
And other guys were walking about with plates with photocopies of food. And it looked like real food. Imagine taking a picture of your full Scottish breakfast and walking about a club with it, and offering it to somebody. And they, in their state, take it. That was the early days, because the artistic risk assessment was non-existent, so the guys could get away with a lot more.

COLIN McCREDIE *[Interviewed in The List, issue 559, 2006]*
Some of us in our final year did mad stuff every Saturday night: me, Tony Curran and Paul Blair. I remember one time we made a suit of toast. We got a hundred pieces of toast and sewed them together and then put butter and jam on it. And we'd be running round the club giving people things. We used to get twenty quid, two places on the guest list and a free pint. It was great fun to be involved with something like that as a student.

ANGIE DIGHT
We continued doing the three-hour gigs (no breaks), mostly Ian and me, but we invited various people to join us. Artists David Shrigley and Dave Clarke, sound editor Colin Monie, TV producer Susan Maxwell and regular Mischief performers and musicians Kozmik and John the Hat, our sound maestro Ronan Breslin and various others who fancied a go. Raymond Burke, Tony Curran and Colin McCredie were all freshly graduated actors who performed regularly and were also part of Arches Theatre Company. There were also many other performers, I remember Shahbaz [Chaudhry] was a regular – a beautiful and hilarious diva who later appeared on *Big Brother*.

In the early days though, the thing that really made it was Andy, he was the face of it and he played that role really well. He was at all the nights, he did his spiel if it was his do, Café Loco, some event, theatre… he didn't always need to, and we did laugh, sometimes at him, but mostly at his jokes or funny lines. But his presence made him the host and he was really good at it.

ANDY ARNOLD

I'd always compère. I'd say, 'Welcome to Café Loco', and so on.

BLAIR SUTHERLAND

It always started, 'Welcome to Café Loco!' In his sort of Andy drawl: 'Welllllcome to Café Locoooo!'

The guy that did the drawings... I can't remember his name... Gerard, or Gerry? The whole side of one of the arches was set up with a big bit of black, and he used to do a chalk drawing on it, and he'd start doing this drawing at this point, when Andy was speaking, and it was only like two or three hours later that you'd know what it was. So Andy was all, 'Tonight we have Gerry doing his picture – do you know what it is yet?' You know in the London Apollo in the old days they'd try and make it sound more exciting – [puts on exaggerated 'cabaret' voice] – '...the most exciting, tremendous, fantastic... artist!' Naw, he was a guy that had a bit of chalk on a bit of board, really. Andy would...slightly exaggerate the excitement that was expected: 'And Mischief La-Bas, watch what they are doing tonight! You might see a kazoo... is it a kazoo? It might be a spider.' You know, a little bit of that. It was probably five minutes, if that. 'And then we have this person playing live...' There was always a live performance at Café Loco. It was a little bit Jools Holland-esque, if there's ways to remember it. The curtain would then open, and then there would be a live performance... I mean, big bands, guys like Stereo MCs, the Hothouse Flowers, played the live performance, then it would be the DJs. So usually from like, say ten o'clock to twelve o'clock it was cabaret, wining, a bit of laid back music, and then it would become twelve o'clock and the club would open.

ANDY ARNOLD

After the band had played, every time a disco classic came on, like Sister Sledge or whatever, that sort of thing, the whole of the trendy crowd would move out of the bar, go over and dance, and then go back to the bar again afterwards. And they loved all that.

ANGIE DIGHT

At first we were just doing Café Loco, but then Slam wanted us to do their nights, which we did. At first we hadn't been so keen on working at Slam. It was Friday night and everyone was off their face and crazier than us and maybe over-friendly, but in the end we preferred the Slam crowd to the theatre crowd. The Slam lot were regulars and they really liked to join in and were actually more fun in the end. They were off their trolleys so they saw things we might not have imagined, or maybe they just totally appreciated the madness. The Café Loco theatre crowd got a bit too knowing/up themselves/too cool to make fools of themselves, and so had less fun. So we were able to set up Mischief La-Bas on a Glasgow Development Agency GDA – unemployed setting up a business scheme and these two club nights at The Arches which we continued doing for two years. (We gave up just before our first child was born; it also felt like the right time.)

ANDY ARNOLD

The thing was, that trendy crowd didn't want to go every Saturday; they weren't that mad about clubbing, you know, the same way that the young clubbers were. So it lasted for two years, but after about a year or so, bit by bit, it got taken over just by young clubbers who didn't want all the theatrical stuff – they kept saying to security, 'When's the DJ's on?' And the DJs were under great pressure just to play house music, and so it changed its culture in a way, it just became more like a club night. We carried on doing everything, we carried on with all the theatricals and so on.

And Stefan King [director of G1 Group, the biggest nightlife conglomerate in Glasgow], he came along and he was standing there watching, him and his mates. They paid to get in and would just stand there, watching. And a few months later he set up Archaos, and it was just a mirror of The Arches …they got Mischief La-Bas to go along there as well.

At that time the bar was still being run by Alan and his lot, the Blackfriars team, and they were paying The Arches Theatre a thousand quid a week or something like that, for us to pay wages.

ANGIE DIGHT

After a few months Ian said to Andy, you should run the bar yourselves; that's where the money is made. That's what Andy and The Arches Theatre Company did and the rest is history.

BLAIR SUTHERLAND

We saw the guys spending all this money at the bar, and then we went, 'Okay, we need to set the bar up.'

Then, when the theatre realised that they were only getting pennies, and the bar was making thousands, they set the retail company up.

LORI FRATER

Alan had had the franchise, and we very smartly removed that from him. Because part of [the] licencing problems derived from him. Because he was making a lot of money from that, and I then [realised], 'Hold on, somebody else is making an awful lot of money from this building that we're not', and we desperately needed that money. So we bought him out, and we made it kind of impossible for him to stay.

ANDY ARNOLD

And that was a game changer for us – suddenly we were running the bar, which meant we could actually pay our bills and all the rest of it. And also, we could pay British Rail a rent. It wasn't sixty grand, but it was probably about forty, you know – it was relatively serious money.

But we then had a business operation, and we set up a subsidiary company, Arches Retail Ltd, which was a subsidiary to the theatre company, which was a charity obviously. This carried on until the end. And all the money from the retail company, the profit from that, would subsidise the theatre.

LORI FRATER

I still don't know where I got the idea from, but very early on, I turned The Arches into the first arts venue in the UK that was publicly *and* privately funded. And it was a model that nobody else had ever looked at. And I was really surprised, because when I moved to Cardiff, and I

became a trustee of Chapter Arts Centre, they had only put that model in a couple of years before that. And that was years and years after we had done it in the Arches.

We got really criticised for that. Because arts organisations in the 90s had been very used to the money coming from Glasgow's Year of Culture, and were just looking at being publicly funded. And suddenly there we were saying, 'Well, actually we can do this, on a very small amount of public money' – by private funding. We were the first to have the charity, but also the commercial arm as well. And a lot of the arts organisations didn't like that – they thought that we were putting public funding in jeopardy for them. But it was the only way that we could survive. It was the only way that we were ever going to be able to keep afloat.

ANDY ARNOLD

So these all happened at almost the exact same time – Café Loco, Slam and *Alien War*. And I remember one Saturday… all day long… I came down in the morning and there was a massive queue of people waiting to go into *Alien War*. There was no booking system, you know… it lasted ten minutes and people would queue, sometimes for three hours, they'd go through that thing in ten minutes and then go to the back of the queue again, it was unbelievable. For years after that, the doorbell would ring and people would be there saying, 'Is this the alien thing?'

So people would queue all day for that, and then in the evening the queue would start for Café Loco. Suddenly these two things happened, and suddenly we had two viable projects.

We were getting a rent off the alien spaceship thing, a rent off Wet Wet Wet when they used the empty arches to do their production stuff as well and a grand a week off the bar, from the people running the bar for the club nights.

And we had the occasional gig as well. I always remember, we were sitting around in the Arches talking about bands coming to Glasgow, and this guy, the technician for Slam, said, 'Canned Heat want to come, but nobody wants them, they're old.' And I said, 'Let's book

them. Even If I'm the only person there.' They were my student heroes, when I was a student in Dundee. The original band, most of them were dead but nonetheless, one or two of the original band were there.

And there they were, in my Arches. Canned Heat. It was amazing.

LORI FRATER

The combination, I think, of Slam, Café Loco and *Alien War* all running at the same time really transformed the building.

We were all still stuck – I mean, Andy and I were in a tiny little office, with him at one side and me at the other of a tiny square. That was it. But with that combination, the money really started to come in.

DAVE CLARKE

The way it expanded was incredible. Because Andy's main objective was just to keep the theatre going. It wasn't any big plans afoot; it was just a regular source of income that funded the theatre beyond what the Arts Council could do.

LORI FRATER

I remember one weekend we had the clubs, and it was Mayfest as well, and we had a record and CD fayre as well… I mean we were having everything. We still only had that £10,000 of public money; we had to create the money.

ANDY ARNOLD

In those early days we had to apply for a late-night licence every single week – for a three o'clock licence, to have the clubs. Other club people were dead against us because we were too successful, they hated us. And there was a lot of corruption, I think, in the whole licencing committee and so on; they were listening to powerful club people.

LORI FRATER

Some of the other clubs were not happy with us, because we were so popular, and so successful. There were times when the other club owners were probably having a quiet word in ears because we were

getting far more trouble than anyone else. There was this time not long after we had taken over the franchise of the bar…

ANDY ARNOLD
…and suddenly Building Control came and visited. We had a stone floor, for the dancefloor, and they said that we had to have a wooden floor. It's too dangerous to have a stone floor, and we couldn't have a licence. We were told that on the Friday morning, and we had Slam that night, at eleven o'clock.

LORI FRATER
Now, we'd been going for years! But this night, they phoned up at four o'clock… this was a Slam night, and they said, 'You can't have the licence tonight unless you've got a dancefloor.' And I was like, 'Right, we'll have a dancefloor.'

ANDY ARNOLD
So I said, 'If we can get a wooden floor down, can we have our licence?' This is about four o'clock in the afternoon, actually. And they said, 'Well…yeah, I suppose so.' But we knew they'd come and visit. So we managed to get hold of a building supplier in Paisley who could provide eight-foot by four-foot batons – enough wood for the area.

LORI FRATER
Pedro [McShane, Slam co-promoter] immediately went off with a van, brought the wood back. By that point I had got all of our carpenters in.

ANDY ARNOLD
And I got hold of this guy, I've forgotten his name now… one of the guys who worked with me now and again, he was a joiner. So he came down. And by six o'clock we were all carrying these eight-by-four sheets off this lorry. To make the joists underneath, my joiner friend was battering away, we'd carry these things in and he'd hammer them down… and we had to paint them all black.

LORI FRATER

We also had a theatre production on, and the dancefloor had to go in the arch opposite the theatre production. So the carpenters were in laying the bits of wood… as they were laying the wood, me and Jenny [Rothwell, front of house manager] were painting the wood! So we were going in, they were going out… we were painting… then we'd all stop when the theatre had to go back on again, then we were all painting…

ANDY ARNOLD

By half past ten at night, we'd done it.

LORI FRATER

When the police turned up at eleven o'clock that night, there was this beautiful brand new dancefloor.

ANDY ARNOLD

We had covered the floor, and got building control to come down, and they were all, 'Okay, I suppose so, yeah.' And went away.

LORI FRATER

And we got our licence. The only thing was, the paint hadn't dried by this point.

ANDY ARNOLD

I think we opened it late, about half eleven, or something. There was a queue outside. But that was it. We opened the doors… and in those days people used to really dress up all the time, especially Slam nights…

LORI FRATER

As the nightclub went on, it got very, very warm… and everybody got covered in black paint! But these were just the kind of things that we had to do!

ANDY ARNOLD

It was extraordinary. But it was that 'never say die' thing.

LORI FRATER

The police were constantly on about the nightclubs, you know. And they were constantly coming down. One of my absolute favourites was... the licencing board decided to come down one night. It must have been one o'clock in the morning or something. Now, they were all in their sixties, seventies, the licencing board. As these councillors turned up... the looks on their faces... and I remember this old lady saying to me, 'What are they doing?' And I said, 'Well, they're dancing!' And the horror on their faces as they walked around, as you can imagine. I've never seen faces like this in my life before. And the police that were escorting them, they were in stitches as I was walking around with them.

It's fair to say that we were always on the radar of the licencing board. One time they absolutely refused to give us a liquor licence; they were just like, 'No.' It was the time when the council had said they wanted all clubs in the whole city centre to close at two o'clock in the morning, across the board. And nobody could enter a club, I think it was after eleven o'clock or something. But they'd said to us, 'You're not having a liquor licence at all.' And I said, 'Well, that's fine, I still have an entertainments licence.' So we still put the club on, we just didn't sell alcohol. So of course I turned it around, I said, 'We're doing this, we're not having any alcohol, are you going to support us?' And everybody was like, 'Absolutely.' So they were really annoyed with us again, you know. Yes, there was a history between the licencing board and the venue.

DAVE CLARKE

We had the introduction of the curfew coming in while we were at The Arches. Our famous flyer had this pumpkin on it... you had this situation where the council were suddenly telling people they had to be in by midnight or they would turn into a pumpkin. And the club shut at two o'clock. We had this campaign, and all sorts of people got involved. We ended up getting The Shamen to do a concert as part of a demonstration at George Square. This was all about '93, '94... and you know, within several months the curfew was getting bad publicity and they got rid of it and they gave everybody the

three o' clock licence back. That was a big achievement, through the community of The Arches.

STUART McMILLAN

We were there the night the police raided. That was when we were still doing the Fridays. And they came down and raided the club... I think there had been some unfortunate drug death in the papers... I think it was round about the Leah Betts time [Leah Betts was a teenager from Essex who died after taking ecstasy in 1995; the case made headlines for weeks], which was awful. And I think the police felt that they had to be seen to be doing something. And they raided the club, and of course they found nothing.

DAVE CLARKE

My lasting memory of it is that the lights were on for about ten minutes and it was just dragging on, and there were all these policemen standing about near the door, and eventually everybody just started chanting, 'Get to fuck, get to fuck, get to fuck.' And then someone said to Orde, 'Right, you can put a record on now.' He put 'Positive Education' [Slam's biggest hit at the time] on and people went wild. And then the police just left because there was nothing else they could do.

STUART McMILLAN

What's interesting about that scenario is that if you fast forward to what eventually happened, the situations and the mindset of the police hadn't essentially changed from that point to when they eventually closed the club. I don't know whether The Arches, being a more creative, theatrical background, was maybe less subservient to someone like the police... that there was some sort of friction between the two things.

What The Arches had was quite unique within the UK. Okay, you had things like Cream and Ministry [of Sound], bigger nightclubs but it was certainly unique.

DAVE CLARKE

Yeah, I think having the theatre and the arts side of it gave it the balance. And the people running it weren't breadheads or strict businessmen, and that really suited the style.

STUART McMILLAN

How anything turns out, or how people are treated or how people behave in any business, always comes from the top down.

DAVE CLARKE

So you've got to give Andy Arnold a lot of credit.

STUART McMILLAN

Yeah, that creativity... if it starts with creativity then everything underneath that is essentially going to be creative.

DAVE CLARKE

It was the most versatile venue for sure. Anywhere. [At first] they didn't have an alcohol licence through the back, so for us [going bigger] wasn't an option. But then gradually the whole place got licenced, and things changed. And clubland changed. Different promoters and different nights happened, but that initial period was pretty special.

3

1993-1999
Here We Fucking Go

'It was kind of like my church in Scotland at the end of the day. Carl Cox at The Arches was kind of like... folklore! It was like a night not to be missed, you had to be there, no matter what. And that was what it felt like to me. It was definitely my church, every time I went to play there.'
Carl Cox (Superstar DJ and producer)

ANDY ARNOLD
We ran Café Loco every Saturday for two years, and we'd just had enough of it. It was dwindling. It was like organising a big party in your house every Saturday night. I remember, I used to get quite pissed before the nights... never at anything else before or since, but I was so nervous about people turning up for Café Loco, because it was so important financially. I used to look at the queue, then go round the pub for a few drinks, then pop back to see if it got any bigger.

[The clubs and bar] never subsidised theatre shows, or productions – it just managed to pay the bills, and pay our wages. That was the trick. The only subsidy we'd get was twenty grand a year from the council, and applying for project money from the Scottish Arts Council. I managed to get about three in-house productions a year. One would be at Mayfest, who would pay for us to do something, and then a couple of productions which we would get Arts Council money for.

On my way down to Café Loco every Saturday, I'd go into the local video shop to pick out some obscure Russian silent film or something, because what had been left over from Glasgow's Glasgow was a big projector hanging off the wall that projected onto that dancefloor arch.

So we used to plug in this video, so that when people were dancing there would be this mad video stuff going on, it was great actually.

And once it was [Fritz Lang's 1927 silent sci-fi classic] *Metropolis* I put up there. I was thinking about applying for some funding to the Arts Council for another theatre show, and I remember looking up at *Metropolis*, projected onto the wall above the dancefloor, and thinking, 'Ah, yeah, we'll do a theatre show of that.' And I put an application into the Arts Council, and then pretty much forgot about it. Then a few months later, we got a grant for it! And I thought, 'How the fuck am I going to do that?' *Metropolis*!

DAVID BRATCHPIECE
I went to *Metropolis* with my drama class at school. That blew my mind. It was amazing. Quite terrifying sometimes – it was gloomy and you could hear the trains and you weren't quite sure if they were part of it or not. I didn't think theatre like that could be possible.

ANDY ARNOLD
Up until then we hadn't really put anything in that main space, those upper arches, and I think it was just seeing those images [from the film] of those workers with their hats, and they were walking, swaying side to side as they [went] along, it was a wonderful sight, and as I was watching that, I was thinking, 'Wouldn't it be great to have that going down the spine of The Arches', so I suppose that's what really triggered it for me, as a visual piece. We needed a big cast. We had a few professional actors – we had these guys from Russia, a Russian actor and director, but he didn't speak any English. We were meant to direct it together but I directed it really – he looked after his Russian actor. We had Andrew Dallmeyer as the boss. Angie Dight as Maria, the main sort of beauty, and we had a live band. But the core was about forty or fifty volunteers. We did it as a community project, we invited people who wanted to be a part of it.

ANGIE DIGHT

Autumn 1993 was a big time for us at The Arches – Ian and myself were chosen by Andy to be part of the *Metropolis* cast, with live music created by Ronan Breslin and no words. I was to be Maria (I was super-chuffed) and Ian [was] the Doctor/Professor who creates a robot in her image. There was a big mixed cast of community performers and actors from various organisations and groups too. We did big movement sessions with us all for months before; it was so good.

ANDY ARNOLD

Ian Smith was going to design it with Graham Hunter, and they were chalk and cheese. Graham Hunter would do very realistic things and so on, and Ian was just dabbling about doing silly little cartoons on the walls and so on. So, bit by bit, Graham took over on that and built these massive great doors, which became the entrance into the Garden of Delight. And there was the 'harlot's house' thing where he had all these wonderful red shaded lights hanging down. And then in the end of the arches at the bottom, the damp bit, is where Maria's cave was. So atmospherically it was a great opportunity to use all those spaces. And there was a scientist's laboratory and so on, so each arch had something there.

ANGIE DIGHT

We were also clearing the back arches (latterly the foyer and bar at the Argyle Street entrance), painting it and turning it into the set for *Metropolis*, under the watchful eye of Graham Hunter, and the production guy Colin Proudfoot. We asked Andy if we could have our wedding reception in there, we did and it was a riot… in a good way of course. We were supposed to leave by ten when the club started – I think we were a bit annoying! There was loads of extra food, because two friends catered the whole thing as a gift; we took tons round to the St Mary's mission on Midland Street. A week later we were back finishing off the decor and starting the rehearsals.

ANDY ARNOLD

That was the first time I had been involved in a promenade show like that. I've forgotten what size of audience it was, but it wasn't many. It was like twenty-five people – with almost a hundred people performing, with the band and all the rest of it. And twenty-five audience members. And it was the first time I learned about a promenade, and how you draw people along, you say 'come this way' to the audience, rather than being behind them and pushing them. Because we started off by pushing them and they would be looking behind them, looking angrily at us.

ANGIE DIGHT

I really loved all the hidden spaces, the down-below spaces, where I saw a few performances. What a great warren of a place it was, and the backstage and tech area, and before that a great big room full of costumes... and all those toilets. As the robot impersonating Maria, I had to incite the workers to go wild and rise up. I made them crazy, made them dance, before I rushed out of the door and into the side lane, which poor Jenny [Rothwell] would have had to clear of the local lane clientele, as well as check the ground for any dodgy shite (literally). What a great place!

ANDY ARNOLD

The extraordinary thing was, at the end of it, the audience would go out of the doors and then they were shut. That world was shut to them. And they would stand around outside, and they were applauding but they weren't applauding anybody because the doors had been shut, and we didn't come out again. We felt it wasn't right... they had left that world and they couldn't see us again. That was interesting. There was a bit of a battle about whether we should have a bow, but I said no, we can't have people seeing anything at all.

FIONA SHEPHERD *(Arts journalist) [Review published in The List, issue 216, December 1993]*
Anyone who's frequented The Arches, walked through its cavernous bunkers, clumped across its stone floors, seen its air vents and heard the trains rumble overhead can already appreciate the feel of

the piece, even without reckoning on the inventiveness of designer Graham Hunter. He has the ever-watchable Andrew Dallmeyer as evil *Metropolis* overlord Frederson staring omnisciently from a video screen as the audience, on promenade, enter his soul-destroying domain... Everything captures the quaint futurism of the film perfectly.

Angie Dight as Maria, the tender dissident on whom Rotwang models his robot, is every bit the baby doll silent film star, from her startled eyes to her stilted, exaggerated movements. Aside from her contributions, the dramatic high-point comes in The House of Sin when the audience are invited to join the hedonists watching a blithering stand-up... before the rioting workers overturn the joint.... An orchestral ensemble lend a Nymanesque baroque feel to The Garden of Delight, then guitar and percussion resonate bleakly through Workers' City, far surpassing Giorgio Moroder's film score. This 'Metropolis' is thrilling to behold and gripping in execution.

ANGIE DIGHT
The show was such good fun to do. I loved it and I loved my starring role and decided I should become an actress – but then I got pregnant.

JULIE WARDLAW (*Arches staff, various roles including front of house, admin and publicity, 1994–2000*)
The [Studio Theatre] was quite a nice little performance space, only spoiled by the regular thunder of the trains running (as it sounded) right above the room. I enjoyed the performances which took place in other parts of the building: Frantic Assembly were always a favourite and I always loved *The Crucible* by Andy's Arches Theatre Company.

There were not many staff in those days, so everyone did a bit of everything to help out: it was a bit haphazard as money was tight so a lot of things were thrown together with whatever materials, people and money there was to hand in the early days. In consequence it had a real feeling of a gang, a community, a group with a common attitude. It relied a lot on volunteers who were happy to be part of the experience and often led to permanent jobs as The Arches: Andy Arnold believed in giving people a chance who were not necessarily from an academic background.

ANDY ARNOLD

The Crucible was the best one really, in terms of using the arches. It was Graham Hunter that designed it, again, and it had seventeen actors in it; they weren't all waged, it was some sort of profit share thing at first. And they were mainly a young company although they were playing middle-aged people. We used an empty arch and we got hold of about twelve church pews to make seating, around the empty space. And Graham got two tons of earth. So we had earth on the floor, and these pews which the audience sat in; in the beginning, they were sitting there in this incredibly atmospheric space... and then hearing this church hymn being sung in a distant arch...you know, it was incredibly atmospheric, it was brilliant. And then the cast would come in wearing all their Salem gear. But the fascinating thing was, in the earth you normally get little eggs of flies. I hadn't realised this, and because *The Crucible* ran for a few weeks, suddenly there were these great big bluebottle things flying around the space. The audience sitting there watching this witch hunt trial, with these flies flying around. It was as if it was meant to be, it was incredible.

JOYCE McMILLAN *(Theatre critic) [Review published in Scotland on Sunday, 13 November 1993]*

It's difficult to say, indeed, what makes Arnold's simple, shoestring production so compelling. Many of the cast members are young and inexperienced and the quality of the acting varies wildly. But some of the leading players bring a degree of emotional intelligence, understanding and precision to their roles that could scarcely be bettered. The simple setting – in one of the dank stone tunnels to the rear of The Arches, with candles guttering in sconces on the walls and hard church pews to sit on – might have been built to contain and emphasise the stark, simple lines of the tragedy; and the eighteen-strong cast (an impossible dream in a fully professional production) throws itself into the mood of the play with such feeling and accuracy that every strand of its complex meaning... emerges with overwhelming clarity... They act like people who know what it is like to live in a world gone mad, where common decency is subordinated to dogma, where lies become truth... and if we do not want to find

ourselves witnessing in our society [the fate of Salem] we had better start asking ourselves why.

ANDY ARNOLD

When we did *The Crucible*, we did another show as well, three comedies by Chekov: *The Bear*, *The Proposal* and *The Wedding*. I was in it, so it was me and Andrew [Dallmeyer] and an actress – two or three-handers. But *The Wedding* was about an old colonel being paid to go to a wedding reception, to give a speech, and he gives the wrong speech. And so, you know, you need all the wedding guests sitting there… and it's a fifteen-minute piece. And we were doing that in the Studio Theatre and *The Crucible* was in an arch further up. And I worked out: act two of the *The Crucible* lasts about half an hour, it's followed by the interval, and there's only three actors in it, Proctor, Mrs Proctor and Mary. So I thought, the other actors, the fourteen of them, could all change costumes and come in and be the wedding reception guests. Andrew Dallmeyer had to give this one long speech as the Colonel. But he didn't have to speak to anyone, he just had to give this speech, so he didn't bother to learn it properly. The idea was that the wedding guests would all fall asleep during it, but because he changed it every night, we'd all be shaking with laughter, everybody corpsing away because he came out with such ridiculous stuff all the time. It was great fun.

I've got two spaces at the Tron, why don't I think of doing something like that again? It's great – people acting in two plays, moving about to different audiences. What's wrong with that? I mentioned that at [Andrew Dallmeyer's] funeral as well, because we got this review from Joyce McMillan which said, 'As for The Arches Chekhov plays, best to draw a veil over that.' And Andrew said to me, 'I've had many a veil drawn over me by Joyce.' *[Laughs]* Great.

LORI FRATER

If we had all the things in place now – minimum hours, minimum wage – The Arches would not have been there, it just wouldn't have. It would never even have got off the ground. It was just people doing it for the absolute love of it. And, you know, the people who were there,

some of them were just probably out of school or college… you know, it was their first ever job. It was actually just being a family. That really is what it was, I suppose, with Andy and I as the mother and father, although I kept saying that he was the old man and I was the young girl!

We were… I don't want to say subversive, because I don't think anyone would probably ever class me as subversive (okay, Andy was always definitely subversive!). But I think there was an innocence in the belief in the building, a belief that we could do something that was positive for people that would probably never have gotten those chances before. At one point Jimmy Boyle was basically one of our benefactors. And that was obviously important for him, that we were doing that kind of positive work, and the art was actually a means for people to come out of the circumstances that they had been in, or could find themselves being in. We had schemes that we ran, for long-term unemployed people and for ex-convicts as well.

ANDY ARNOLD
One of the blokes from that Rutherglen unemployed group, he was an ex-plumber. And he showed me how to professionally unblock a toilet. And that became a crucial part of my work in the early days. 'Cos the toilets were constantly getting blocked.

CORA BISSETT (*Actor and director*) [*Writing in The National, June 2015*]
'I've got 8K left over, I think you should make a show.' But Andy, I dunno how to make a show, I'm just out of college, I need a script, a director, I dunno where to start. 'You'll work it out.'

These were the words of Andy Arnold… in 1997 when I first graduated from the Royal Conservatoire, and, for me they sum up the founding ethos of an organisation which was all about just trying stuff out, learning your craft without pressure, without any overbearing expectation, just letting you get down in the sandpit, play, get dirty and work it out. Work out how to say what you want to say, how to say it in the way that feels true and original to you, and maybe just in the process create something that matters to a whole load of

other folk... Andy had seen me organise an album launch gig there for Swelling Meg, my alt-folk rock band at the time... He offered me my first professional acting job off the back of that performance and then followed it up with the insistence that I make my own show. That transpired into *Horses, Horses, Coming In In All Directions*, co-created with [Grid Iron director] Ben Harrison; a promenade piece which took audiences through the various spaces in the Arches, sat them under an enormous patchwork quilt, took them to a dark butcher's world, where clay was moulded into body organs and thrown at wall. It culminated with Harry Ward and Itxaso Moreno thrashing about in a great shower of water (garden hose hanging by a few hooks) in the end arch with a team of drummers approaching while Patti Smith's 'Horses' howled out of the PA.

BLAIR SUTHERLAND

Oh, Cora Bissett's *Horses, Horses...* We were sort of running a water tap... running a tap from the bar, a big hose from the bar, so when the horses were dancing – they were just guys – dancing in Arch 6, we had to turn the tap on at the bar, so the water came down above them. That's the way it worked, and there was only five of us staffing the show. Two on the bar, who were running the water.

We were just continuing, everything was still growing. There was more theatre, we were starting to do more corporate events, we've got more staff joining on. We've got dedicated visiting theatre people by then – Trish McDaid, who is sadly no longer with us.

ANDY ARNOLD

Trish worked as my first Programme Administrator. She was brilliant and I loved her dearly. [Following the refurbishment in 2000] her face was etched on the big dividing glass on the main floor and that meant a lot to me. She was great at her job and also slightly mad and chaotic – the essence of an Arches worker – her death [from cancer, aged thirty-eight] was so very tragic and unfair.

BLAIR SUTHERLAND

She really brought the company on with her professionalism, and bringing in outside theatre and arts performances. So it wasn't just the Arches Theatre Company; Trish was bringing in visiting theatre. [Long-running festival of performance art] National Review of Live Art, as well – that started [at The Arches] in the mid-90s.

DAVID BRATCHPIECE

The National Review of Live Art was certainly an eyeopener for me. Which is exactly what it was supposed to be, I guess. I was aware of performance art and live art, and indeed the stereotypes that come with it, but it completely changed my perception of what art could be and how it can connect with an audience. When your shift over the course of a day entails guarding a jelly being made out of real human tissue, as mine once did, it tends to do that. Actually, my very first ushering shift was National Review of Live Art, guarding a chalk outline of a body that had a large amount of real human ash in it. Nigel Turner was the front of house manager then, and he was like, 'Here's a radio, stand by this FOR HOURS and make sure nobody messes with it.' So I dutifully guarded this thing for hours and hours, and then by the end I was so tired I actually walked right through it. Human ash going up my trousers. I was panicking, trying to pat it back into place.

Jokes aside, I can't imagine a more perfect venue to host the National Review than The Arches. One minute you could be in one of the main arches watching jaw-droppingly beautiful pieces of physical artistry and trapeze work, the next you could be in a dark corridor as a soundscape installation travels along the walls, exciting and terrifying you in equal measure. It never stopped amazing me, all those years that it ran.

NIKKI MILICAN *(Artistic director, National Review of Live Art 1979–2010) [Interviewed in The List, Issue 705, October 2012]*

I have so many fond memories of working in The Arches. If I had to pick just one it would be by Alastair MacLennan. In 1996, his work 'MAEL 69/96' occupied a whole arch for three days. Simple lines of

lightbulbs with the level pulsing from near-darkness to a sort of half-light, illuminated lines of burnt-out cars while the soundtrack listed the names of every person killed during the conflict in Northern Ireland between 1969 and 1996. There's always some sound leakage between the arches so for days I was aware of the haunting list of names and, like most festival visitors, I dropped into the installation regularly. On one occasion, Alastair appeared out of the darkness and placed a small child's shoe in front of one of the cars before slipping back into the shadows. It was one of those magical moments – a simple gesture with such a big emotional impact – the kind of thing that only live art can give you.

JULIE WARDLAW

Because it was a multi-arts venue and club, people were always asking, 'What does it want to be?' But there was nothing else like it in Scotland at the time. I think it was envied by other arts organisations/venues because the money raised from clubs went towards theatre and other cultural activities so they didn't have the same restraints as other publicly funded theatre companies or arts venues in that they could choose to do what they want. The staff I worked with were amazing, everyone worked so hard and was so committed to the success of The Arches. It was a huge laugh most days! It was a really close-knit team. Every day was different, the turnaround of events some days was impressive, even insane.

LORI FRATER

We were all living out of each other's pockets, really. We were there so many hours of the day. I think that's a thing in the arts… I don't think it's necessarily unique to The Arches, I think it was necessary for The Arches. Actually, having now worked outside of the arts, one thing that I notice a great deal is, the arts work for a common goal. People who are in the arts work for it because they love doing what they do. And they have a very common goal as to what they are all aiming for. And I find that quite difficult when you're working in a world that isn't the arts.

But it was difficult. We lived on top of one another. When you're in a building seven days a week – a short day was fourteen hours. We opened at ten o'clock in the morning and sometimes we wouldn't close until four o'clock in the morning. That was just a standard kind of day. You get to know those people incredibly well. You are utterly dependent upon them having your back. And you have to be friends as well. And as I say, even when we weren't there, even on those rare nights when we weren't all in the building, we'd be going out for a drink or we'd be going somewhere together. And I think that was the case all the way down from… well I think it's an attitude as to how you treat the people you work with. Everybody in the building had a role, from Andy to Roseanne the cleaner. No one was more important than anyone else. Everybody was needed. Every single one of those roles was needed. And it was recognising that, and just being there for one another.

ORDE MEIKLE
I just think it was really well run, as well, you know? All the staff were really amenable and it just…everything came together. It felt like a really nice place to spend an evening.

STUART McMILLAN
Yeah. I think in general The Arches was a very open place – it wasn't exclusive, it was very inclusive – whether you were gay, straight, whatever. Or whether you were a bit rough around the edges, I think The Arches was very inclusive. It wasn't just for a select few – it was for everyone, within reason.

ORDE MEIKLE
And it was quite European, in that it had a nice mix of different ages. It wasn't one particular demographic – you really felt that it was very mixed, as Stuart says, in all senses.

DAVE CLARKE
We got involved with Graeme Thompson and helped him set up the midweek [club], Love Boutique. Lily Savage did the opening night. That was a breakthrough, because half of the crowd was the Glasgow

gay scene, and the other half was our Friday night crowd, mixing for the first time. Which was quite adventurous at the time.

GRAEME THOMPSON *(Promoter, Love Boutique)*
I remember Andy Arnold saying to me once that Love Boutique was pivotal in the history of The Arches, just because of the things that happened at it. The main thing that drew me to The Arches would have been Slam's famous Fridays, and I probably was there all the time, but I've also always been attracted to an arts venue, to the performances and the exhibitions that happened there. I was never a person that just went to gay clubs. And I'd be in, say, the famous Bennet's in Glasgow… and these places can be really enjoyable as well… and then I'd be in the Sub Club, and then I'd be in The Arches. And I thought – I want something else. I want to hear the quality of music that I'm hearing in somewhere like the Sub Club or Slam on Fridays, you know, with proper fantastic club music, but I want it to be mixed. Anybody that comes to it must be comfortable with a crowd being flamboyant, and with quite a large part of the crowd being gay. I want there to be performance, I want there to be visuals. I want it to have all that stuff happening. So that I could get things that I get in all separate places, but it would all happen in one place. And that's how I came up with the idea of Love Boutique.

And I think I must have spoken to Dave Clarke about it, because obviously they had that connection with The Arches, and Dave was very supportive. Another important part was the idea of putting unusual things together. I was determined to have Lily Savage – still one of my favourite drag queens ever, but a very difficult person to book when you don't have any connections in show business. I noticed in the *Gay Press* that Lily was appearing at some club in Wolverhampton. So, getting desperate, I thought, Right, I'm just going to phone this club up. The club owner answered and was so nice. He said, 'Come down and see the show, and I'll introduce you after.' So I went down – it was around Christmas – and Lily had on her suitably trashy Lily 'slightly Santa' outfit, with her wee PVC handbag and everything. And then afterwards, the guy took me up this big staircase, up into the heavens,

to meet Paul [O'Grady, the performer behind Lily Savage]. And he was sitting there kind of half dragged up, reading a book about Marlene Dietrich, smoking a cigarette, and shoving his costume into a poly bag. And he said to me, 'You're not the stupid cunt that came all the way down from Scotland to book me, are you? Of course I'll do your fucking club.' So we ended up with a very unusual opening night line-up of Lily Savage, Stuart and Orde from Slam, and a young, relatively unknown DJ from London called Jon Pleased Wimmin, who went on to be a very well-known club DJ, a regular at Love Boutique, and is still DJing to this day.

Love Boutique was initially a mid-week club. It really had a cult following, and a really good crowd of people coming, but I could never really make it pay financially. And Dave, again, was supportive, and he said, 'I know, I feel sorry for you, you're doing everything right.' And The Arches were great, they were really supportive. And I thought, 'Right, what needs to happen is that this club needs to go to the weekend.' Because then more people are able to come to it, because mid-week a lot of people can't. And they were like, 'Okay, let's give it a try.'

And we moved to the Saturday, and the numbers jumped right away. And the first guest on the first Saturday was Sister Bliss from Faithless. And then it became a Saturday night, once a month club – the Love Boutique that most people know. It was fantastic mid-week as well, but you need to have more people to make it work. The resident DJ, Roy, was fantastic, and we went on to have a diverse range of guests including the original Balearic DJ Alfredo, Mark Moore, Richard Fearless, Jon Marsh of The Beloved, and loads more.

AL SEED
I was a regular at Love Boutique where I used to cut about in a frilly red shirt, leather trousers and homemade devil horns. I think I was attempting a sort of 'dandy' phase. Not sure how successful it was!

GRAEME THOMPSON
I think what was very important about Love Boutique was a very unusual mixture of people. Hence the fact I kept having to have

conversations with security to try and get their heads round the fact that they were saying to people, 'This isn't for you, this is a gay club,' to people on the door. And I kept saying, 'It's mixed.' Now, it sounds like a simple thing to say but it's not a simple door policy to apply. Because a mixture, for me, makes a club much more interesting. I don't particularly like clubs that are all male, or clubs that exclude people.

DAVID BRATCHPIECE
I was a bit too young, but I got the train through from Motherwell and somehow got into the club. My first club, and it was Love Boutique! That blew my mind in a whole different way. I was a wee rocker more used to drinking Buckfast in the park and the first thing I saw when I got in the doors was this muscular man with no top on, silver hot pants and angel wings. Surrounded by the best looking women I'd ever seen. These were not sights we were accustomed to when drinking Buckie in the park in a small town, as you can imagine. And I was like, 'What is this? This is GREAT!'

GRAEME THOMPSON
It really broke down barriers. From the early days, it attracted cross dressing, transsexual and non-binary people, who I was very pleased to see felt safe and welcome there. People would tell me, 'Yeah, I loved going to Love Boutique,' but it would be a straight guy who thought there were lots of really beautiful women there.

NIALL WALKER (Designer then marketing and design manager, 2000–2014)
I know I was there in '95, because it's on film, when [ITV late night clubbing programme] BPM was at Love Boutique, you can see me dancing with shoulder-length hair. And I saw Leigh Bowery performing at Love Boutique – that was my first memory of The Arches, him doing his famous birth routine when he gave birth to his wife on stage at Love Boutique.

GRAEME THOMPSON

I had seen them do this performance before, but I didn't realise they were going to do it in the club. I was standing in the DJ booth watching, and they were playing the music, the band together, and Leigh Bowery is at the front of the stage. And during the first song he gives birth to a person that's wrapped up inside him. And they fall out onto the stage. The umbilical cord was sausages and there was blood coming out and everything, and she falls onto the stage. It was Nicola Bateman, who married him later on towards the end of his life, for a very short period because he died. She was all wrapped up inside him. That's one of his most legendary performances and he did it at Love Boutique – and it was incredible, it was brilliant.

I remember getting a phone call from one couple who always came to Love Boutique and they said, 'We love coming to Love Boutique, but we were absolutely horrified by what we saw in The Arches on Saturday night.' They were totally freaked out. I wouldn't laugh at somebody like that, so I said, 'We'll refund you, the money will be left at The Arches.' But really, they were the only people that reacted like that.

I feel really honoured to have worked with him and met him. And at the end of the night, we were standing in the office and he came up to me and kissed me and said, 'Graeme, I really enjoyed that, let's work together again, we'll do some other things.' And he wandered off out into Midland Street.

And not a very long time after that he died. It was New Year's Eve, 1994 when someone phoned me up and told me; he had AIDS. I was reading something about him recently and it said that if he had lived for another couple of months, the combination therapy that was getting worked on, he would have got it and would probably still be alive.

You know, the word 'legend' is definitely a bit overused in a lot of situations, but Leigh Bowery is a legend without a doubt. I mean, there's so many people in culture who have been influenced by him – you know, Lady Gaga, Grayson Perry, the designer Alexander McQueen. Obviously he was very friendly with Boy George, who once described Bowery as 'art on legs'. Amazing person.

GERI O'DONOHOE: *(née McALEESE, box office assistant then manager, 1998–2001)*

Looking back, it fills me with pride that I was part of such a small happy team that worked together to create events that had a huge cultural significance. The mix of voices, backgrounds, reference points and humour meant that the variety of creativity covered every form of art and culture. There was just nowhere else in the country that had a National Review of Live Art during the week and also hosted internationally renowned bands and DJs, and 3000+ clubbers at the weekend. It was just all so exciting! I felt like I'd found my tribe immediately and I recognised that I was incredibly lucky to be accepted into the fold. The collective sense of humour meant that we could accomplish anything together. Monday mornings, after a big club weekend, were particularly fun – walking into the Box Office, you never knew what you might find!

JULIE WARDLAW

I arrived at work one Monday morning and, instead of empty beer bottles and plastic pint glasses on my desk after the weekend clubs, sitting there was Tony Wilson of Hacienda fame, waiting to have a meeting with Neil Mowat [then club manager] to discuss an upcoming music festival.

RICKY MAGOWAN *(Promoter, Streetrave and Colours)*

We'd started out doing Streetrave [club nights] down in Ayr. After going to the Club 9 events in Motherwell, the soul nights. At that time – you're talking '87, '88 – there was movement in music from soul music, to soul all-dayers, to the house explosion. So that started that age group moving on from Club 9 to a bit more of the ravey thing, and obviously ecstasy pills.

IAIN 'BONEY' CLARK *(DJ, Streetrave and Colours)*

We booked Yogi [Haughton]. And I think we paid [him] about – this must have been about 1988 – three hundred quid (it was quite a lot of money at the time). But when he came on, he played quite a lot of tunes that I had. And it was one of those things where I was, 'If he can

do it, why can't I do it? How can I not DJ?' And that's basically how I got started.

JULIE McEWAN *(Promoter, Streetrave and Colours)*
I met Ricky in a pub I worked in. Through his friends. He used to come to the Aquatec, which was a sports centre. But Ricky used the sunbed. He didnae come in to do sport.

RICKY MAGOWAN
We were a wee bit more fashion-conscious, a wee bit more designer gear, rather than the ravers who were into the fluorescent stuff.

IAIN 'BONEY' CLARK
We decided to leave Ayr Pavilion [by now known as Hanger 13, gaining notoriety for three drug related deaths].

RICKY MAGOWAN
We moved to the Fubar [in Stirling], this was '94. And at that time there was another movement. The rave thing was going downhill and the superclub had appeared. This was '94 into '95. And obviously we had heard about The Arches and we were looking at The Arches, but there was already Saturday clubs there and we couldn't get a Saturday night slot. So then what happened was, we got offered the bank holidays – and the first Streetrave there was the 1995 September weekend Sunday.

ANDY ARNOLD
The club promoters always preferred to talk deals with me as Lori would be ruthless and drive a hard bargain – but I was glad that she did! The fact is that place wouldn't have got established financially without her. The club nights were all mainly in that bottom part of The Arches. Then we heard Cream, from Liverpool – they were looking for a Glasgow venue.

DUNCAN REID *(Founder, Breastfed Records, promoter, Inside Out and Freefall)*

I was [promoting] the Friday night at [Glasgow club] The Tunnel. Simon [Foy] was DJing at that night. A guy called Alan Green had worked at The Tunnel, as sort of an events booker, and he went to work for Cream. And Bobby Patterson had also worked for Big Beat, that owned The Tunnel. So Bobby Patterson moved to The Arches, and Alan moved to Cream. And Alan phoned up one day and just said, 'We're thinking of doing Cream in Glasgow. Are you interested in putting the night on for us?' So I phoned Bobby, and I was telling him this, and he was like, 'Well, I've just got a job at The Arches. So I can speak to Lori and Andy and see about bringing you in to do it.' So me and Simon went down and spoke to them and agreed to do the night.

They were like, 'Yeah, we're up for that.' Which was a bit of a surprise, because at the time they had Love Boutique, and they had their own night [Café Loco], and they had Slam on the Friday.

So we ended up doing our opening night [with Cream] on the last Saturday in October 1995.

SIMON FOY *(DJ and promoter, Inside Out and Freefall)*

I hired a Fiat Cinquecento and drove to Aberdeen with flyers, to flyer a Ministry of Sound night. I mean, we did…

DUNCAN REID

We went absolutely nuts, didn't we?

SIMON FOY

We went mental with the PR. You know, for me to drive up on a Thursday night or something. I think it was when the students had gone back. There was a Ministry night up at Ministry of Sin, I think it was called up there. Drove up, flyered it, and then I slept at the side of the A9 with a duvet in the back of the Cinquecento. And every time a lorry went past, the little car would sway with the wind.

DUNCAN REID

I don't think we'd realised quite how big a night that was going to turn out to be, because we didn't ticket it, we made it pay on the door.

LORI FRATER

The very first Cream night – I'd never seen anything like this in my life. I opened the door… we had no idea how many people would come to the first night of Cream.

ANDY ARNOLD

The capacity was up to 1,900 people by then, that's what we were allowed to have. And at the first Cream night, there was 5,000 people outside the place. The queue went up Jamaica Street, along Argyle Street, it was right round the block.

DUNCAN REID

Round past the Sub Club, and past Tower Records, and then started coming back down Oswald Street.

LORI FRATER

Right around that entire block in Glasgow. We had so many people in the queue, that when we closed it, we filled up every single other club in the city that night.

DUNCAN REID

Everywhere in all of Strathclyde was mobbed that night. The Tunnel were having their tenth birthday that night, and they thought they were going to be wiped out. And they had a queue down to bloody Argyle Street. Because we let in capacity, and then those however many other thousand people had to go somewhere else.

SIMON FOY

I spoke to some police by the car park diagonally opposite, and they were like, 'We were meant to have a shift change, but we're all staying on, and the extra shift is coming on.' And then at that point the horses came round the corner with the riot gear on them.

But I don't think there was anything too bad really. A lot of disappointed people, but it could have kicked off.

LORI FRATER

I remember the bar manager coming up to me, Alan coming up to me – I mean, we were only probably in an hour – and he said, 'We've run out of change.' I said, 'What do you mean you've run out of change? You had four grand.' He said, 'We've run out.'

That night probably kept us all going for months!

ANDY ARNOLD

So that suddenly transformed us, you know, the big club nights.

LORI FRATER

But to be honest, that's the first night I looked out and I said, 'There's a danger in these clubs. There's a danger in relying on these clubs being our source of income.' And obviously, a number of years later, that rang true. I desperately wanted to move away from that dependence on the clubs, because the heart of The Arches was about giving new artists a chance, you know. Giving people who would not normally be given any kind of platform, to give them a platform. And the clubs detracted from that. The clubs became far too much a focus of the building. And I always suspected that the clubs would then have a serious negative impact on what was the core ethos of that building.

ANDY MACKENZIE *(Arches staff 1999–2006: bar staff, duty manager, front of house manager, operations manager)*
Manchester had the Hacienda. Ibiza had Space. Liverpool had Cream. But we in Glasgow had The Arches. So much more than just a club, a place where everyone was welcome. Not driven by money, not driven by ego, not conforming to the latest fads or trends.

GERI O'DONOHOE

Our tiny box office was always heaving with lost property on a Monday morning, mostly jackets from the cloakroom. It's funny how people

would forget to pick up their stuff before they left, I can't imagine why that might have happened…

The calls would start early – we'd usually have ten to fifteen voicemails left on the Sunday when we were closed. At least half of those wouldn't have been left by the clubbers themselves, but by their mums – it was always mums, never dads. Everyone knew that if you didn't have your ticket, you didn't get your item. Them's the rules! BUT Wee Boab's maw et al couldn't ever comprehend this and also clearly never fully appreciated the absolute STATE their son or daughter was in at 4am on Saturday night. Maybe they shouldn't have worn the leather jacket you got them for Xmas to go clubbing, it's not my problem! I'm sure there's still a few elderly mums who have a vendetta against 'that wee bitch in The Arches box office'!

DUNCAN REID

I think that Cream night had a really big effect on how other promoters were booking the venue. Because I think Ricky did a Streetrave birthday quite close to us starting Cream, and I remember him and Jamsy were putting up a poster, and he was like, 'fifteen pound a ticket'. Like, 'look, we're charging fifteen quid because we're going up a gear.' And Graeme from Love Boutique booked Billie Ray Martin and… not a full orchestra, but a string section. You know, really started going for it.

GRAEME THOMPSON

She did the proper full live show – sometimes when people do club appearances they'll just do a playback thing where they'll have a track and they're singing over it, but it was the whole live show with all the musicians. I got that lump in the throat moment when she came on. She was probably a lot more well known to a lot of people then because she had just had a big hit with 'Your Loving Arms'. So that was brilliant, and she was really nice to meet as well. It was a bit frightening because the night before, she had appeared at a major London club, and her manager sent me a message. I don't know if

it was in the morning or the day before, but he said, 'Just to let you know Graeme, Billie is a very particular lady and she walked out last night because they didn't have things the way they were meant to be in her contract" – And I thought, 'Oh my god.' So it was quite a nice feeling when it all went really well. And she was like, 'Definitely let's do something again together.'

RICKY MAGOWAN

We started Colours in '95 in Edinburgh. And that was going to be nice artwork, bright, Mondrian artwork. And it was all house music. Roger Sanchez and Masters At Work did our opening night.

It took us a while of doing all those Arches Bank Holiday Sundays [but eventually] we got the second Saturday of the month.

JULIE McEWAN

With the agent of an artist like Boy George, they had the nicest press pics and they used to send you up a nice envelope with a hardback thing with nice pictures and biographies of all their artists, and I would fax them out to like fifty different press publications... like even things like the *Inverness Courier*, everywhere. So that's kind of what my job was, I just used to send all that stuff out and deal with M8 Magazine and things like that, and then eventually Ricky was like, 'Do you want to come in full time, and you can sort the flights and stuff.' So I started right at the beginning, of how all that evolved, just before it all blew up with the superclub thing.

Coming to The Arches, I remember, I did a mailing list for Ricky – me and Jacquie [Mcmillan]. We did his postal mailing list. And that used to be 8,000 to 10,000 envelopes. And he would give us six flyers, a newsletter, the envelopes and the stamps, and we'd put it all together. And it took us...

RICKY MAGOWAN

You got in for half price, didn't you!

JULIE McEWAN

Naw! Thirty quid or something you gave me, and a queue jump for The Arches. That's what we got! Not even in for nothing. A queue jump! And it was the Easter one with Sasha and Digweed. And I remember Jinx saying, 'Aye, come on up the front.' And I remember being absolutely buzzing at the fact that I wasn't waiting in that queue. Apart from the fact that I wasn't getting paid for it, I was walking by everybody.

I had been to The Arches before, I don't know what night I went to, it might have been Love Boutique – but the velvet drapes were down, so when you went in the first doors by the box office and into the first wee bit of the arch, you didn't really know what you were going into, and then you went through these curtains and you were like, 'Holy shit!' It was just the most amazing feeling.

And then, when I started working there, honestly, you could have told me that someone had died and I still would still have been elated… that feeling that you couldn't have brought me out of that euphoria. And for years I felt like that… until you get a bit older and you get complacent, don't you. But every time you went to work, you were like, 'This is the best place in the world to work.'

IAIN 'BONEY' CLARK

I can remember when we first went to see it, it was before it refurbished, and it was total shithole. But that added to the attraction of it, it was one of those warehouse, 'nobody gives a damn'-type places.

I can always remember: if you went into The Arches with a white top on, it wasn't white when you came back out. Because all the dirt and everything in the ceiling, all the sweat, it just dripped everywhere you went. Everybody's in there, the place is jam packed, everyone is sweating, it's all condensation and all that, so by the time it hits the roof… it was like a self-cleaning thing! If you had a white t-shirt on, by the time you walked out, it was black, and it was this horrible kind of brown tarry stuff. And if you had worn that, there was no way you were cleaning it again, it was ruined. Absolutely ruined. So that's one of the first things I remember – going in with clean stuff and back out with it dirty. Even your trainers –

your trainers came out absolutely filthy. So there was no point in wearing your good clothes when you went there at night.

BLAIR SUTHERLAND
You'd go to a club and there was stuff that would fall on you. And you'd be like, 'What the fuck is this?' I'm in a nightclub, I've got my new white gutties on...' You'd always learn: never wear white gutties to The Arches after the first time. Don't wear white clothes! You'd see all these wee clubbers coming in and you'd be like, 'Naaah. You've never been before, have you? You've got your white velvet Stan Smiths on.'

CARL COX (*DJ/producer; Arches patron 2006–2015*)
The first time I went in, the DJ booth was on the floor. I remember walking through, it was on the right-hand side, and it had a cage. I was thinking, 'Why've they got a cage? Can't be that bad down here, can it?' They moved the DJ booth around a lot; one time they had the staging near the inimitable toilets. So I'd be doing my thing and have people wandering on past all the time; they'd had a pee, pop back out and carry on dancing... that wasn't really the best bit. But they did get it worked out in the end... it was amazing to see how it developed over the years, evolving more towards what the artists needed. Where it ended up they put it so you could see a lot more of the rooms, so me as an artist performing in The Arches, I could see at least two lanes of people, rather than just a load of heads in front of you while hoping that everything was actually going off.

SIMON FOY
Around about that time, everyone else was doing that progressive kind of stuff, and Cream wasn't really hitting the nail on the head. And I think we were the ones that were really kind of... going off and banging. You know, your Tall Pauls and Seb Fontaines and stuff.

ANDY ARNOLD

Duncan and Simon came to us with the idea of this thing called Inside Out [where] they would get the same big name DJs but they'd run it and so on, and we said, 'Well, yeah, why not.'

DUNCAN REID

We sat down with Andy and Lori and said, 'We know what it will take to make this work.' And to be fair to them, I think Andy had already decided, he had already spoken to Lori before they'd decided, and they probably said, 'If these guys want to keep the night going we'll let them.' Because we didn't really have to talk them into it.

SIMON FOY

Yeah, I remember thinking it was going to be a tougher sell than it actually was. I think we got on with them, though. You know, I think we had a good relationship with them.

We had to basically start from scratch with Inside Out. So we didn't start Inside Out until December that year [1996]. Was that the twenty-seventh?

DUNCAN REID

It was, yeah, it was the day after Boxing Day. It was a bit of a nightmare night to try and collate. But Si had a good relationship with Tall Paul, and we actually went down to London to speak to him directly, because we knew that if we could get him, we had the start of something. So we actually went down and Simon went into… which record shop was it?

SIMON FOY

Traxx, or something like that?

DUNCAN REID

Yeah. And we were both… well, I don't know about you, Si, but I was shitting myself…

SIMON FOY

Because it all rested on that.

DUNCAN REID

Yeah. If he says yes, we're in. If he says no, we've got nothing. But he was really nice, he said, 'I've been looking at the line-ups, they're not playing stuff I'm into playing...'

SIMON FOY

And he was the same, he was like, 'Look, I've got a good relationship with you guys. I'm happy to go with you.' But I remember, it was a frantic, dashed meeting. And it was a short period and then we had to head back up.

DUNCAN REID

Yeah, we kind of got there by the skin of our teeth, basically. And we got the poster together – Damien Smith, from ISO, that does all the Sub Club stuff. He did the Inside Out logo with the dots, and he also did like a yin-yang thing. So the first flyer was folded and it had this embossed yin-yang logo. We were really going for it.

SIMON FOY

We spent a bit on that.

DUNCAN REID

And it was a black flyer, and then you opened it up and it was the fluorescent orange. And that was it. Black and fluoro from then on. It was great.

That first night we got... I don't know, six or seven hundred or something?

SIMON FOY

675 or 650 or something.

DUNCAN REID

That sounds right – 670 in my head. And I think we were like, 'There's something here.'

SIMON FOY
Yeah. I think the atmosphere was the thing. We were just like, 'This is going off.'

DUNCAN REID
We basically had six months where we were kind of getting there. We didn't really have very many big name DJ's. But we sort of had the right idea, and it was working, and people were liking it, but… we were up against Cream [by then taking place in The Tunnel], so we were still competing against them when they had people like…I mean they had Seb [Fontaine] and Boy George one month, and we had to go up against that.

I can't remember if it was a year in… but we basically got one night that sold out the whole building.

We did a *Mixmag* night and Dan Prince came up from *Mixmag*, and we had TWA and Darren Stokes. Darren smashed it, I mean he absolutely tore it up. And TWA were good but they weren't as good as Darren. But Dan Prince was like, 'That was fucking great.' And then we got the review in *Mixmag*, and all that was helping. But it was always building – people were just having good nights. But we hadn't got [Judge] Jules, and so we went down and made a big money offer to get Jules to play an October. That might have been a year in, it might have been more. So we sold that out, and it was almost like, 'Okay, we're in business.' Because Jules was very much like, 'Why haven't I been here before?'

JUDGE JULES (*DJ/producer*) *[From the documentary Colours: The Arches – An Insight, Lemon Video Productions, 2017]*
There was never a mediocre night [at The Arches]. Not even one. Literally, arriving from Glasgow Airport, I knew every single time that it was going to be excellent. And it actually makes you DJ better, when you turn up somewhere where you know people are going to be so responsive.

LORI FRATER
The clubs made a lot of money, they were seductive, but they weren't what the building was all about. They weren't why Andy and I had

started it. We had all those different schemes running, just to make that kind of social difference. I don't want to give names away, but some people you now see on your TV started off in those schemes. To me, that was it was always all about, and the clubs were never really in the same... they were never in that sphere.

ANDY ARNOLD
During those years no one worked harder for The Arches than Lori. She was absolutely pivotal to getting The Arches set up as a business operation and was the main driver in the successful £4 million Lottery funding application.

LORI FRATER
When I left, in September/October 1996, I don't think I had much more left to give... I don't think I could have gone on working those eighteen, sometimes twenty hours a day. It was just not possible to keep doing that.

SARAH WELLS *(General manager then executive director, 1996–2002)*
I'd been working down in London, helping set up a new arts venue, but it was funded and run by the local authority, in Croydon. I felt I needed to get out of local government and I wanted to know what it was like running a business. The general manager job, as it was called back then, was advertised for The Arches, and I thought, 'Ah, what the hell!' So I went up, and I really liked Andy, and I loved the building. And even though I tripped over a jakey on my way into the interview, I thought, 'Well, this could be interesting.' You know, this is quite a challenge. Andy wanted someone to look after all the business side of the company... that's what I was interested in. So, it went from there, and it's the best job that I've had. Andy and I worked really well together. It ended up I was sort of level pegging with him – he was the artistic director and I was the executive director, and that meshed well, because we understood what we needed to do there, and we were of the same mind about what was important at The Arches, in terms of getting the right mix, and giving the right priorities to the different things. There was a lot of competing interests, and lot of ways where

The Arches could have gone in the wrong direction. But we stayed true to what he'd originally come up with and that worked really well.

ANDY ARNOLD
Sarah Wells came in, she was brilliant, actually…

SARAH WELLS
It was an exciting time because when I started there in '96, we only had the Midland Street entrance, no work had been done on the building at all, and the bar licence only went up to the dance arch, so it was only those offices at the bottom on Midland Street, and then the dance arch with the first bar, and then the second arch with the theatre in it. You couldn't take your drink any further than that.

So we had to have the bouncers standing at the metal doors that went through into the next arch, making sure people didn't take their drink in, it was a total pain in the arse. And of course you were also limited with the capacity then as well.

BLAIR SUTHERLAND
In 1994, we'd done the launch of Massive Attack's *Protection* album. That's probably a bit of a historical point because that was the first time that we ever allowed a performance in the north of the building – we did some theatre performances, like in the cathedral arch and the devil's arch – but that was the first time there was a live performance.

We had no alcohol licence beyond the steel doors… the building capacity, I think, at that point was 1,700, but up to the steel doors it was 800, so we had to take alcohol off of everybody going through the steel doors. It was a big night for us, because usually the bar would turn over, back in the day, a couple of grand. On that night it did seven grand. We were all going, 'What?'

That made a big point for us to get a licence for the top of the building. Back in those days we had a public entertainments licence, which was the whole of The Arches, and then you had an entertainments licence which was the alcohol provision stuff. It all changed in like 2010 or something. Anyway, we tried to go to the

council and say, 'Look, we want a licence for the whole of the building.' And they thought that would be a management issue. The licencing board thought that by granting us an alcohol licence for the top, it would be too much of a management struggle to cope with – I don't know what the words were they used – put too much stress on the management to crowd control and all that.

SARAH WELLS

One of the things that I was tasked with when I started there was trying to get the licence changed. And they knocked it back the first time because our lawyer was rubbish, and we put it in again so by about '97 or '98 we got the new licence through. That meant we could have drink all the way through the building, and that was a significant change, because that meant that all of a sudden we could increase our capacity up to… whatever it was… was it 1,795, 1,800? Can't remember!

The fact that you could drink through there meant we immediately built the second bar. And it meant that all the clubs and all the gigs could properly function. Because a lot of the promoters were saying, 'This is a real pain… the punters are always saying we need to get our drinks through there.'

So, we hugely expanded at that point, with that licence change. And, you know, coupled with that it meant that we stopped using volunteers to work on the theatre side. We just employed people, so that we could actually bring people on a lot more and have a bit more control of what was going on, rather than it being a favour… people turning up just to let the customers in didn't really work for me.

BLAIR SUTHERLAND

We got granted the licence beyond the steel doors, and then we saw the full potential of it… it was sort of oh! It was becoming a bit of a superclub then, if you look at the scene. It enabled us to have two [events running simultaneously]. After that all our live gigs were down in the bottom arches, in Arch 6 – right in front of the bar. Bands – Stereo MCs, Jesus and Mary Chain, Morcheeba, guys like that – played there back in the day. Mogwai doing album launches

down there. [Comedian] Bruce Morton used to do a wee cabaret night. And obviously, book readings… Chuck D from Public Enemy did his book reading, and then you had Stephen Lawrence's dad [Neville] down there doing a talk about the crime in London. And Irvine Welsh did his *Filth* book launch…

ANDREW O'HAGAN *(Journalist and novelist)*
On 12 August 1998, I was chairing an event with Irvine Welsh, both of us feeling eloquent, go-ahead, and much refreshed from the pre-event rider, to the point where nothing could faze us. I'd always had a confused relationship with The Arches. I didn't understand the layout, and, in my clubbing days, my pals were often being sent to find me. For a bookish kid, it was astonishing how regularly I could be found among the finest Balornock neds, dancing in a damp T-shirt and puffing their joints. Still, the night with Irvine was a gentle affair of wise literary chat by a virtual fireside, with an eager audience of poet-tasters eager for wisdom about Scottish literature. 'Shut it, ya Irish Catholic writer-cunt frae London,' shouted one of the studious mob, at me, we presumed, seeing as Irvine's Catholicism has always been well-hidden. So well-hidden, in fact, as to be non-existent. Anyway, the crowd laughed, but not as much as we did. 'What do you think was the most insulting word in that sentence?' I asked Irvine, via the live microphone. 'Frae London,' he said, laughing. 'Nae doubt about it, likesay.'

JULIE WARDLAW
There was one time I was standing in the old Foyer on Midland Street Entrance, and Andy was introducing me to Father Jack actor Frank Kelly (he was so tall); then I turned round to meet Roni Size who had just won the Mercury Music Prize.

CARL COX
I used to play there quite a lot with Slam, with Stuart and Orde, and also for Ricky Magowan of Colours. So I actually had two lots of different people when I played at The Arches; it was never for one or the other. It was always balanced between the two elements. So I

would play a more accessible rave sound for Colours; for Stuart and Orde I would play more professional, underground, techno music. I liked the idea that I was crossing over to different genres of people from two elements, even though it was at the same club. And for me, it was probably the only club I played where I could represent myself, my sound, give the very best I can to the audience, based on those two elements, based on The Arches and what it gave to everyone.

SIMON FOY

I think what Sarah was good at, as well, was keeping the clubs separate. So if Ricky would try and book an Inside Out DJ or a Pressure DJ, she would say to Ricky, 'No, they play for...' whoever it was. She would keep the equilibrium, the status quo of it all.

RICKY MAGOWAN

I think we complemented [the other promoters], because obviously Slam were a bit darker. Inside Out you could say were a bit more full-on, and we went in there with good American vocal house music in the beginning. Guys like Norman Jay. The first gig was Justin Berkmann's Colours party, so he done four hours, which nobody was really doing. And I was just looking at some of the earlier line-ups – Smokin' Jo, Norman Jay, Farley and Heller, CJ Mackintosh – so, big influence of Ministry of Sound at that time. There was an opening there because obviously Slam weren't using those guys and Inside Out weren't using those guys.

JULIE McEWAN

Masters At Work was another big one, I remember you bringing them in and it was a massive thing.

IAIN 'BONEY' CLARK

Masters At Work. It was a Sunday night, so we had arranged for them to arrive during the day. And there was a certain amount of money... five grand or ten grand... but they wanted paid in dollars. And Ricky is like, 'What do you mean you want paid in fucking dollars?' They

wanted cash and they wanted it in dollars. And Ricky's like, 'It's fucking Sunday, where the fuck am I going to get this?'

They actually held the club up – they were meant to come on at ten o'clock at night – but they held the club up for three hours until they got their money. And to this day I don't know how Ricky got the money or where he got it from, and I don't know if they got the full amount of money or they got some of it, but they wouldn't go on, so they held up the club for fucking three hours. And everybody was like, 'Where are they, where are they?' And they refused to go on until they got paid in dollars. Which I thought was bang out of order.

RICKY MAGOWAN
Roger Sanchez played a lot of times as well.

JULIE McEWAN
And remember the time we had Armand Van Helden? And he played music that we didn't like.

RICKY MAGOWAN
At that time, he went to number one with 'You Don't Know Me', and at that time that was the busiest we'd ever been, that was roadblocked outside. That was our first ever roadblock.

IAIN 'BONEY' CLARK
We had Shaun Ryder up. He was fucking out of his nut, he was hammered. He cannae DJ. So he's up on the stage, and I'm up behind him, down on my knees, putting CDs on for him and pressing play. And he's up there, disnae have a clue where he is, and I'm up there playing records and pressing buttons for him, and everybody thinks he's fucking playing records.

RICKY MAGOWAN
Remember, back in the day, Boxing Day in Glasgow was empty. It wisnae a thing. There was nothing, nothing at all. Hotels were dead, the clubs were dead, the pubs were dead. Nothing happened. Then

we came in, in '96 [and put on the first Colours Boxing Day Event, which would go on to be a Glasgow tradition]… and they actually called it Ricky Day, I know that's a wee bit wanky sounding, but… because we had all this infrastructure from Ayr Pavilion, we had the crowd from the Fubar, we had the West Lothian and Lanarkshire audience – we imported the whole audience there for a Boxing Day. So we brought everybody in. Because Boxing Day in Glasgow wisnae a thing at all.

DUNCAN REID
By the late 90s, we were getting the line-ups, we were selling out, it was away. We got the momentum by that point.

SIMON FOY
Doing the *Mixmag* ads and stuff gets you into that sphere of being the so-called 'superclub' kind of thing, but we never lost sight of the music policy and who would deliver on the night.

DUNCAN REID
There's no doubt that when we were flying Jules up on a jet for him to get to Gatecrasher on time after his Radio One show, and we were advertising in *Mixmag*, we were definitely in that zone. But to get to there, I don't think we set out thinking, 'Let's do this.' I think we just thought the venue was amazing and the night worked. It was a little more organic, wasn't it?

SIMON FOY
Yeah. And I think the thing is – there was loads of our friends used to come, and it would just be a good laugh.

DUNCAN REID
Exactly. So much fun. And maybe that's where to mention, 'Here we fucking go.' Sarah was so upset about it she tried to stamp it out! The earliest memory I've got of it is, we were in the Tunnel, in Bar Two, and Simon and Ross were chanting it. So that's the Ark, that's not Inside Out, but somehow it ended up over there and went nuts.

SIMON FOY

Yeah, because I think Dougie Bruce and Kyle and everybody and Zammo would all do it. It is amusing because when you'd see T in The Park on TV and they would have to try and pull down the crowd level when Calvin Harris or something was on. Or on an Essential Mix.

DAVE CLARKE

Although we discouraged it, the 'Here we fucking go' chant, which became massive at the main stage of T in The Park when people are watching a band, definitely originated in The Arches.

STUART McMILLAN

Yeah, 100 per cent.

DAVE CLARKE

To the point that 'HWFG' is now an acronym.

STUART McMILLAN

Yeah. In fact, if people started chanting it, I used to pull the record down, so that they wouldn't do it. And then just go, 'Finished?' And then back in again! It used to really annoy me, that.

CARL COX

The one thing I will forever remember about The Arches was the chant. Here we... here we... here we fucking GO!

DUNCAN REID

We had Jules up once on a Friday night to do a live Radio One thing, and it was like seven till eleven, and honestly I've never heard it louder. It was deafening. And I was saying to the BBC guy, 'Are you okay with this?' And he was like, 'Fine.' And Kris Harris, the DJ, I ran into him the next day and he was like, 'I was in the car, I had the radio on, and all you could hear was, "Here we here we here we fucking go". You could hardly hear the music.'

It was a wee bit of a shame for Sarah, because obviously Inside Out was getting quite an up-for-it crowd, and because The Arches had an artistic sensibility about it, and they had Love Boutique, and another night that was a little bit full on. And they had signs up all over the building: 'Please don't chant.' They had this whole thing: 'We want you to enjoy yourselves, but we think chanting is moronic.'

WILLIAM DANIEL *(DJ, Inside Out and Freefall)*
Play anything with a good kick-drum and bassline and the crowd would go wild, starting that infamous Glasgow chant with a football stadium-type atmosphere. I know it's like Marmite to some but there is no better feeling in the world [to] play and to get a reception like that. I'm very humbled and fortunate that I got the opportunity to do so, so many times.

SIMON FOY
Generally, the crowd was – although they might be a bit mental, they were very friendly, and there was a real atmosphere of everyone getting on. And you could meet people. People used to be in the same part of the building – like maybe in the corridor, or a specific bit – so when you went past that bit continually, you would get to know those people. And if you bumped into someone, or someone bumped into you, both of you would apologise at the same time kind of thing.

GRAEME THOMPSON
It was the people that gave it the atmosphere, plus the fact that physically the venue was so wonderful. The fact that the trains are running over your head – well, not literally, but you know what I mean.

Yeah, it was just unique. Because when you were at The Arches, that's the only place it could be. Clubs in interesting spaces are always the best. I think spaces that weren't actually meant to be clubs make the best clubs, in a funny way. You know, there's been famous clubs that have been in old theatres and things, and I think they often make the best venues.

IAIN 'BONEY' CLARK
You played a drop on a record, and the place just went bananas. Again, as soon as people walked in the door, they would be dancing immediately. Find out who was on in each room, and that was them. And sometimes a person would go into a particular room depending on what kind of music was on in that room, and they'd be there all night, down the front.

It was just a brilliant vibe, an absolutely brilliant vibe.

SIMON FOY
There's no doubt [The Arches] had a special atmosphere. I almost gave up trying to DJ at other clubs… clubs that I'd heard were really good. I remember I went down to Hereford to do some club that I'd heard was brilliant, I got there and I was like, 'Is this it?' I did the same at Stoke. There was nowhere that was as good. I think the crowd were amazing, but I think just the shape of the building and stuff. I think that's the thing with railway arches though. You know, I've been to The Cross in London a couple of times, and it's similar – it was good. Even the Poetry Club at SWG3 I've DJ'd at, and that's like a small version of The Arches. So there's something about that shape of venue that obviously works. And it works with the sound, and the crowd noise.

DUNCAN REID
[Sound tech] Phil Zambonini said an interesting thing. He said he used to watch people coming in the venue and you'd see guys literally do that – [hands punch the air motion] as they walked through the door. It's amazing to think that folk would just come in after a week or a month of stress or whatever is going on in their life, and were just like, 'I'm going to let it all go.' A place where you can let all that pressure off.

CARL COX
It was stuffed at the time you got in and STUFFED by the time you finished, people crammed in there, hot, sweaty, amazing atmosphere. The soundsystem was killer – because when you have a soundsystem in a room which is full of bricks the sound takes on a life of its own as well,

based on, there's nowhere for the sound to go apart from in the room. So the sound was always of a very high level. The Arches was a lifestyle for everybody. They felt a part of it. You haven't been to Glasgow unless you've been to the Arches. And that's what it was like, really.

IAIN 'BONEY' CLARK

I know you always get people saying, 'Oh, Scotland's the best place for crowds'… but see The Arches, if you put a night on there, it was a party atmosphere as soon as the doors opened. And that was the great thing about The Arches. I can't remember ever once having a bad night in The Arches, in over twenty years.

Even just the aesthetics of it as well, do you know what I mean? It was never designed for a club, just an old industrial warehouse, which added to its charm. Just a total raw club. I think that it made it a big attraction as well.

Look at all the big clubs in the world – like The Limelight, which was an old church. Just these unusual buildings which I think make it. And again the Arches was just the old railway building, it was ideal. Perfect. Because it's a long tunnel, the sound was brilliant as well, it just travelled. The sound was superb. One of the best sound systems ever in there. The only other sound system that I played like that was in the Ministry of Sound. Their sound system, I'd say, was on a par.

DAVE CLARKE

I suppose part of it, as well, is that nobody could actually build that as a club. That structure has to be built as an engineering feat for another purpose. And to be able to turn it into a club and a venue…

And I guess it must be something to do with the people that have been through it, and the history and the people involved in it for sure. It's got some amount of character.

GRAEME THOMPSON

The fact of Andy Arnold being an actor and a director and you're in that environment, I think it nurtures doing projects that are more theatrical. And everyone at The Arches was really great.

GERI O'DONOHOE

It was also a privilege to be involved in creative discussions. It really felt like everyone's opinion was listened to – Andy made sure of that.

GRAEME THOMPSON

And also, it's very important not to forget all the people like my friend Scott [McDonald] that did the visuals, the sound people, the security, the cleaners – they're all part of it as well. Everybody is all part of it.

I remember once, quite a while after Love Boutique wasn't happening anymore, I was sitting in a café, reading an *Evening Times* when they used to do their club thing, and there was an interview with Sister Bliss. And they said to her, 'You've played in Glasgow a lot, played in different places – are there any particular memories that stand out?' And she said, 'Love Boutique. Everything was right.' And I got that lump in the throat moment again, it just gives you a lovely feeling, you know?

STEPHEN McCOLE

Slam nights, Café Loco and the Love Boutique, I was there for them all for years, harassing the DJs every time a great tune came on, taking that list and spending all my wages on the music I heard.

DAVE CLARKE

[On the relationship between the theatre and clubs sides of the business]: It was definitely symbiotic, and there was enthusiasm on both sides. Andy was working on a play called 'Caligari'…or 'Caligari's Cabinet' – he got Slam to do some music. There was a relationship beginning there. Yeah, I think he was very open-minded. That's the memory. And enthusiastic.

ANDY ARNOLD

The Cabinet of Dr Caligari! We got the Slam guys to do the music for it. Which was great, actually, because we suddenly had a crowd coming in that wanted to listen to the Slam music, to see our theatre show.

STUART McMILLAN
Andy obviously knew we were producers and we were making music as well as DJing and stuff, so he said, 'Look, do you guys want to do the music for this?' And I was like, 'Yeah! Perfect. It sounds great.'

DAVE CLARKE
We had a readthrough with him and another guy.

STUART McMILLAN
Andy's a theatrical guy, so he read out... [deep voice], 'He's a somnambulist' and all this sort of stuff. And we took away the script and just made the music to it. I really enjoyed it; it was quite a dark subject matter, and quite moody.

DAVE CLARKE
It suited your music.

STUART McMILLAN
I remember Andy being really happy with it as well, which was amazing because it's probably the only thing we've done to a script. We've never returned to that, but that's not from the want of wanting to do something like that again.

ROB WATSON *(Technician, then technical manager, 1997–2015)*
Fotofeis was a porn exhibition – 1998, it was. In the middle bar – I can't remember the guy's name. Simon something? A young guy, he looked like a surfer. And he built [an installation called] 'Ode to a porn star's death'. He built a slope, from the ground, and then built a house on top of it, on the slope. In the house there was a bed, a TV; you were the porn star, looking down on your own death. And it kind of summed up The Arches for me: it was about six weeks' worth of work that the guy did, to build this six-metre by eight-metre structure with a sloping floor that you couldn't see because it was housed outside – for a three-second effect. So you were like, 'Oh fuck, I feel like I'm floating here – wow, I'm floating

above that bed.' And there was a porno on the TV and the bed was messed up and stuff, and it was that wee effect. And that kind of summed it up where all of that work that goes unseen, just for that wee moment.

At the other side of it, in Arch 7 (we called it 'the Devil's Arch'), it was a square metre where they created a grid, and it was just these strings with fly paper. And on the fly paper was proper hardcore imagery. And they opened it to the club – it was deemed acceptable at the time to open it to the club. So you would see people going in out their nut, going in amongst the fly paper, and going, 'Oh, Jesus Christ', and trying to get back out again!

JULIE WARDLAW

Fotofeis, the porn-themed one, is one of the exhibitions that stands out, particularly the bit with the fly paper that was made of rolls of slide film with hardcore pornography images on them. They were hard to see but, like fly paper, extra sticky, so if you naturally gave in to curiosity and tried to get a closer look, fingers and hair got stuck. Egged on by [long-time Arches handyman] Eddie [McGregor], I looked, and got my hair stuck. Then came the embarrassment of calling for assistance.

SARAH WELLS

That was a really great one, because the work was there on display over the weekend, but we merged it in with the club in a challenging way. But it was fantastic, having the work there and the clubbers in at the same time.

ANDY ARNOLD

We always talked about that sort of crossover between clubs and theatre people, and it never really happened. I mean, we'd get somebody coming for a theatre show and getting a ticket for it… like 'The Caretaker? Yeah, whatever' sort of thing. And they'd go and see the show and then when we were clearing out we'd find them hiding

in the toilet, because there was a very expensive club night following on after, and that's why they'd come in.

There were things like *Caligari* when we had Slam devising the music for it, it would bring in that crowd, which was great. But generally speaking, that crossover thing didn't exist. Different cultures altogether. There used to be quite a lot of theatre companies who would try, because clubbing was so much youth culture, so they'd try and do theatre shows which would try and reflect that, and it never worked, because the whole basis of clubbing is being out of your face, listening to very loud music and you're screaming in each other's ears. You can't really have a narrative for a drama, at a club night.

ROB WATSON
Fotofeis always sticks in my mind, because it was one of the few artist-led exhibitions where they were happy for the clubbers to interact with it. And after that, it felt as though it was very much a separate thing – don't touch the art. Never the twain shall meet. And it lost some of that crossover identity, I suppose. And then became, you know – live music venue, club venue, and so on.

DAVE CLARKE
The whole club scene was changing. We began to think that our weekly Friday thing had run its course. Slam were touring a lot more. They were developing, putting records out and going on tour. We just felt it was a good move to stop doing it and take a break. It just felt right to finish on a high note.

And then the idea of doing Pressure [Dave and Slam's monthly techno club, which ran from 1998–2015] came about because of the expansion of the venue and this idea where you could do two rooms. On that bigger scale, we just didn't think we could maintain that, weekly. And it really did work, it was something different for Glasgow.

STUART McMILLAN
So the whole expansion to the Pressure thing was that, I suppose we didn't really pay too much attention to what was happening outside

of that front arch and, you know, one day it just became apparent that there was all this other space within the venue.

DAVE CLARKE
But I remember clearly that there wasn't an alcohol licence and then the idea was to expand… although people had raves and some people didn't drink; for us, to be a club you wanted to have a bar in each area, you couldn't leave your drink at the door and walk through the other bit.

ORDE MEIKLE
If I remember rightly, some of the back arches were filthy. There was oil that would come down from trains from Central Station… it took a long time to redevelop those back arches.

DAVE CLARKE
Pressure started at the end of '98.

STUART McMILLAN
So we had The Chemical Brothers doing a live set for the first night.

DAVE CLARKE
It was a DJ set. But let's not nit-pick!

STUART McMILLAN
Was it not a live set?

DAVE CLARKE
No, they DJ'd. They stayed all weekend!
Originally they were supposed to play at the weekly club as The Dust Brothers, then something happened and they cancelled on us at short notice. This was way back, a few years before that. And they had to change their name to The Chemical Brothers because there was a Dust Brothers in America. And they became pretty big pretty quickly. And we talked them into playing at the opening of Pressure because they owed us one, because they had pulled out previously.

STUART McMILLAN
Yeah, that's right! So they came up and played, and that was the birth of Pressure.

DAVE CLARKE
So they were already pretty massive when they played. But I guess, once you've already had Daft Punk DJing at your club then people know it's a big deal. I'm trying to think… Gene Farris and Green Velvet played on the same night.

STUART McMILLAN
And then I guess we wanted to do a bigger party but do it monthly rather than weekly. I think the weekly thing for us meant that we couldn't focus on doing something on a grander scale, and bringing other DJs.

DAVE CLARKE
Soma were the first to sign Daft Punk. Hence all the Glasgow shows at the beginning of their career. We put the first three singles out.

ORDE MEIKLE
There's various people who have claimed to have put Daft Punk on for the first time in the UK, but I know it was us, it was Glasgow.

STUART McMILLAN
Not a lot of people know this, but when we closed that last Friday night to then go on to do Pressure monthly, Daft Punk were in attendance.

DAVE CLARKE
They DJ'd, with Irvine Welsh and Kris Needs.

STUART McMILLAN
Oh yeah, they DJ'd. But also, prior to that, they came as punters. They came just to party. They came across from France just to hang out.

DAVE CLARKE
When Felix da Housecat was over.

STUART McMILLAN
Yeah, they came to the club.

DAVE CLARKE
That blew my mind, someone from Paris coming to Glasgow on holiday! Unheard of. Things have changed.

STUART McMILLAN
Yeah, it's quite amazing to think about them as clubbers – they had heard of The Arches, and they had heard of the night and they wanted to come down.

It wasn't always techno though – we had DJ Shadow and Cut Chemist and so on. We kind of mixed it up a bit. But generally it became that our main room was techno, whether it was the Vitalic style or the Ritchie Hawtin style… It was the place to go for that kind of music.

STUART McMILLAN
Which was quite unique for the UK to be doing that… I know it's really popular now. But at that point, you know… maybe Cream in Liverpool would be putting on Paul Oakenfold… we'd be putting on Jeff Mills and getting similar numbers for doing that. So it became probably the UK's biggest techno event.

DAVE CLARKE
I think so. Bucking the trend! Glasgow leading the way.

CARL COX
I like being challenged by techno. The Scottish audiences – they do tend to go for the more commercial style of music at the end of the day, but they had such a great time with it. But because I was always caught between those two elements, personally, with the sound of Slam, I always felt challenged by it. When you're doing anything like

that, you get a lot more self-gratification, because you've dug a lot deeper to play that music, making sure that the audience has got the very best of what's going on out there.

STUART McMILLAN

It was people like Laurent Garnier and Richie Hawtin… it was always those guys' favourite place to play. If they were touring the UK, they would make sure they were doing a Pressure date. So it's quite a nice legacy to leave behind because it always feels like if you're trying to introduce your musical style or your musical vision to people – doing it on that sort of scale, you feel like you've achieved something. And you know, Pressure ran for seventeen years… it's only when you look back on those seventeen years that you think, 'Wow, that was quite something', to keep something going for so long, and keep people's interest.

DAVE CLARKE

Keep it fresh. And it became where generations of people came. I guess most people get four or five years of clubbing and then they move on in life, and then another generation come. And I think, with the longevity [of Slam's relationship with the venue] especially towards the end, you'd start getting children of the people that used to come, becoming regulars of the night.

ORDE MEIKLE

That's right. 'My mum and dad met here!'

DUNCAN REID

It's got to be said – Andy… his impact is phenomenal.

ROB WATSON

I was often terribly late. And it was the big thing that Koos [Zwart, then Technical Manager] hated, was latecoming. I got a warning, then a written warning, and then a final written warning. And then I was three hours late after that. So I got called into a meeting, and it was Andy, Sarah, Koos and me down in the old main office. And they were

like, 'Why were you late?' and I was like, (mumbling), 'I'm sorry, I don't know... I don't know why I was late.' All that.

I got told to go out. And half an hour later Koos came out, and he was fucking raging. He was absolutely raging. They'd sat and had a discussion about me and my future there. Koos was like, 'I hate latecoming. I just find it disrespectful, it's my personal irk, I want shot of him, I'm done.' And Sarah was like, 'Well, you're the boss of the department. That's fair enough. If you want rid of him, then just get rid of him.' And Andy had said, 'Well, how is his other work? Does he get on with people alright?' 'Aye.' 'Is his work okay other than that?' 'Aye.' 'Well, the boy obviously likes his bed. Can you not give him a later start?'

And it was Koos that told me this! He was livid, raging! He was like, 'You've got more lives than a cat.'

And I look back on that as a kind of pivotal point. There's kind of being 'in', at that point. If you feel that level of support in adversity then you feel as though you need to reward it. You feel as though you have to be like, 'Aye, of course. Andy's invested that in me.'

4

2000-2008

Drop The Pressure

SARAH WELLS
There was a lot of pressure for the club programme to take over, and if the promoters had had their way, they would have just had it as a club where almost always other things would have been cancelled, shifted, and we absolutely always stayed firm on that one – that we wanted to make sure they couldn't. And that the proceeds from the clubs were there to fund an artistic programme that wouldn't be run otherwise.

BLAIR SUTHERLAND
By the time we opened the top of the building and we had the alcohol income, the wet bar sales income for that, the retail company was then jumping. From being just a very small benefactor to the theatre, to probably its main donor. The theatre company was the licence holder; it owned the lease for the building. And we negotiated a lease at that point – from what was initially three years, up to fifty-two years!

SARAH WELLS
It was a fantastic business model. It can't be achieved anywhere else because you've got to have a venue that can work in that way. But, you know, to have such excitement going on after dark when other people are asleep, and to use that money to fund somebody that's written a play for the very first time, doing a one-man show somewhere in the basement to about twenty people… we wouldn't have been able to afford to do that unless we had 1,800 people queuing up on a Saturday

night. I can't imagine anywhere that could possibly match that – for a charity to run in that way, to do what it achieved in that time, was pretty unique.

Everything really moved on further when we got that licence changed; it was very exciting. We started doing a lot more big events as well. We employed more staff.

NIALL WALKER

When I started as the designer, there was a whole new marketing team being brought in around that time. There was me, Sandra Marron brought in as full-time press officer, a full-time marketing manager. It was like they'd suddenly realised, 'Right, we need a marketing team', whereas before [the programmers and administrators] had all sort of been grappling to do it themselves.

A thing that comes naturally to me: if I see something I like… my immediate reaction is thinking about which of my friends would also like to see it or experience it, and persuading them to see it or experience it. And that's kind of what I then went on to do for fourteen years in The Arches, [which] was: go to everything, and love it – I loved the gigs, I loved the theatre, I loved the clubs. And my job was to basically persuade everyone else that they should go along too, because they would love it as well, and that's pretty much what I did. And I was always aware – and it's a bit of a contentious issue – that when I went to a gig, or a club, or a theatre show, I went as an audience member. I never wanted to be there as a member of staff. So, I drank beer and got drunk at the gigs, I got high at the clubs, I put my hand up for audience participation at the theatre shows. Because I wanted to experience it as a genuine member of the crowd, and not as a member of staff.

So, some other people might think, 'Oh, maybe I shouldn't drink or…', because I'm a member of staff, but I was like, 'No, I need to feel this. I need to really feel it, so that I can then sell it genuinely to everyone else.' And that's, in a nutshell, what I did for fourteen years after that!

SARAH WELLS

We expanded the bar team too, and we got in a music programmer, Tamsin Austin. She was really key in developing the music programme back then.

TAMSIN AUSTIN *(Music programmer, 1999–2003)*

I was twenty-eight. I moved from Leicester. I had never been to The Arches before and I just remember going down Argyle Street and there was piles of vomit outside. In the middle of my interview, this huge train was going overhead… and I was being asked a question at the time. And I just remember the sound – I could see Andy and Sarah's mouths moving, and I literally had no idea what they were saying. They obviously just weren't hearing it, because they were so used to it. And I was lip-reading.

The job was so full on, it was like nothing I'd ever experienced. I'd been brought in to get a live music programme going. Because they'd got the theatre going and the clubs going, and apart from DF Concerts and CPL putting the odd gig in, there wasn't really any live music going on at all. I was so green and new to it, and we didn't have any live gig equipment at all. We just had the club PA. So I very rapidly realised it was easy to put on hip-hop, because you didn't need much live gear, so we started doing loads of hip-hop! And we had the Infesticons, and loads of old school West Coast hip-hop, because I had a mate that was a really good hip-hop agent. So we started doing that because I realised we could do that, we had enough gear to do that. So we had bands like People Under the Stairs and stuff like that. I was just kind of learning as I went along.

NIALL WALKER

I'll never forget the first flyposter I designed – it was for a hip-hop act called The People Under the Stairs, and it was back in the day when printing single colour was so much cheaper than printing full colour. This is 2000, it doesn't seem that long ago!

And it was printed in green. It was literally my first day there, and Tamsin came running up to my desk, and said, 'Oh my god, I need a

poster design for tomorrow!' And that never changed with Tamsin! She would always need a poster design tomorrow. But having been exhibiting my own artwork to the same thirty or forty people in Glasgow over and over again for, like, a good three or four years, – I'll never forget when that flyposter went up all over Glasgow, all over the walls in public. I was just like [*takes sharp breaths*]. That gave me so much more satisfaction than having some piece of conceptual work in a white cube gallery somewhere. So it was a real rush, I really loved that.

TAMSIN AUSTIN

I was so out of my depth in so many ways. The first gig I actually booked was Roni Size and Reprazent, and it was at the height of drum and bass. And I remember getting loads of crap from other promoters, going, 'You shouldn't be programming this, you shouldn't be promoting.' I was just this young woman that had been appointed at The Arches to develop the live music programme, and I was like, well, it's just my job, that's what I'm doing. I've got to get artists in here.

I think that was it – you were in the deep end. You weren't in a purpose-built venue, you were in a fucking railway arch. And you had to make shit happen – that was your job, to make shit happen, and to give people a good time. And that's what you did, that's what essentially you got up in the morning to do – and you made it work, come hell or high water. Even though you didn't have a bespoke venue with all the right gear and stuff, you were just kind of creative and worked with creative people and made stuff happen.

SARAH WELLS

What I loved was the fact that we had that almost impossible mix. During the day you could have the National Review of Live Art, with a performance artist somewhere cutting themselves with razor blades, and then you had a theatre show going on in the little theatre that was set in nineteenth-century Ireland or something, and then we had the club promoters waiting to get in so that they could have pounding music in another bit.

And even though that was very stressful if you were working on those types of night, that was what was exciting. During Glasgow's City of Architecture year – it was 1999 – they asked us if we wanted to be involved. Nobody was doing anything on fashion, so we created Intervention: three weeks of events that were all to do with fashion. And it was great, because we had talks, we had Glasgow School of Art fashion students doing stuff there, we had a fantastic runway show, we had Bret Easton Ellis come and do a launch for his book *Glamorama*, which is about the fashion industry. And then we had Love Boutique, where the emphasis was on dressing up. And that Saturday, all of that kind of thing was being done in one day, it was just fantastic. Even though Intervention was across the full three weeks, there were four things going on in one day. One minute you're standing next to one of the theatre actors, and the next minute it's one of the bouncers asking where the first aid box is.

ANDY ARNOLD
It was purely a night-time economy… [but] we were there in the office during the day, it was freezing cold all the time, it was damp and freezing. And so, you know, you'd do a theatre show in the afternoon for the schools to come in, like *Merchant of Venice* or whatever, and they'd all be sitting there in their coats, shivering away. The studio theatre, that was warm because it was an enclosed space, but otherwise it was always freezing. And I got a chest infection every spring, and so did people like Colin Proudfoot and so on, it was just too much.

TAMSIN AUSTIN
When I first started, we were all still working down in the bottom office. I have memories of being in that bottom office for a good couple of years, and it was pretty grim. You'd come in on a Monday morning, and your desk would be covered in dead pints and fag douts. Because it was essentially the box office as well. So it was just minging on a Monday morning.

We didn't have any kit, and we just made do with what we had, and it was really difficult, getting the live music programme going and

getting audiences in. Because it was really underground and really alternative, and trying to get different kinds of audiences in at the time was really tricky.

We were also trying to do a family programme at the time, and kids' things. But older audiences and people with families – coming down Midland Street, it was really intimidating. And getting them to come in that bottom entrance… in terms of audience development, it was really challenging, you could barely do anything.

But then the refit really was a game changer.

ANDY ARNOLD

It was a long, long project. I mean it took a long time to put the bid in, for a start, we had a design team and so on, and it was two years really applying for the money. And then another two years doing the work.

LORI FRATER

Originally, part of the plan had been, for the refurbishment, you had to put down what your programme would be for the next five, ten years or something. And in that programme I had phased out the clubs. It didn't obviously happen, of course, because it wasn't for me to put into place, but in my mind I knew we had to phase out the clubs. And I wanted the refurbishment to provide new opportunities for where that money could then come in. If you could turn it into an actual hub for all kinds of different artists; use the basement for those kinds of activities where you could give artists that space to be more creative down there. If you could start to use the building for other activities where you would get in the guaranteed funding, that you didn't then need to rely on the clubs. Whether or not that would have been practical and could have possibly replaced the money that the clubs were bringing in was another story, but I always knew in my heart that it had to change itself and get back more to where its heart lay. And that was, you know, being innovative in terms of the arts. Giving new artists that platform. But, you know, arts organisations, funding… you do what you have to do to get the money in.

SARAH WELLS

It took a while for us to write the brief, so that we were really clear about what we might want to do with the building. We knew that we wanted better facilities for the performers, and we wanted a better office for ourselves, because that was challenging – being in that little bottom office to do everything. I also knew that we could transform that building if we got a different entrance.

The key thing was there was an Indian restaurant recently vacated on Heilanman's Umbrella at the other end of the building – they'd just run off. There was a takeaway sitting in its foil packet on the counter there when we went into it! And Railtrack said, 'Uummm… yeah, I think you could use this as your entrance.' That was quite convenient because we worked out exactly where that would be in our building, and we were able to say, that's what we want – we want to get through there.

So I was quite clear about what we wanted to achieve. We didn't need to start from scratch, we already had a fantastic building. The atmosphere was those brick arches, and the scale of the building. So, in that respect we didn't need to work with somebody that was going to be designing some new thing. We wanted someone to deliver what we wanted.

The lottery gave us three and a half million, and fortunately, they had a very nice woman at Railtrack who had swanned in and was trying to make change, and I took her round the building. And then I called her and she said, 'Well, how much were you thinking?' I was looking at Andy going, *[motions in silence] What should I say?* She said, 'I was thinking maybe £300,000.' And I went, 'How about three fifty?' And she said, 'Oh, okay.' Couldn't quite believe it, but that came in very handy!

There were so many conversations like that. On the phone, trying to persuade people. Once I called up Bill Drummond [of The KLF] – he'd come and performed a couple of times, with various hats on – because we were looking to get some patrons. We needed some endorsement by some interesting people. He was like, 'I don't like the idea of being a patron, it sounds terribly stuffy and corporate.' I said, 'Come on Bill, it's The Arches! What the hell, you take risks, don't you?' And he said, 'Yeah. Alright then.'

ANDY ARNOLD

Originally I had wanted to get involved with the design of it all, but I just got so fed up with it because it was so boring. You'd spend hours talking about what type of rubber bottom would be put onto a chair or something like that, you know… or so many discussions about fire exit routes and that sort of stuff. I lost interest in it, and it was really left to Lori, then Sarah. We had bids put in by architects to do things quite revolutionary… you know… have seating which would go right down to the basement, so you'd have like 200 seats or whatever, quite radical ideas.

The firm we went with in the end were just ones who would deal on a practical level with just stuff in the building in terms of damp treatment and tanking it all and making it dry and heating and so on. But what we said was that they had to bid separately for the design of the Café Bar. Because we knew that had to be right. Because that wasn't just a café bar; it had to compete with other café bars as a place for clubbers to go to and all the rest of it.

BLAIR SUTHERLAND

We had an idea of what we wanted for the look of the place. And certainly the Café Bar at the time. We brought in a guy to do the project management for the refurb, once it all got passed and everything, we brought in a guy to deal with that, but we decided that [for] the Café Bar – as it ended up being – that would be a separate budget for it. So the overall refurb, that was one main contractor for it but it was important to put an identity on it just on its own. Because at the time there was no sunken floor or anything like that. There were two levels but there was no access between them.

So we went through the whole process of architects, and all that stuff. Ten people submitted proposals for the Café Bar on its own, from all over the UK, you know. And we ended up picking [young Glasgow design firms] One Foot Taller and Timorous Beasties.

SARAH WELLS

I'd seen that they'd designed a fantastic lighting installation somewhere, it was a big chandelier somewhere, and I thought, 'I think we can work with them.'

One Foot Taller and Timorous Beasties came to talk to us, and we said, 'Here's the brief. We want you to make the whole Bar Café double height space – we want you to make it look fantastic. What can you do?'

I said, 'One of the concerns I've got is, whilst you can walk in that entrance and be wowed by a double height space – something you wouldn't expect in The Arches – if you're sitting having a drink at the bottom of it, it can feel a bit echoey and not quite as intimate.' And so they came up with the design for the lights, where they hung down all the way from the ceiling, but they created almost like a false ceiling of these big, round, fantastic pools of light. So that when you were down on that ground level, you felt like it wasn't quite as open and cavernous as it might be. They also designed the furniture. So that was a really nice collaboration; One Foot Taller was just the two [people], and they were really young. It was nice to work with some young people on the design. They designed the box office counter as well, actually.

BLAIR SUTHERLAND

If you go back to '98 or '99 when we gave them the contract, they'd only designed a few bits of wallpaper and light shades and there wasn't masses of stuff they'd done. But I think we all felt that their design was quite exciting. It was. Looking back, it was pretty long lasting, because it embraced the architecture. We could have had a big multi-level staircase and fancy lighting and everything, but we felt that their design was the best.

SARAH WELLS

We also selected an artist to do some work on the acoustic panel – that glazed screen in between the top arch and the Café Bar. We wanted to capture something about the work, so she filmed us all for a little bit and then she transferred the images of us onto the glass in that screen there, and also on the outside elevation of the café as well. So some of us are still etched on there in those images, until they rip them out.

And so, yeah, we appointed a project manager as well, and went out to tender for the building project.

One of the challenges with that project – not just running a project of that size, was we took the decision to keep the building open and running all the way through the works.

ANDY ARNOLD

Other venues like The Tron and The Citizen's Theatre, they were well-funded and they just closed down whilst building work was done. We depended totally on the club money, and gigs and all the rest of it. We couldn't close down, so we were a building site during the day and a venue at night.

SARAH WELLS

We thought, if we close the building for a year, they'll go elsewhere. The club promoters will not wait, and the audience won't wait either. They'll end up negotiating a deal with some other venue that won't be as good as The Arches, but they'll do something somewhere else because they'll continue to want to make money – they won't go on hold.

And we thought, We can't do that. We can't risk that happening. So we co-ordinated the works to be going on at the same time.

ANDY ARNOLD

Every single week we would agree on what was going to happen that week, and then, you know, suddenly what was meant to be a dancefloor, would have two tons of sand dumped on it beforehand which wasn't meant to be there.

It was meant to be a three-week job, knocking through the wall [of the Indian restaurant onto Argyle Street], to make the entrance there. But apparently over the years mortar and brick gets harder and harder...

SARAH WELLS

[It] was like the Channel Tunnel, drilling through. It set back that whole project – they just couldn't get through that wall. And it took a hell of a long time.

ANDY ARNOLD

What was meant to be three weeks ended up almost three months. Originally the idea was just to bore through this massive three foot-thick wall, but then the regulation was changed, you had to slice through. And the machine they had couldn't slice it, they had to get stuff from Germany... And of course that was intended to be the main

entrance for all the equipment and all the rest of it, so it was holding up everything else. So the quantity surveyors had got everything wrong in terms of the advice you had to give, the expert advice, and as a result of that, everything got put back and it was a much longer project than it should have been. And much more expensive as well.

SARAH WELLS
It was a challenge. It was very, very difficult to co-ordinate a construction project and have the audience coming in every single day, whatever it was for. There was actually drilling going on at the same time as one of the clubs because we said to them, 'Do you know what? No one's going to hear it! You can start after the theatre show stops on Saturday night, and you can get drilling that bloody wall again.' They did that all the way through one club night, and you still couldn't hear it. Because the project was really quite complicated, because we had the building running at the same time as all the works, and because I was running all the business side as well as the capital projects, I thought it would be really handy to have somebody that just could come in, and purely work with me on doing some of the day to day... organising the meetings, liaising stuff with staff, doing various things like that.

BARRY ESSON *(Refurbishment project assistant, 1999–2000; later directed experimental music festival Instal at the venue)*
I think it was a very Arches thing to do: to hire a twenty-four-year-old with punky hair and nail varnish and a limited background (mostly in theatre) to try and work with a bunch of hardened Glaswegian builders. I feel like a part of my job was supposed to research how the new spaces opened up by the redevelopment (the basement, etc) would get used, so more a kind of future programme line of work (what kind of programme could go in these new spaces). But once I started it was 90 per cent just helping co-ordinate how we all worked around the refurbishment, and how we tried to get what we wanted out of it.

The lead architect was Peter Welsh. I got on really well with Sarah, the architects, the project manager, and also with the actual builders doing the hard work – the foreman Big Andy, and the handyman Pat. I think Sarah did an amazing job in getting the project finished, given the budget and time constraints.

When I started the project was £500k over budget and six months behind schedule – something like that. There had been a big issue with breaking through into the old Indian restaurant that became the box office. Because it was an arch holding up Central Station, Network Rail were understandably very cautious about knocking a big hole in it. It just took a lot longer than had been estimated and budgeted when the job was tendered. I don't think we ever made the time back, and I think Sarah worked really hard to bring the budget down, and then negotiated some kind of deal at the end of the project to reduce the debt further – maybe the contractors got first option on any future redevelopment in return for writing off some of the costs… but don't quote me on that. I think that was the major issue.

SARAH WELLS

Barry and I worked really well together. He was really good at getting what needed doing with me and getting on with it. [He was] sort of thrown in the deep end, and quite young and so I think he learned quite a lot. He had to come along to some really tough meetings, where… oh my god… arguing with the mechanical and electrical engineers about lighting and everything, and some really difficult ones with the contractor – they were really unpleasant meetings where I was a real cow! Because you're really having to fight your corner against a whole machine of people that work in a certain way, and we were trying to work in our way, and we were the client. It was quite exhausting… that was difficult, that. And those meetings were not easy. I think they hated me!

BLAIR SUTHERLAND

All the key staff were at the Pentagon Centre [temporary office spaces in central Glasgow]. It was only the frontline staff that stayed in The Arches, because there was that much dust.

DAVID BRATCHPIECE

We were still there, running the Box Office from Midland Street during the refurbishment. It was fascinating getting to watch everything happen from that front line. We'd go up to the top of the building and be staring down a massive hole (which became the Café Bar eventually).

NIALL WALKER

I'll never forget my first day at The Arches – I wasn't in the main building, I was in the remote office, with Trish McDaid. She was a lovely woman, the theatre programmer at the time, who sadly died a few years after that.

And I remember she phoned along to the main building, because some of the team were in there, including Sarah, and I heard her on the phone, going, 'It's Niall's first day today guys, I think we should take him out for a drink.' And I was like, 'She's so nice.' I then took that on board – it was such a simple thing, but I really learned that from her, so whenever a new member of staff then started with me I would be like, 'Right, let's go for a drink.'

Then the next night she was like, 'Right, there's a theatre show tonight. You need to come.' And I thought, Okay, I'd better go, because she took me out for a drink. It was part of this Irish season they were doing, with visiting companies, and it was one guy on stage. And I swear, there was not much more than one guy in the audience. It was me, Trish, and I think maybe three other people. And we sat and watched this hour-and-a-half-long monologue on stage. I thought, Shit, I'm going to have my work cut out for me here, trying to get an audience in to see this. And I said to her after it, 'Is it normally that quiet?' And she said, 'Eeehhh… no, not always!'

DAVID BRATCHPIECE

I have memories of Trish and I remember really loving her a lot. She was a great person, and a powerful force in the venue. Theatre administrator, I think, was her job title, but [of] all of us back there in that back office, in the Midland Street days, she and Andy were

really like the mother and father figures at that time. I think she instilled that in me, too – when I became front of house manager, almost ten years later, I would always try and instill that feeling of this being a family to the FOH teams. I don't think anyone ever took me aside and formally told me that. It was just what we did. By that point, we'd gather the teams at daily briefing together and say, 'This is a family, if you've got problems, even in your personal lives, you come to me.'

BLAIR SUTHERLAND

Nothing was cancelled, during the building works. Not one event. There's Heras fencing up in the space in the middle of a club night, and we had a steward in front of the Heras fencing to stop anyone getting too close, because behind it was an eight foot drop down into the basement. Because we're digging out the Café Bar.

ROB WATSON

One night, we turned up and there was a digger. It was left parked where the stage was going to be for Inside Out. We were freaking out at the time, going, 'What are we going to do?' And John Mills [then head of security] said, 'Look, they don't take the keys home. That's not what they do on building sites. They leave them onsite, because if your guy's off on Monday then they won't be able to get back, you know. Just check, just have a wee look.'

And it was that Terminator 2 thing with the keys above the steering wheel! So I'm pretty sure at the time there was a couple of scrape marks from the fork where I'd managed to move it but scraped into the deck!

But I think the big thing with the refurb was – we tried to accommodate, that was the whole point. We wanted to see a busy venue, we wanted to see it as full as it could be, safely, reasonably, without it necessarily affecting the depth and detail of each of the shows. And we did that alright. And there were some really good successes.

BARRY ESSON

Smaller things happened all the time… I think I now know too much about how the machinery that pumps shit from the toilets works (they used to back up a lot at the start). I remember the times when the staff who still worked in the building had to be evacuated due to diesel fumes from machinery in the basement. [We had] contractors working all day with heavy machinery and big holes in the floor, and then this all having to be turned around on Friday afternoon so that we could run Pressure or Colours or something in the evening.

DAVID BRATCHPIECE

One night, some of the staff decided to squirt Judge Jules with a water pistol from some scaffolding nearby the DJ box. That was fun.

GERI O'DONOHOE

We moved from the tiny black box in the foyer on Midland Street to the refurbished new entrance on Argyle Street, so it was a really exciting time.

SARAH WELLS

We put decent dressing rooms in. So again, music promoters as well as the theatre groups and everything, they just had much better facilities. So that was a really big change for The Arches, actually. And yeah, it was great. It wasn't an easy job for me! Or anyone else that worked at The Arches.

BLAIR SUTHERLAND

We were supposed to open in August 2000 and eventually opened in January 2001. Just because of overruns.

TAMSIN AUSTIN

We had a big opening, I can't remember who we had on now, but the last wheelbarrows were going out as the audiences were queuing to get in. It was on the same day that the builders were leaving that the audience was coming in, and we had stuff on.

But it did look amazing. It was all hands on deck when it reopened – I remember us all being downstairs in the new bar, having to clean and get all the dust off everything. Every single staff member was there – all hands on deck, cleaning up – the floor, the windows, the light fittings, everything. And the builders were clearing their stuff out. We had stuff on that night, and we had to get it all ready.

SARAH WELLS

When we first had the opening for that, it was a fantastic night – it was just brilliant seeing everybody coming in that entrance for the first time, having never expected that that's what the building would look like after all its years. And again, we still had performance artists in the basement doing some weird stuff on that opening launch night, so it was good.

BARRY ESSON

I remember the very first thing that happened after the works finished and after the relaunch party was National Review of Live Art. I was pretty attached to all the work that had been done, and I remember they came in and cut holes in doors, fucked things up. I think Franco B was covered in white clay and blood and then rolled round the freshly painted walls; the concrete floor had just had an expensive seal put on it and I remember walking into a performance where some young artist was raking a pile of raw meat across it, cutting it to ribbons and getting meat juice all in it. Pretty annoying on a micro scale, but when you pan out it's just totally 'Arches', and the point of the refurb to start with, I guess…

BLAIR SUTHERLAND

When you see The Arches refurb before and after, a lot of people would say, 'A lot of it's not… what did you do?' A lot of it was fixed wiring, and safety and support for all the arches, because the whole building required additional support and beams. And air-con… there was no air-con! For five years there was one air-con unit in that whole building and on a good day, it was suspect, you know?!

CARL COX

Things got better after The Arches decided to spend a bit more money, to do a little revamp on that place, because one thing's for sure: the air conditioning they had in there didn't hardly work at all! They just opened the back door and hoped the air would go through and cool everybody down...

ANDY ARNOLD

I remember that when it was all done, standing at an event, I thought, 'Well, this is brilliant, but what's the difference?' because it looked exactly the same in the arch, but the difference was that it was suddenly warm. You know, this is after more than ten years. So it was warm, and it was great.

But something also died as well. We had these big new offices. We had been jammed into the one at the bottom of the place, you know, on top of each other, in what was meant to be a temporary little office for Glasgow's Glasgow. And suddenly we had all this space but from the point of view of the team, as it were, I thought we'd lost something. I couldn't put my finger on it... maybe because we had more people as well, because we were suddenly a daytime venue as well, we were open during the day, the box office and all the rest of it, whereas before we'd only open the doors in the night-time.

I don't know what it was... but we lost something, with this conversion. I think all lottery projects did. Building-wise we did nothing too radical, we made it more functional by bringing the basement into play and having an entrance onto Argyle Street and so on, whereas places like The Citizens Theatre and The Tron completely fucked up. Architects trying to design theatres haven't got a clue, you know... with architects it's all about daylight and hard edges and glass and steel and so on, rather than more atmospheric and shambolic stuff that make theatres attractive.

TAMSIN AUSTIN

And then after that, we just spent all our wages in the Café Bar, after work every night getting hammered!

We worked really hard, and we played really hard, and we just lived there.

LYNDA FORBES *(neé FORREST; Corporate events manager 2000-2006)*
Money. It all came down to money. The Arches, post-renovation in 2000, was a huge building with a large staff and comprehensive arts programme. The club business paid the bills but we recognised an opportunity.

Glasgow was driving forward as a business destination with the SECC and the Armadillo winning many international conferences. These conferences, attracting upwards of 2,000 attendants always come with hospitality programmes and Glasgow had a problem. Venues, even hotels, with the ability to cater for between 200 and 600 were thin on the ground and one of the only venues with such capacity, Kelvingrove Art Gallery, was closing for refurbishment for up to three years. Using our newly refurbished Arches 1, 2, 3 and 4 seemed like an open goal to raise much needed funds.

I had a background in conferences and hospitality and had specialised in this role in unusual buildings including the Royal Festival Hall and BBC Broadcasting House in London. So as Commercial Manager of The Arches I launched the venue as an unusual venue for conference programmes, Christmas parties and even the odd wedding. It was important to use the beauty of the building and our creative links to offer a unique package where we could dress the venue specific to client requirements. Whether that was a company's logo and colour themed through lighting, linen and stationery or themed events and dinners we had the in-house talent and operation to fulfil. I worked with the Glasgow Convention Bureau to put The Arches at the heart of their sales pitch and worked with our in-house design team to produce sales materials.

Sales visits commenced. It was not always the easiest proposition to conduct a sales visit on a Monday morning after a series of club nights with the building filled with the ambience of alcohol and sweat! But we prevailed on many, many occasions to persuade the suited organisers that The Arches had such beauty and, importantly,

flexibility to suit their needs. An important sales story was also being very clear that holding their event with us would help support the arts.

I worked as Commercial Manager in The Arches for six years, and over the period we earned more than £1million from the corporate hospitality programme. Our themed events were our speciality, we transformed The Arches into, amongst other things, Baroque Palace, a World War 2 bunker, a 60s pleasure dome and a church. I was very lucky to have such creative people to work with, from in-house design to fabulous contacts for props and costuming, the in-house lighting and sound facilities, and the technical team behind them were highly creative.

DAVID BRATCHPIECE

By 2001, we had a whole brand-new box office and it was like, Right, things are shifting up a gear. There was more staff starting. At Midland Street, you had to push the buzzer and we would open the door for you. At Argyle Street it was different; people could just wander in but that was part of the point. They wanted that bigger footfall.

LJ FINDLAY-WALSH (nee LJ DODD, arts administrator then arts programmer, 2005–2015)

I was shopping in Glasgow one day, and happened to walk in at the same time as the National Review of Live Art was on. And I had no expectations... I was just walking into this building. Without knowing it, I'd just missed the Franko B show. All that was left was a chair and a pool of blood. And it was in Arch 2. Chair and pool of blood. And it was so confronting, so beautiful, and so confounding, like, 'What has happened here?' And also, 'Where the fuck am I?' I'd been to The Arches as a club before. I knew it as a club. Suddenly standing in a club environment and bearing witness to something where only my imagination could do the work as to what had taken place was incredible. And I couldn't get it out of my head for ages. I just knew that that was where I had to be. Basically, something beautiful about a building drawing you in.

DAVID BRATCHPIECE

With the Café Bar, the capacity for club nights was now up to 2,275. We had to up the technology at the Box Office, there were bigger events like the Banksy and Jamie Reid exhibition, Peace Is Tough. Jamie Reid was actually the massive name headliner at that point, because he'd designed all the Sex Pistols' cover artwork; Banksy was like the up-and-comer. We felt we could go for it, have these bigger, more varied events. It was all very, very exciting.

TAMSIN AUSTIN

In 2001 I was living with [then Arches Arts Programmer] Lucinda Meredith, we were sharing a flat. And she said, 'We should get Banksy to come and do something. I think he's going to be really big, this guy.' And through some contact I had in Bristol, somehow or other we managed to get in touch with Banksy, and Banksy's people, and arrange for them to come up. It's all a bit of a blur to be honest. I can't remember whose idea it was to do something with Jamie Reid. I don't know whether they'd agreed between them that they were going to do the exhibition.

Banksy came up, and he had all these guys with him. And we were never quite sure which one was Bansky. So we showed them round The Arches… and at the time, obviously we had no idea what a big deal this was, at all. We were just producing this event, but it wasn't like, 'Oh my god, this is going to be big.' We literally had no idea what we were dealing with. They went off to the Barrowlands, to go to the market, to get props and stuff. So the Mona Lisa they did, the big gold frame – they got that from the Barras.

To be honest, we were all paying a bit more attention to Jamie Reid, because his work at that time had been more prolific. Everyone knew who the Sex Pistols were and [his cover art for them] was recognisable. But when he came to do the install, his end of the arch was really chaotic. All these big banners and tie-dye stuff up. And Banksy – they just kind of beavered away, and it all came together. When I think about it now, it was just phenomenal. Because all of those really famous artworks, with the policeman and the girl with the balloon and everything, they were just all there. It was all there, installed in the arch. And then he'd done the whole of the wall with the monkey and the Mona Lisa and then he'd

done stuff outside, and he'd managed to get some of an old brick wall, and did a murder-type scene with chalk lines round a body.

ROB WATSON

Jamie Reid, the headliner, was massively more important at the time, in terms of ego as well. The thing with Banksy, there was no ego with it. There was a completely underground element to it. It was like, we looked at the wall and went, 'When did that happen? Right, stick a light on it.'

Whereas Reid was more 'That light is not good enough. Can you make sure it's a fifty-degree angle, we don't want to see reflections on the Union Jack', or whatever.

TAMSIN AUSTIN

We all got offered pieces of work at the end, because they didn't want to take everything back to Bristol. And I got offered a pair – the policeman one and something else for like £600. And I remember thinking, 'I really like them, but I'm really skint. I'd better not.' So I just didn't. God, I could have given up work years ago if I'd done it.

And yeah, Lynda had a conference the next day and we had to get the painters in and roller over all of the work.

LYNDA FORBES

There's one small myth I would like to bust! The story of the Banksy mural in Arch 2 has been reported a number of times. PR at The Arches in its last years suggested that it had been painted over due to corporate hospitality. This could not be further from the truth.

The mural was painted as part of the FuncT Festival, I think in 2001. When what to do with it was asked post-festival – and it should be noted here that Banksy was not the huge name he is now – I was quite sanguine about it and moved that we would just hang a black or a star cloth in front of it if clients didn't like it. I was quite keen that as an arts venue it could easily stay and become part of my sales story. But I guess it's easier and a better story to 'blame the money' than admit a questionable decision!

TAMSIN AUSTIN

We just had no idea, did we? It was just a moment in time. No criticism, it was just one of those things that you can never repeat, really. It was incredible.

I remember going to South by Southwest, probably about five years later, and Banksy was doing an exhibition there. It was like the biggest deal of the festival. I remember Brad Pitt queueing to get in. It was just crazy, there were queues for miles for people to get in. And I remember thinking, 'Wow, we were really on to something, but we just didn't realise at the time.'

ROB WATSON

It's horrible to say it now, in hindsight. That realisation: fuck, we actually had that level of artist in our premises, and we painted over it.

ANDY ARNOLD

When [in 2018, post-Arches closure] the new owners were trying to restore it 'for the nation', saying it had been painted over by mistake I wrote to the papers saying that was bollocks – it was deliberately painted out for a club night, and was only meant to be transitory.

DAVID BRATCHPIECE

To announce the reopening, Niall did this really memorable face-swapping campaign. People would still talk about it years later. Large posters, lots in underground stations, everywhere in Glasgow, and it had people's faces merged, so you'd have an old man's bald head with a woman's face and stuff. (Years before such things became common on the Internet – it was very unusual and striking for the time.) I think the posters just had the images, with the Arches logo, maybe a couple of quotes and the box office number. A general awareness raising campaign kinda thing.

NIALL WALKER

It was for the relaunch, so it was a big old campaign and lots of folk saw it. I was determined from the word go – and I think it's

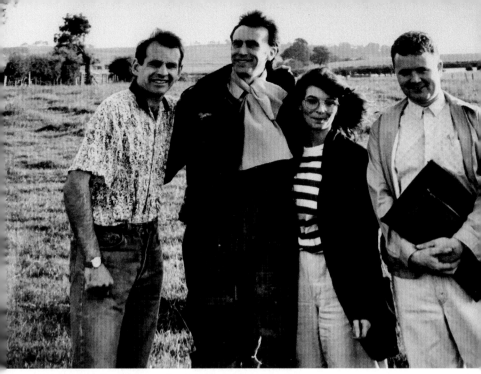

1. Andy Arnold, Benny Young, Lori Frater, Graham Hunter

2. Ian Smith and Angie Dight performing at Cafe Loco

3. A scene from *Alien War*

4. The original sign, with its designer Rory Olcayto, 1993

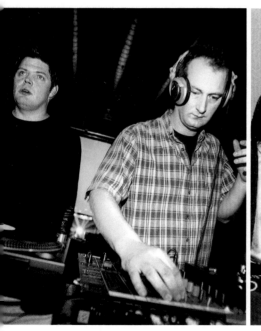

5. Slam (Stuart McMillan and Orde Meikle)

6. *Accidental Death of an Anarchist*
 Arches Theatre Company (1993): Craig
 Ferguson, Raymond Burke, Andy Arnold

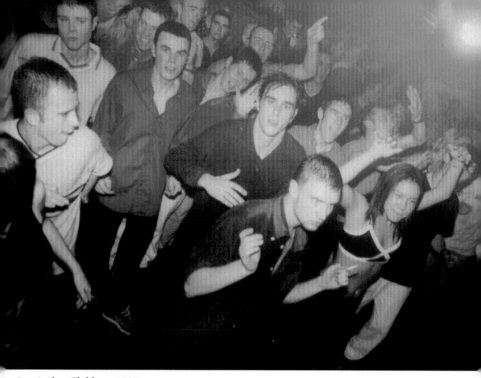

7. Arches Clubbers, 1990s

8. Blair Sutherland

9. Dave Clarke, Andy Arnold

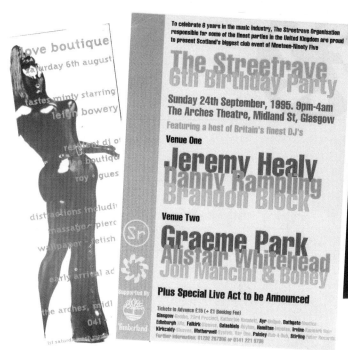

left: 10. Leigh Bowery @ Love Boutique flyer; right: 11. A Cream flyer from 1995; centre: 12. First Streetrave @ The Arches flyer, 1995

below: 13. Daft Punk play at Slam, 1997

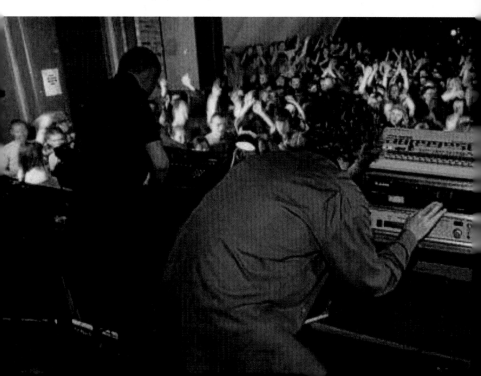

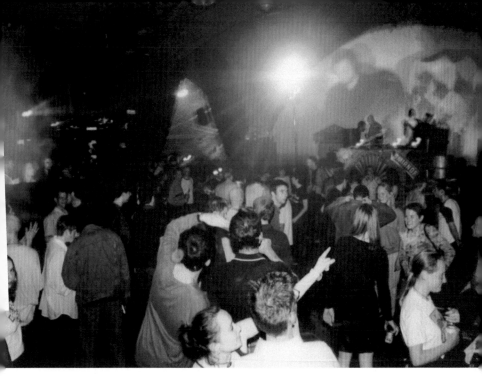

14. Massive Attack album launch, 1997

15. Andrew Dallmeyer and Paul Riley in *The Dumb Waiter*, Arches Theatre Co, 1998

16. Rob Watson

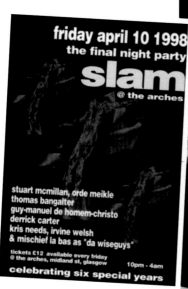

17. Final night of Slam flyer

18. Niall Walker

19. Arches staff circa 1998 w/ Koos Zwart, Tricia McDaid, Nigel Turner, Sarah Wells, Tiernan Kelly, Geri O' Donohoe, Tamsin Austin, Julie Wardlaw & Cara Stewart

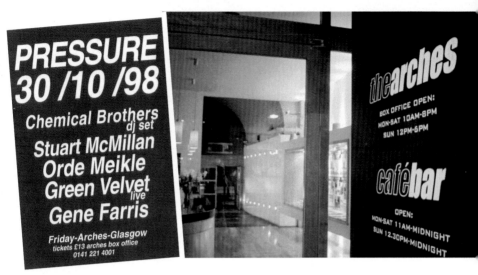

20. The first ever Pressure flyer

21. Argyle Street entrance

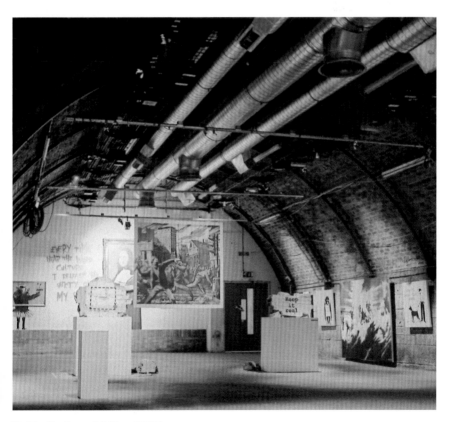

22. The Banksy exhibition (2001)

23. Carl Cox on his way to the DJ box, 2001

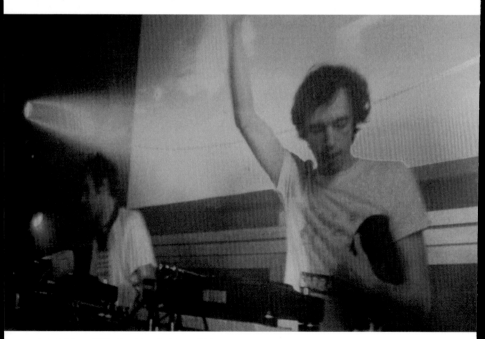

24. 2 Many DJ's play Death Disco, 2003

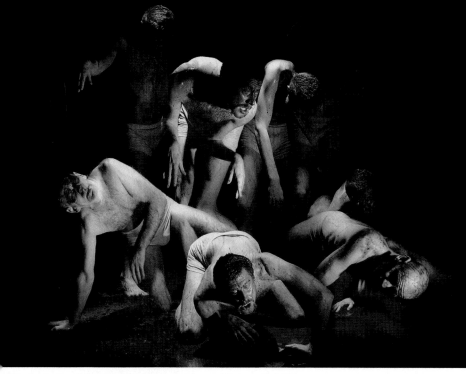

25. Andy Arnold and Al Seed in an *Inferno* publicity still, 2006

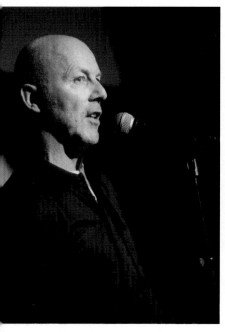

26. Mark Anderson

27. Original spray painted vinyl pressing of Mylo's 'Destroy Rock and Roll'

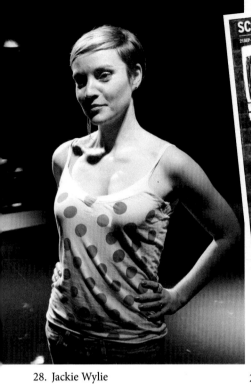

28. Jackie Wylie

29. The Arches guest edits *The List* magazine, 2006

30. LJ Findlay-Walsh

31. Clubbers at Death Disco

32. Taylor Mac in the Studio Theatre

33. Nina Miller and Lisa Dunigan

'HERE WE, HERE WE, HERE WE FUCKIN' GO'

Several thousand Arches punters, 1991-2012

34. The Arches 21st Birthday campaign

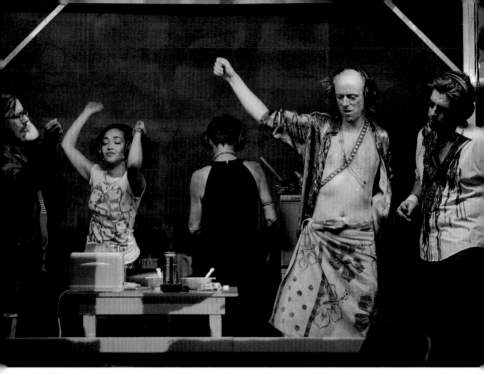

35. Ruth Negga at The Arches with Pan Pan Theatre Company, 2007

36. Adrian Howells' *May I Have The Pleasure....?*, publicity still, 2011

37. Damon Albarn arriving at Central Station with the Africa Express, 2012

38. Soul legend Ben E King plays in The Arches, 2012

39. Kieran Hurley's *Beats*, publicity still, 2012

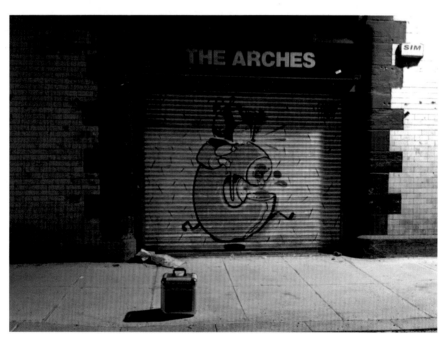

40. The Midland Street entrance closed for the final time, 2015

probably along with Andy here, I think he was my sort of inspiration – that, despite the fact we had this flashy new entrance that was all very slick, and a new café bar (designed around the trendy style bar aesthetic that came around in the 90s I guess) – I was determined that our brand wouldn't become all slick and clean. I think we did have to play with it a little... and that's why that campaign of the faces worked. I felt it was kind of grotesque, which I liked.

Sarah Wells would hate me for saying this, but looking back I do wonder if the aesthetic of the Café Bar and the new entrance were the right thing. I mean at the time they felt right, but a few years later, we just wanted to make them all crusty and grungy and more urban again. I don't know, I kind of felt like it created this... almost a divide in the aesthetic of the building, which was almost reflected in a divide in the aesthetic and the tastes of the company and the staff. It was like, 'Are we big and slick and commercial, or are we arty and creative and urban and all the rest of it?' And I think there was a lot of tension between those two things, both like I say in the building and in the company. I don't think it's necessarily a bad thing – there's something really interesting about that, and it created a lot of arguments, discussions, creativity.

For me, that's kind of where Death Disco came along, and kind of captured that dissonance.

DAVID BRATCHPIECE
All the clubs at that point were being run by outside promoters. And I think there was a feeling that we should have more in-house stuff, like Andy did in the first place. We had a new music programmer and a lot of the staff were DJs and musicians with their own ideas and their own connections. I don't think there was any intention to create a huge club night or anything, more just varied and offbeat music policies.

TAMSIN AUSTIN
We were always trying to think, Right, what can we do that's different? I met Andrew Divine, who was running [soul night] Divine at the Art

School, and Simon Hodge, who was running a club in Edinburgh. Got them together, and we got the Funk Room going, and that was a really cool thing. It went for quite a few years. I think what we were trying to do was play on the fact that The Arches was a club, but we could put live music into it. So we booked bands like Breakestra, Sharon Jones and the Dap Kings, The Blackbyrds.

DAVID BRATCHPIECE
The Sunday Social was early 2000s. A Sunday event, in the afternoon, with quite cool DJs. It was before the smoking ban and EVERYBODY used to just come in and smoke weed. The air was thick with it. You could never get away with that even five years later.

TAMSIN AUSTIN
Sarah wanted to do a Sunday all-dayer, because every Friday and Saturday was busy with Slam and Colours and everything. She wanted to do this all-dayer as an event we could run ourselves, rather than through the club promoters. I remember thinking, 'But it's going to be absolutely minging.' Stinking after the clubs, you know.

It was kind of around the time that [annual festival of alternative dance, chill-out music and comedy] The Big Chill was happening. That first Sunday Social was very influenced by The Big Chill – that kind of afternoon vibe. We had McFall's Chamber Quartet playing, and there was a couple of VJs that I used to get in regularly.

NINA MILLER (*Steward then joint head of security, 2000–2015*)
Happy memories! The Sunday Social, sitting smoking dope in the front bar and watching videos and all that…

TAMSIN AUSTIN
But it was really laborious to put it together, because the club would clear out at 4.00am on a Saturday night, and we'd need to be ready for twelve noon. And the whole Arches would just be completely steaming and stinking. We'd hose it all out and have to be ready for lunchtime.

NIALL WALKER

The Sunday Social was amazing, but it didn't really take off in a big way. Then Tamsin was running The Funk Room, which was The Arches running our own club again. But Death Disco... I remember Tamsin and Tiernan [Kelly, Arches Operations Manager] coming to me and Sandra [Marron, then Arches Press Manager] and saying, 'We want to start our own night!'

TAMSIN AUSTIN

We were all going to The Sub Club at the time, and everyone was really into [weekly Sunday club night in The Sub Club] Optimo, and electro was getting really big at the time. I remember talking to Tiernan and [Death Disco resident DJ] Jill Mingo, and again we just thought we'd try and do something which involved putting live acts into a club thing.

NIALL WALKER

I actually don't know whether Tiernan went to Tamsin, or how that initial conversation between them came about, but they were both very passionate about doing their own club night which was more dance music orientated. 'Electroclash' was very much the word at the time, but then Jill Mingo... sorry, DJ Mingo-Go, was brought on as the resident DJ and she hated the word electroclash, she hated it. I remember her going off on rants about it: 'I'm not part of electroclash!'

We were sitting around the table and trying to come up with the name. From my recollection, I think it was Sandra who said Death Disco. We had a massive list. And there was a slight problem with Death Disco in that there already was a night called Death Disco...

TAMSIN AUSTIN

Alan McGee had a club called Death Disco at the time, and I remember we had some issues. We'd already called it Death Disco, and I don't think we realised. And then we got some threats, like: *You can't use that name.* But we just ignored them and carried on!

NIALL WALKER

It was more of an indie night in London, and it was very small. I mean, okay yeah, it was in London, but it was tiny. But we just thought it was so perfect at the time. It felt like… it's like 'death metal', it just described what the music was going to be, which was disco but really sort of out there, hard disco, if you like.

TAMSIN AUSTIN

A lot of that music was coming from Europe. So at first, we had themed nights by country. We had a French one and a Finnish one. It was really fun, but it was really hard to programme. Booking all the live acts for something that was monthly did end up being really tough. Getting people over, it was quite hard work. But it was fun.

NIALL WALKER

The first one was actually a Norwegian-themed night. I've got the flyer somewhere. And then there was a Finnish-themed Death Disco. And the first sort of bigger one was the French one, which was Jacques Lu Cont and Étienne De Crécy, and that was right at the sort of crux of the French House scene, which was also very much part of the music policy there.

TAMSIN AUSTIN

We had Jacques Lu Cont and Les Rythmes Digitales. I remember everyone going, 'We've got to get Jacques Lu Cont.' And I managed to get him somehow, I can't remember how. I've got no idea which agent I went to.

NIALL WALKER

I remember chatting to Jacques Lu Cont, or Stuart Price as he's now really known, in the dressing rooms. And he'd just finished touring the world with Madonna, because he was Madonna's music producer at the time. So when I heard he was coming, I was like, 'Right, I'm meeting him.' I remember having the conversation with him: 'So how was it, touring with Madonna?' And he was like, 'Oh yeah, she did this, and she did that…' And I was like, 'Oh yeah, she's totally like that…!'

But I'll never forget this – the reason I'll not forget it is I've still got it – I swear to god, he said to me that night: 'I was going to give up DJing completely until tonight, and this has changed everything.' And he wrote that on my flyer. And I thought, Fucking hell, that's all we need to hear. We probably had 800 people that night, it was a bigger one but not massive. I think it was December 2002.

TAMSIN AUSTIN

The 2ManyDJs one was probably the best club night of my life. It was just awesome. They played in the back arch, against the glass doors, and it was just phenomenal, so good.

NIALL WALKER

I remember Tiernan and Tamsin being at their desk, at the main Argyle Street office. They were standing at the computer, and I didn't know at the time, but they were waiting to hear back from the agent, or if they had won the bid to get these DJs. I just remember the two of them going like *(punches air)*, 'YES!' Like, so chuffed. And I was like, 'What is it?' And she goes, 'We've got 2ManyDJs, we've got Soulwax!' And I was like, 'What, seriously?' Because I didn't even know they were bidding for them, they had kept it quite secret. And they knew it was a good booking.

That whole era from 2003 I would say… it was 2ManyDJs that really kicked it off, in my mind. It was basically going to a club where you could hear a bit of indie mixed in, or a bit of rock, or a bit of Dolly Parton, alongside dance music or whatever. So yeah, from 2003 to 2008 maybe, I think were the big five years of all that. It was so good.

KIRSTIN INNES *(Press and publicity manager, 2004–2006)*

Glasgow, in the mid-noughties – it felt like the epicentre of electro. Or like something was definitely happening, anyway. And not just the clubs; there was a lot going on. Franz Ferdinand were suddenly one of the biggest bands in the world. [Biennial international visual art festival] Glasgow International was starting, Mylo had this huge

worldwide hit, but for Glasgow it had started off a couple of years earlier with this viral marketing campaign, with DESTROY ROCK & ROLL stencilled in spray paint all over the city.

TAMSIN AUSTIN
Mylo really kicked off at that time, with [his single] 'Drop the Pressure'. And I remember Duncan [Reid, Inside Out promoter, also running Breastfed Records, Mylo's record company] hand-spray painting all those 12-inch singles in The Arches. I've still got some of those. I remember The Arches stinking from the spray paint.

DUNCAN REID
We were in The Arches with all the records out on the floor, spraying them. And we literally couldn't have done that, if we hadn't had a space like that. We all went home with horrendous headaches, because it was so toxic. And the fact that Sarah let us go in there and spray paint over and over again for months and months [was important], because that was a big part of the early campaign for [Mylo], that people were like, 'Oh, these sleeves are cool.' Mylo had his first gig in The Arches. He used to do the Sunday nights in the Café Bar and then go to Optimo. It's funny how The Arches touches into all these things.

BLAIR SUTHERLAND
Mylo. I mean, I gave Mylo a gig in the Café Bar on a Sunday night and paid him twenty quid, because I liked a mix CD he'd made! Next thing, he's a multi-millionaire and he's trying to charge me ten grand to do a Saturday night. These type of things are like folklore between Arches staff. I think that's what the sort of spiritual side of The Arches was always about, a platform for someone to express themselves. Be it your Calvin Harrises or Slam doing their first gigs.

DAVID BRATCHPIECE
Calvin Harris played some of his earliest gigs at Death Disco. This is before he got all ripped and handsome and still looked like someone

from Dumfries. One night there was a power cut just as he went up to the decks, the place plunged into darkness and the emergency lights went on. If I remember right, he just cancelled the gig and went home. But yeah, despite that one hiccup, most of his gigs there were great, there was already a buzz about him.

NIALL WALKER

When Death Disco first started, it was small and creative and arty and alternative and all the rest of it. It was the night that 2ManyDJs performed at Death Disco that it suddenly just became this other thing. And so it seemed to marry the kind of commercial side of the business, and the arty side of the business – or, the creative side of the business is a better word – and marry it all in one big fabulous monster that worked. Because it made money for the company, it brought loads of people into the building – who weren't paying a lot to get in as well I remember, so that was the accessible side of it... Plus, the choice of talent at it and the DJs was much more creative and interesting than what the other club nights were doing.

TAMSIN AUSTIN

At Death Disco, some really weird shit went on. A friend of mine just turned up out of nowhere. I just ran into her in Glasgow one day. When I'd known her when she was a kid, she was called Gemma Bailey, but she'd become this alter ego, a performance artist called Meg Spotov. I went, 'Oh yeah, just come and do something at Death Disco.' And she came down and brought all this offal. She basically screened out the whole of one of the arches in see-through plastic, like a medical environment. And had all of these antique medical equipment things, I've got no idea where she got it. It was not exactly a very chilled thing at all! She had all this offal that she was trying to fix onto the wall and stuff. And it took her ages to do it, and I was like, 'Hurry up, we've got to open!'
It was just bizarre, but anything seemed to go in those days. It was just like – it's performance art, it's theatrical. It's fine, we'll just put it in and see how it goes.

NIALL WALKER

We'd throw in ridiculous performances. Like Ann Liv Young urinating live on stage! Or Le Gateau Chocolat in a skin-tight leotard singing 'Nessun Dorma'.

AL SEED

There was one time at Death Disco I was on a raised stage, mostly naked, in evil-clown make-up and crown of bullets, strapping myself into an electric chair. The crowd seemed to be really into it, then I spotted one guy looking up at me, very concerned, and waving frantically. Trying not to break character, I leaned out to him and offered my one free hand in greeting. Relieved, he put a lit cigarette between my fingers and shouted over the music, 'Before ye go, mate!', winked, and disappeared into the strobe lights. I sat up, stuck the fag between my teeth and carried on. This got a cheer.

NIC GREEN *(Theatre-maker and artist) [Interviewed in The List, 18 October 2012, Issue 705]*

I remember, while I was a student, working with a performance collective called BarArt. We made performance interventions for night club settings and Death Disco was our favourite place to perform, as the crowd was always so appreciative of anything out of the ordinary. The most memorable night was one where we wore discoballs over our heads and created an installation of light shining and moving in all directions in the dance arch. People really wanted to touch the heads, as if they weren't real somehow, and I remember being in the midst of the performance when one guy licked my armpit.

NIALL WALKER

I'll never forget that moment. I mean, Death Disco was just on its way up then. And you do wonder – how much did those four people in mirrorball heads arriving on the dancefloor and doing a flashmob…
It makes you wonder how much did that affect the actual growth of the club. Because everyone who was there that night spoke about it. I think that night was one where we had maybe around 400 people,

it was just the Dance Arch. And it was just after that that it just really started to become massive.

JACQUI REID (*Clubber, Death Disco PR staff 2004–2011*)
It was *the* night of the month for the flamboyant masses of Glasgow to dress to impress. The effort people put into getting dolled up was immense. That night gave people confidence to wear whatever the fuck they wanted, the wilder the better. It gave many a safe space to express themselves.

I spent my twenties growing up there, usually high as a kite and bouncing about from arch to arch, leaving a trail of sequins falling off whatever second-hand embellished frock I'd chosen for the night. It meant the world to me to be a part of it.

NIALL WALKER
The first Myspace profile I ever looked at was Jacqui Kilday's – she's Jacqui Reid now. And I was like, 'Oh my god, this is like permissible narcissism!' You can have your own page all about you and what you love and who you love. I'd never seen anything so positive. Jacqui is amazing, she's so full of life. And one of her lines was, 'I pure fucking love Death Disco, by the way.' And so we started using that online enthusiasm and online narcissism, for want of a better word, because it kind of is in a way, to appeal to that generation who wanted to see themselves up on a big screen, or in this case on a big poster all around town – that they could then share on their social media.

JACQUI REID
I have to mention how iconic Niall's posters and flyers were. They were like nothing else getting distributed around Glasgow at the time. Featuring Arches staff members or club regulars, he pushed the designs to another level (it was like when Anna Wintour started using celebrities instead of models on the cover of *Vogue*) and the crowds that followed the night couldn't wait to see who the next person on the flyers would be. I worked as a PR for Death Disco, handing out those flyers all over Glasgow in bars, shops and at the end of other club

nights around town. For years my bag was weighed down with flyers so I could dish them out at any chance I had. Niall won a marketing award for the DD campaign – very well deserved! I remember at one of the birthday parties of DD, the middle arch had all the posters from previous months on one wall. All the photographs and neon text looked so good together in one place.

KIRSTIN INNES

I was the first Death Disco flyer model I don't think it was any particular compliment; Niall just looked up and saw me at the desk in front of him and thought, 'You'll do'. Anyway, I had to lie down playing dead on the concrete floor of the corridor, with the biggest mirrorball the techies had balanced on my stomach – my fishnet-clad legs poking out underneath. The idea was I'd been literally put to death by disco. Niall was standing above me taking pictures and telling me he would add the bloodstains on in post-production, obviously. The mirrorball was huge, so I couldn't see a thing, but I could hear a few voices coming and thought this might be a bit embarrassing. I rolled it off myself and looked up to see I was surrounded by a group of older gents – what I'd call 'gently crusty', with instruments – it was The Levellers on their way to a soundcheck. We later found out that image was nicked for the cover of a Norwegian black metal album. My legs have travelled.

NIALL WALKER

We used Myspace. It was the first event to really make use of social media – we didn't really say 'hipster' back then, but it was absolutely a hipster crowd. The way we used to get people to apply to be a Death Disco poster model was just to send me an e-mail with the letters 'DD' in the subject line, that was it. There was no online application form, no nothing. And then a photo of themselves. So I'd come in and I'd have all these e-mails going, 'DD, DD, DD, DD, DD, DD…' This is going back to what you were saying about dissonance, if you like… but I always tried to choose people that didn't just look like clubbers, but looked kind of artistic and creative. We kind of dressed them but we worked with their own aesthetic and their own style, and created

something that was not just a clubber but a really interesting clubber, a really interesting person and… I hate to use the word freak, but kind of a beautiful freak kind of thing. And it was to appeal to The Arches arts audience as much as it was to The Arches clubbing audience. And it seemed to work. It was a sort of membership scheme, if you like, where folk were getting half-price passes. I mean, that's kind of what it was – you felt like you were part of a club that was a club night.

JACQUI REID

I featured on a few of the Death Disco flyers, one in particular I'm photographed lying on the wet floor of the ladies toilet. God knows how I ended up being under the cubicle with my head poking out. Can't remember if it was my idea or someone else's but looks pretty funny on the final image that was chosen. I'll never forget that damp stench of those Arches toilets.

NIALL WALKER

And obviously it was part of the whole electroclash movement, but it felt like there was a moment in 2007–08, where… I can't remember who the DJ was – I remember Tiernan saying, 'Niall. There's two thousand people here, and I don't think anyone knows the names of the DJs. They're just here because it's Death Disco.'

And that was a shame when that changed, because eventually, three or four years later, all club nights became about one big massive super-expensive DJ performing at it. Which was, you know, in many ways the death of the clubbing scene everywhere because most places couldn't afford them, and they were playing stadiums, playing in America and all the rest of it. But that moment, those few years, it was great when that happened – it just felt like everything came together, in the company and round the globe. When I first got there in 2000, for the first sort of four or five years, obviously the money side of things was an issue, but it didn't seem to be the be-all and end-all. It just felt so exciting. It all just came together and worked. It was amazing. It was so, so good.

DAVID BRATCHPIECE

Yeah, Glasgow felt like the epicentre of all that, and The Arches was the epicentre of the epicentre. It just was. Death Disco was three times bigger than similar nights running in London. I view that period, when Death Disco was up and running, the early-to-mid noughties, as a second sort of golden era, maybe the first being those early-90s days where it all began to click. And then, yeah, it just rode another wave where it got bigger and bigger. It was working.

SARAH WELLS

One of the other challenges was convincing the powers that be that The Arches was absolutely a well-intentioned and completely and utterly dedicated arts venue, first and foremost. And that the club programme was absolutely something that young people wanted, needed, and that we did it really, really well. It was frustrating, because Andy and I, what we were trying to do there was something for people that were interested in a live experience… [in] challenging new work, and not everybody appreciated that. It was quite nice that you might have an audience that would never necessarily go to something else that was going on in The Arches – that didn't matter, I didn't think. That was never a problem for us, we didn't think, Oh, if you're a theatregoer you must want to come to a music concert, you must want to come to a club. We didn't need to do that because not everyone's the same, are they? What was important was actually making sure that we were providing a venue for all of the people that might be creating something new, in those different programmes.

NIALL WALKER

[There were also a few] building-wide art installations round about then, which the National Review of Live Art tied in with. I remember a one-off called Vault, organised by Lucinda [Meredith]. And [art-punk band] Uncle John and Whitelock built a whole shack in Arch 2, and they performed in it. Back then, it felt like it wasn't all about making money. So yeah, you could give over the whole building for a night or a week just to have… 'just' to have art in it, he says! There were loads of people there, and DJs, and the art, which was amazing.

But of course it didn't bring in any money – people don't buy tickets for that kind of thing, they want to just be invited along, and be there.

SARAH WELLS

Whether it was a young actor, writer, or whether it was a new DJ coming through, it was just great to be able to give them that platform. And not going down the road of going, you know what, we could just ditch the charitable status, and just run as a licenced venue and take the money. Now, don't get me wrong, there were some terrible things on! But you had to allow that to happen, didn't you, because in amongst some work that didn't quite work, you had people that were learning – you learn by failing. And that was the same for us, running the building, as well as it might have been for the people performing. But Andy was fantastic at taking those risks with people and, you know, he may not necessarily have known someone well, or what they wanted to do, but he wanted to give them the go, so that was good. And you just had to take that risk. But that's what's exciting about live work, isn't it? You don't know what you're going to get.

JACKIE WYLIE *(Fundraising officer 2004–2005, arts programmer 2005–2008, artistic director and co-chief executive officer 2008–2015)*
Megan [Barker, award-winning playwright] and I had formed a theatre company in our final year of uni; we got this scholarship to make a show that ended with Megan being birthed out of a giant vagina. Andy came to see it, and from there we got a gig to put something on in The Arches. That was an amazing thing about The Arches: its commitment to the uncovering of newness. I don't know of any other arts organisations where success was taking a chance on people. It's revolutionary, when you think about how hard it can be – people are so focused in on value judgements that are inherently hierarchical and based on status – what is 'good' art, what is 'excellent' art – to have an institution where the more risks you could take on the newest artists, that was what success looked like. So, a few years later, when I applied for a job at the venue, in 2004 – I wasn't ever completely sure what my first job was! I think I applied for a different job – and then they liked me so Andy made me some sort of role? Anyway when I applied for

that job, I think that spirit of trying to just put something on was a good thing to be bringing into the organisation.

ANDY ARNOLD
That was always my particular aim when I started that place, you know… asking Bob Palmer to keep the seats… discriminating in favour of local young artists, rather than trying to bring up companies from down south or whatever, it would be a platform for young theatre companies to develop work, and the whole ethos for the development of all those basement spaces was for young artists to have the space to develop work, and then take it upstairs to the studio theatre to make it happen.

KIRSTIN INNES
I always remember Andy sitting me down and explaining quite early on, actually – and it really really stuck with me – about the 'right to fail'. And how that seemed so central to all the possibilities that the building had… Andy was kind of the only person in Scotland creating this space for artists to have a right to fail and try again and try again and work on it. Rather than expecting them to spring fully-formed into a funding grant.

SARAH WELLS
And I think it was great for people that were starting out to come in and do that in that kind of venue, where it was a little bit more flexible and a little bit more unexpected. I think people fondly look back at the fact that they may have created work in The Arches, because they knew it was in that type of environment rather than in a more sterile experience. And we had to have the professional music and club scene involved, because it had to be done well – to have a steady income coming through. I left in 2002, and didn't come back too often – it's hard, you know? It's hard to come back in when someone else is running the show.

BLAIR SUTHERLAND
Sarah was so important to what The Arches became. Sarah was the most important thing of that period.

MARK ANDERSON *(Executive director, 2003–2015)*

The Arches was probably in its adolescence when I joined, and I kind of like to think I helped to steer it into adulthood and maturity, really. Because what I was able to do, and there was plenty of scope to do it, is that…it was a bit unruly, it was a bit wild… it needed discipline, if you like!

When I joined it had not long completed the capital investment programme which allowed it to open the box office on Argyle Street, it refurbished the bottom arches to allow the full scope of the building.

But actually, I remember when I came up for my interview, this is probably a good example – and I'm not going to use the word unprofessional – of how much scope there was to improve things. The Café Bar was closed to the public because there had been a fire in the kitchen. And it's fair to say that the fire came about because their health and safety practices weren't up to speed… and it should never have happened, but it did. And, you know, that was certainly one of the areas where I was tasked with getting everything up to speed. Bringing it properly into a health and safety regime. But that was a really small part of it.

Yeah, there was certainly systems that needed put in place. I mean, everyone was committed, but in a way that required kind of… yeah, I'll use the word discipline, because I was shocked. When I got in, probably nine o'clock in the morning in my early days there, I couldn't believe the time that people would start drifting in, maybe ten thirty, eleven o'clock. In fairness, some of them would be working into the evening, but not all the time.

Tamsin was running the music programme at the time, but she had a very polarised vision of what the music programme should be. She was actually a folk musician herself. And I'm just giving you this as one example – there was a lot of folk music on, not always, there was a broad range of things on, but there was certain things she wasn't interested in and wouldn't put on. And when I got there, I just didn't think that we could be, or allow ourselves to be, so selective. You know, there was scope to broaden it. So one of the first things I did was bring in new bands nights, local bands. She hadn't thought

of it or just didn't see it as part of the programme that she wanted. And I thought that was important. You know, in a musically rich city such as Glasgow, you want to support local bands. Anyway, they were challenging because getting audiences in to see unknown bands is never easy.

TAMSIN AUSTIN

Sarah had left and Mark had come in. And it was just a time of change. I had really enjoyed working for Sarah, and I think it was just one of those times, I just thought it was time to go.

MARK ANDERSON

The programme at that point was nowhere near as busy as it became. That was probably the biggest scope that I saw – we had a building that had the capability… and it was doing a lovely little programme, don't get me wrong, you could see the quality. But going back to what the board told me, and this was really vital to my role in basically all of my years there, it never relented. There was a deficit, a financial deficit: £100,000 pounds, it was.

So I joined in April 2003, and that was my mission – overturn that deficit and start building financial reserves. I had to have meetings with the three big clubs – it was Colours, it was Inside Out, and it was Slam. That was one of my first objectives, to sit with those promoter guys and tell them, 'Listen, you're not paying enough. You're making an absolute fortune here, guys. And we're not charging you anything like what we need to be.' And I was honest with these people, I said, 'You've been raking it in during the 90s', and they certainly would have, 'while we've been losing money. So, the party's over, and you'll still make money.'

But, you know, it was every aspect of the business, really, so we were able to make wins. Did we charge for the cloakroom? I can't remember – we certainly put the cloakroom prices up a couple of times in my time – things that were no-brainers really. When you've got those captive audiences you can get away with stuff.

It very much was about instilling a bit more of a business brain in as many of the managers as I could, and helping them along the way to run their budgets more successfully.

NIALL WALKER

What they did with the theatre programme eventually, which was a big change – and it was when Jackie was taking over, I think – was, rather than spreading the visiting theatre throughout the whole year, or throughout the season, they gathered it into Arches Live [a festival of new work by emergent local artists] and what was originally the Arches Theatre Festival, which became [international theatre/performance festival] Behaviour, and kind of gathered them in a timeframe, which was better for the workings of the building and better for selling to audiences in many ways as well, and I think that really worked.

JACKIE WYLIE

Andy believed in new talent but actually it was Jean Cameron [theatre programmer 2002–05] who set up Arches Live. Jean really mentored me… I think Jean was a person who actually in the history of The Arches is too footnoted, I would say, given that she seeded a lot of the stuff that LJ and I carried on.

Andy had a punk rock spirit, this drive to take a chance on artists and they will do something extraordinary, and then Jean took that spirit and turned it into something that was more structured, began to formalise it into talent development initiatives [awards and scheduled festivals]. I took on the mantle from Jean as well as Andy in the sense of bringing that internationalism and finding those opportunities for artists.

[In 2006] there was a season when we paired local artists up with international artists, and [Glasgow playwrights] Alan McKendrick worked with [New York political theatre group] The Riot Group. The TEAM [Theatre of the Emerging American Moment] were a young company then too. There was loads of international exchange. In all senses of the word. And that's all I'm going to say about that. That was youthfulness.

KIRSTIN INNES

Almost everybody working there, even in fairly highfalutin roles, was well under thirty. Niall and Blair were outliers for being older and both of them were still under thirty-five. So we were all young, and we were very hyped up on being in Glasgow, in the centre of something at that time.

DAVID BRATCHPIECE

It was a very youthful energy. I loved it. I just really felt – particularly during that period – this is where I belong. This is my home from home, this is my world.

LJ FINDLAY-WALSH

That is how The Arches worked, it was pretty DIY. People weren't paid properly for what they were doing.

It was kind of an interesting model, because it was driven by youth. I've thought about that a lot – it was driven by our labour in terms of youth within the arts team, but I wonder how that economy was sort of built onto artists as well – at what point should The Arches have grown up and started paying people properly. Because originally it was almost like, what can we make happen on nothing. So Andy was like, 'Yeah, but I've got nothing, we've all got nothing, we're just here, we're just doing our thing!' And then we got so successful that actually there was a duty of care to really value knowledge and people getting older and that sort of thing. So I think that was a tension that always existed within The Arches, maybe.

ANDY ARNOLD

I'd been making a lot of use of the basement spaces. Lots of little pieces of theatre that worked in that space, like Beckett plays and Pinter plays and so on, where the sound was dripping off the ceiling and the trains were going overhead, it was perfect for them. Then we did The Basement Tapes – *Krapp's Last Tape* and *Rockabye* in right down underneath, with a bit of installation stuff going on, a bit of film [projected in a dark stone stairway] – yeah, that was great. You couldn't do that type of theatre anywhere else, where you're going up

little stairs to find other little bits of theatre and so on. From that I got the idea to do a show called *I Confess*, in and out of all those nooks.

MARK FISHER *(Journalist) [Reviewing I Confess in The Guardian, 13 May 2005]*
Perhaps the most extraordinary moment in this extraordinary show is the curtain call. The voices that have echoed round the corridors and cubby-holes of the Arches basement subside and a musical refrain goes out. Slowly from around the building, actors and audiences gather in the gloom. It feels like the scene in *Close Encounters* where the people assemble to greet the alien spaceship. Then everyone applauds each other.

What happens first takes some explaining. The audience of twenty is divided into two groups which are led in opposite directions. Each spectator is directed to stand next to a different actor positioned around the space. Each of the actors has a five-minute monologue to be delivered one-to-one before the spectator moves round to the next actor. In just over an hour you get through ten intense mini-plays written by ten different authors. The effect is dizzying. The brief to the playwrights was to create characters who would unburden their souls. The resonance is of the Catholic confessional and, indeed, there are many dark secrets shared…What's fascinating is the part that you, the audience, play in all this. For each monologue you effectively become another character, wordless but active.

ANDY ARNOLD
There were some good actors there; quite an interesting bunch of people, those students in *I Confess*. There was Colin Morgan, the guy who became Merlin. Richard Madden. He wasn't very good, was he? Martin McCormick, who I've worked with quite recently writing plays. And EJ Dodds, who's a deaf performer, she did the signed piece. She often refers to that as her first piece of professional theatre. That was the first bit of one-to-one theatre I had done, and then when I was approached by marketing or whatever it was to do a fifteen-year anniversary celebration…

KIRSTIN INNES

I got the programming team to put together a fifteenth anniversary celebration when I realised it was coming up in 2006. I did sort of strong-arm Andy into it. We called it 15 Years, Two Fingers which we felt was very edgy at the time.

ANDY ARNOLD

Because we were still the young kids on the block I hated the idea of acknowledging it had been fifteen years! So I thought, Right, we'll have somebody come in and watch this in the toilet. And then the idea grew on me, hence *Spend a Penny*. Big mistake there, we only charged a penny. And sometimes people wouldn't turn up. We were sold out, and suddenly we were rushing around the bar trying to find somebody who could join in because you needed four audience members, one with each performer in each toilet cubicle.

KIRSTIN INNES

Andy got James Kelman and Liz Lochhead to write some of the monologues for *Spend a Penny* – Scottish literary royalty in his cludgie play. We had reviewers from all the major newspapers crammed into the club toilet cubicles on press night. All because Andy was a bit grumpy that we were making him celebrate the fifteenth anniversary. And because it was Andy, it was brilliant, and the press absolutely lapped it up (not literally). Although one of them did describe it as 'shite-specific theatre'.

ANDY ARNOLD

The Arches was such a gift from that point of view – a site-specific venue. I think a lot of pieces that were created there were inspired by that space. And I always felt, if a piece didn't work in there, there was something wrong with the piece of theatre, because it was such an atmospheric and intimate space. We could try things out, mad things… and the thing was, it was such an atmospheric building that it suggested types of theatre as well, it encouraged you to think of stuff using the extraordinary nature of the building.

The fact that we were in control of it was very important, so sometimes we would be holding a club audience outside while a group of old people or whatever were finishing watching a theatre show, and we had the power to do that. Or to not have a commercial event on one night because it conflicted with a theatre show was completely loss making, but you know, that's what we were about. And had we, for example, rented out the rest of the building just to club promoters and just kept ourselves in the theatre space, we would have been gone within a week.

MARK ANDERSON

Some of Andy's stuff was incredible. I think one of my favourite shows of his was *Dante's Inferno*, which was the promenade stuff that went down into the basement, and he just delivered these fantastic tableaus of darkness and hell, of course. And the building lent itself to that kind of work.

The pressure was constantly on me to keep delivering. I felt it was important to actually bring people more into understanding the state of the business. I'm not sure they really were at the time. Basically, you could take any area of the business – whether it was corporate, whether it was music, whether it was clubs… You know, there was always scope to do more. And that really was ultimately where I saw the growth.

I think fundamental to the success of The Arches, what drove the success, was actually the tension between the commercial demands of the business against the artistic integrity. You know, we saw that week in, week out at the diary meeting, which got bigger and bigger and longer and longer… It got longer because there was more events to put in but it got longer because there was increased debate about 'Should we be doing that? Shouldn't we be doing it?' But actually, do you know what, it was a healthy competitiveness. By and large friendly…

ANDY ARNOLD

Because we were a victim of our own success, I remember we used to have those weekly meetings, the diary meeting every single week, and

we were all battling away about what spaces to use for what. And there would be more and more corporate events, and more and more gigs… Joe [Splain, the music programmer 2005–09] was very ambitious for gigs, and of course he set up the student club night on the Wednesday night. So whereas, for example, the major clubs that used the whole building had been once a month, it was now every week, and then suddenly it was every weekend and during the week as well. And whereas I had loved staging theatre all over the place, over the last few years I just retreated back into the studio theatre.

DUNCAN REID
It just got a bit brutal, and Andy's not a brutal guy.

MARK ANDERSON
I think that he felt the pressure on the building was a bit of a pain that he didn't want to have to deal with anymore, you know. I think he liked the idea of just not having to worry about… will he move his theatre show for this night or that night, or whatever else. Because, you know, at the same time we'd had *Alien War* in its second guise, which was hugely successful, and again – going through *Alien War* and seeing the way that it could bring new people into the building, it was fantastic, but it did require jiggery-pokery with the programme.

ANDY ARNOLD
You'd do a technical rehearsal, for example, and you couldn't find a technician because they were setting up for a club night or whatever.

And the whole sound….you know, we'd be arguing about whether or not you could have a gig at the same time as a theatre show and how loud was it going to be and all that type of thing. I remember going back there a few years later when they had that re-invented *Alien War* down in the basement and you could hear gunshots…I thought 'Oh for fuck's sake'. I had forgotten about how bad all that was….you know, it was great that you could have so much going on in the place, but at the same time it was…from a theatre point of view it was too commercially successful really, and you couldn't turn these things down, they were making too much money for the place.

MARK ANDERSON

Andy, like we all were, was hit badly by the death. *[The first drug-related death of a clubber in the venue, Russell Johnston, in 2007]* happened in his time there. Andy actually wanted to take it upon himself to deal with the parents of the guy. And I think after that he just felt he'd had enough, so he needed a change.

ANDY ARNOLD

I love that place, and I think that if we hadn't been dependent on clubs, you know as a business model, and we got enough funding to run it just as an arts centre, then I would never have left. There's no doubt about that. I loved that place so much, but… the first time that young guy died that was really traumatic. Getting a phone call at four o'clock in the morning to be told about something happening. And then a couple of years later it happened again. And I remember going down there at four in the morning and going up to my office and switching on my computer and just looking at what jobs were going. I thought, this is not what I started this place for. So that was one reason why I wanted to get out. I thought I don't want to be in this type of scenario, I just want to run a theatre.

NIALL WALKER

It would be easy to say, when Andy left and Jackie took over it was a different era. And it was in a way, but Jackie had already started as Arts Programmer so it kind of segued into that, it wasn't like a sudden change. It would be different if someone from the outside had come in. But Andy had been doing less and less of his own work, and Jackie was programming more and more of her work.

ANDY ARNOLD

I've got a brick, of course, in my office. Which is a nice thing – it says, 'To Andy, the originator of punk theatre'. Given to me by the board. On my going away night, Lesley *(Thomson, then chair of the board)* suddenly presented me with this envelope… and I thought, 'Oh, it's a great big wad of money', and I opened it, just to find a brick inside. That was from the fuckin' board… Actually, the

staff did a very generous whip round, a proper whip round, and we ended up getting a lovely upright piano which sits proudly in our front room.

I'll keep the brick, it's fine.

5

2008-2013

It's All Allowed

'Where can you see tomorrow's work today? The answer is The Arches.'
The Guardian

MARK ANDERSON

It was a shock when Andy handed in his notice. You know, the guy started the organisation. And I think we all thought he'd be there to the end. With hindsight I was able to reflect and note that his heart hadn't been in it as much, prior to his leaving. And the reasons that he explained to me: the stress of death in the club, the stress of the building and pressure on it, and just needing a change of scenery – it did make sense. But I was shocked.

And then of course, I turned to the board and said, Right, what do we do now? Clearly it was the end of an era with Andy departing, but everyone saw it as a huge opportunity. Because nothing stands still. It was an opportunity to evolve further. So there was an element of: Okay, this is a great opportunity for The Arches. There's a lot of good people out there.

Jackie had been working for a while in the support role to Andy – I think she was probably producing bits and pieces at that point as well. I can't remember if the board advised her to go for it, but she was ambitious and I'm sure she would have seen herself as a strong candidate. But clearly you've got to go through the recruitment process, and do the legal thing actually.

So we did that. And we saw an awful lot of good people. And maybe Jackie would admit it – I remember at the end of the first interviews, Lesley Thompson, the chair of the Board brought it up, asking, 'Is she

ready for this job?' You know, she was young. I can't remember how old she was at the time – early thirties, maybe?

JACKIE WYLIE

I was so young! This is another amazing thing about The Arches – only at The Arches would there be a twenty-eight-year-old Artistic Director, and now at the age of forty [as Artistic Director of the National Theatre of Scotland], I'm like, 'Oh my god!' It was actually completely insane and totally wonderful. But also so fascinating to be forged in the fires of The Arches, and having that experience of working in that environment.

MARK ANDERSON

It was a big decision; it was a big debate, actually. The other two candidates were established and renowned artistic directors in their own right; Jackie is a producer, not a director. So do we go with someone that, you know, has proven themselves, has done great work in other venues… or do we go with what might be a slightly maverick non-director, with the added risk of that.

There were a number of reasons we ultimately went with Jackie, but one of the key thoughts was, Would those other two candidates come in and ultimately realise, 'Oh, this is a challenge, putting my work on in here', because of the challenges we all faced week to week in the diary meeting. Andy had grown with it, evolved with it. Jackie was completely aware of it, she knew how to adapt to it. And clearly she had a vision, and that vision was a sound one in terms of producing. Because I think she was doing the [Behaviour] festival at the time, there was a lot of good stuff that she was bringing in. And I think ultimately it was unanimous, if I remember rightly, when we discussed it. We talked it through – we knew there was a risk involved, but we felt it was a risk worth taking. And what we really wanted to show, was that, you know, again The Arches are supporting progression through the organisation, because a lot of people had worked their way up through the organisation. And we were proud to give people that opportunity. So it made sense to give Jackie that opportunity.

LJ FINDLAY-WALSH

I went from arts administrator, which ended up morphing into a performance producer's role, rather than an arts administrator. And then I got the producer, programmer type role when Jackie moved up. And then the beauty of that, is that Andy was just so clear…or just stuck to his ethos of what the place was, he allowed a lot of passionate people to drive it. And that idea of him not being hierarchical or patriarchal in that sense, I think really allowed it to flourish. So him leaving and absolutely supporting the people who were in there taking it over was a beautiful thing, and really worked for the building. I don't know if everyone would agree with that though!

BLAIR SUTHERLAND

Jackie had big boots to fill following Andy, but I think she done a great job. And tried to take it in a different direction, which is what I would have done. But such a tough time for her to do it because of various things – I said to her before she even got the job: 'Make the job your own.'

MARK ANDERSON

The minute she got the job, it was like, 'Right, this is what I'm going to do.' And it was like, 'Actually, can we discuss that?' And that's where there was a bit of early friction, if you want, and the challenges never really stopped, but that was not Jackie's fault, and not my fault. It was just because we had a job to do. And clearly, as a newly appointed co-Chief Executive, as well as Artistic Director, you know, she wants to make her mark on the organisation. There were challenges in the way… but ultimately, I don't think the organisation really suffered, I think the organisation benefited from it – and as I say, that competitive nature: the commercial demands versus the artistic impulse. Everyone almost came to the diary meeting with their badges of honour: 'But I've got this, we need to put this in…'

JACKIE WYLIE

The thing I wanted to change or tried to bring to the shift, or the difference between me and Andy, was using the resource of the Arches Theatre Company to do international work. I think Andy's driver was

making theatre that was informed by the architecture and atmosphere of the building, and my driver in terms of the art that went on was: what international elements can come into this building so that the local artists and audiences get to see something that they've never seen before and have their minds blown? And again, I think it's quite amazing when I think back to those theatre festivals we programmed and you would have world-renowned companies like Akhe and The Team and Pan Pan, and then you'd have [legendary Russian artists] DEREVO doing something with paint and body parts and giblets or whatever it was, all actually happening at the same time as part of one festival. And then you'd have Kieran Hurley making a show about rave! Having the existence of those international influences alongside local work was really, really important, and actually looking back – those international companies would come over, and then we'd take them to Death Disco on a Saturday night!

How amazing that those theatre artists would come over, put their shows on and then have this social space. And actually, the influence of those artists is so much more profound because they did get to socialise with local artists, and they did get to be in this subcultural space. How validating, somehow, to be in The Arches was, really – the fact that something could have this reputation globally but also still maintain its subcultural status. I can't think of any other institution like that – that this is a global power when it comes to art and music and pop culture, but also you are completely accepted into it, regardless of who you are. There's always a transaction, normally; status is usually about exclusion, isn't it? Often with arts organisations or arts buildings, it's really hard to unpack who is allowed into them, or what the invitation to come in is.

NIALL WALKER

The arts programme and theatre programme certainly shifted to a more European, international sort of thing, I would say, when Jackie took over. I know it had happened before, but once Jackie took over I did start to see a lot of urination on stage! And you know, LJ has taken that baton and it's still happening at Take Me Somewhere [the annual

international arts festival that Jackie built out of The Arches, of which LJ is now Director]. Yeah, a lot of blood, a lot of piss, a lot of swearing, a lot of drag, a lot of glitter. So yeah, a lot of that came in, from 2005 onwards. Whereas I would say Andy is a twentieth century guy. That's not a criticism – I think he's a huge fan of twentieth century work, and there's a lot of it. There's a lot of really good stuff that still deserves to be shown and explored, and I feel that's kind of what he does in many ways. Whereas Jackie was absolutely a new millennium-type Artistic Director, so yeah, that was definitely an era change.

LJ FINDLAY-WALSH

When we first started out, some of the programming was really couched in [traditional] theatre – as much as it was very often site-specific or promenade – I remember that first Arches Live that I worked on followed more of that route. I don't remember me and Jackie having this conversation directly, but what I see now is that we were immersed in clubbing culture, we had one foot in clubbing culture and one foot in artistic practice, then the programme started to respond to a kind of irreverence that you maybe associate with clubbing culture: an 'anything goes', an anti-establishment kind of value system that was started by Andy but taken further. And I think that ended up being seen quite clearly in the programme as it shifted. And that's something to celebrate – that a lot of people that were working on the programme also had a foot in both camps as well.

KIERAN HURLEY (*Playwright, Arches front of house staff 2006–2009*)
I had started working in the cloakrooms in my third year of uni. I had been going to the club, but on the kind of younger, more studenty end of things with Death Disco, and I had been going to National Review of Live Art, some of the contemporary performance, that kind of stuff. Working there coincided with a time in my life when I started going to Pressure regularly as well… and working there was important in that, in terms of opening me up to that a little bit more, I think. I remember saying to Jackie, who I only knew a wee bit at the time, from parties and stuff – I said to her that there was probably only two people in the whole building who had an exactly mutual

interest in contemporary performance and techno. And it was me and her! Everyone else went one way or another, probably. And it was me hanging coats and her fucking running the theatre!

But yeah, it was quite unusual. Everyone was always trying to get their names down for the most popular shifts. The cloakroom and the front of house department were the same staff department, and the department could easily be divided into young people who liked the nightclub, and young people who were students of contemporary performance and theatre. So that first half were always like, 'Adam Beyer is playing, I want to get on that shift,' and then the second half were all like, 'Taylor Mac is at Behaviour, I want to get on that shift,' and I was probably one of the only people who was putting down requests in both directions.

LJ FINDLAY-WALSH

I think the Theatre Festival had become Behaviour organically, before it was renamed Behaviour. That was just in recognition of the fact that it really had evolved into something quite specific for the city. Something that was heavily international, a real mix-match of new writing and live art practice, which you don't always get.

It was Jason Edwards [Music Programme Assistant c2008] who came up with the name 'Behaviour,' on an Arches night out. So there you go – that's how the best decisions were made. And then of course there's something about the name 'Behaviour' that really spoke to the moment, because of course it speaks about the human condition, but it also speaks about mischief and bad behaviour, and I do think that The Arches was seen as that from the outside. And maybe we all enjoyed that on some level – the kind of renegade aspect of what we were doing. The bad behaviour, perhaps. The being left to our own devices.

But I think Behaviour really put The Arches on the map in terms of our international dealings, and our international profile. And some of the artists that were coming to the Arches were well beyond what we could pay. You know, they would get much better fees elsewhere. The fees that we were able to offer were relatively paltry compared to some of the bigger festivals. And I think that what we were really good at

was inviting artists and companies just before they went stratospheric. It seemed to happen all the time, to be honest. Even Ann Liv Young came and presented at a relatively early stage in her practice. [US Playwright / performance artist] Taylor Mac – another good example. It takes a lot to get Taylor Mac now.

Jackie and I used to joke about how we knew we were punching above our weight in terms of getting some of these artists back, but we had offered them such a good time and such a good party, and had really brought them into what we considered to be The Arches community and The Arches way of being, and that that offer separated us from the crowd. And we often got artists back that we wouldn't have had otherwise, if we'd gone down a more traditional method of how you host artists. It often wasn't traditional. But yeah, lots of those relationships….like, with Taylor, it was important, because you don't just fall in love with the work, you do fall in love with the artist. It's hard not to create those kind of relationships. And at that time, and space, we had the time to invest in that way.

But yes, it's interesting about the relationships you make and then how that sort of drip feeds down into the sector at large. You know, The TEAM's work has been majorly influential in Scotland. As has Ann Liv Young's, as has Taylor Mac's, as has Tim Crouch's.

TIM CROUCH *(Playwright, theatre director, actor)*
Vivid memories of an office powered by the luminous presence of Jackie Wylie and LJ Findlay-Walsh. A young, predominantly female team that seemed to be genuinely alive to the boundless possibilities of what they had in their hands. With some venues, the arrival of the company/artist feels like an interference. At The Arches, I felt like a valued playmate they'd all been waiting to play with. A lot of laughter but also an absolute and absorbing commitment to giving the work its best setting.

LJ FINDLAY-WALSH
I think the beautiful thing about The Arches, and the thing that I've taken away from my experience at The Arches and taken into how

I work within Take Me Somewhere and so on, is that it isn't really a top-down approach in terms of what we presented, it was really responding to the innovation that already existed within Glasgow. Just really keenly immersing yourself in what artists are doing in the moment, from a very early point in their practice. We were also really immersed within the artistic community that we were also trying to support. So that notion of community really started to permeate how that festival ended up. Which was kind of like a life raft – it was like, 'if we've got space in the corner for you and you still want to come, then come.' Because literally, we recognise this to be an important platform and we'll throw whatever we've got your way. And it's not a way of working that I'd condone now, like…I'm so establishment, I'm like 'pay people properly! You can't chuck someone in a corner and give them ten minutes of tech time, a bucket and a ladder!' But there was something to be said for it. It felt like a democratic space, because it wasn't just like you'd curate something and then stand back. I mean, we were so short of people to work on different shows…I remember Martin O' Connor's production…we were presenting it in the boardroom. Obviously not a particularly brilliant space! And he was doing a show in there, and we had to have a tea party with people. And me and Jackie were behind the door making the tea! And it was extremely ramshackle and also extremely exciting.

KIERAN HURLEY

One of the things about Glasgow and Scotland as a scene or sector is that it's small enough where you just need to be loud enough, when you're young like that, for someone to….well, that said, I don't know what we'd be doing now that an Arches doesn't exist, but at the time The Arches had a specific remit for supporting experimental, new, emergent work by unheard-of local artists. So it was absolutely a remit that existed that doesn't exist anywhere else now.

And it was Jackie's job to give support to those sorts of people. I was in a student theatre company; she gave us a 'Scratch' slot [a night where artists could try out new ideas and get feedback from a live audience]

and we just fucking scuttled about being mental on stage. And then the next thing that came out of that would have been an Arches Live show with that big tribe. So it was a bit of a journey there from a Scratch to an Arches Live show, that the building was able to support by just giving us free rehearsal space, and we just made all our shows in these dark basement rooms next to a toilet in a nightclub in the city centre. Because that's what you did. And all of that was while I was working [in the cloakrooms] at The Arches. Then I graduated and had this sort of crisis of 'What am I doing', and I was helping out on front of house at the time. So I thought, I just need to make a solo show. Because it was an entirely practical response to a situation where I didn't know what else to do! And that is what was in front of me: 'I just need to not be tearing tickets at the next Arches Live, I need to be doing a show at the next Arches Live, it's as simple as that.'

LJ FINDLAY-WALSH

I think some of the interesting things that happened is that Arches Live…you know, it's not like it all existed in a bubble and then dissipated. The beautiful thing about was that these were really… sometimes really early career artists that were coming with their first show – not even outside of graduating, it was just like a development of their graduation show. I remember seeing Gary McNair's first show – that ended up being developed further and ended up making it onto the Traverse stages. So these absolute nuggets of incredible work that could be absolutely catapulted from shoving it in some dark, gloomy space in The Arches.

ROBERT SOFTLEY GALE *(Artistic director, Birds of Paradise Theatre Company) [Taken from 'Theatres That Made Us', The Guardian, 23rd July 2020]*
There was a group of theatre-makers in Scotland in the 2000s and early 2010s who were all working at The Arches. The place stank of fags, booze and many bodily fluids. We loved it.

In March 2012, I was to premiere a new solo piece there called *If These Spasms Could Speak*. Jackie Wylie, now National Theatre of

Scotland's artistic director, wanted to programme me as part of their Behaviour festival. I thought she was nuts – I'd never written anything before.

The writing process was hell – I was stuck in front of a laptop doubting every word I typed and thinking it was all shite. The first night preview went well but on the second night the press were in. One scene into the hour-long show I got a massive unexpected laugh from a gag and then I completely dried. Couldn't remember my own name. Wanted to crawl off stage and die in a hole. The show went on to do more than 100 performances in four continents. I still miss The Arches.

RICHARD GADD *(Actor, writer, director)*
It felt like a place of pure acceptance, that didn't cater to the pomp and ceremony of the predominantly white middle-class audiences like most theatres do. It didn't care about celebrity, or the 'big sell'. It cared about taking chances and making challenging work that pushed the boundaries (and buttons) of normal theatre-going audiences. It saturated itself with a million different festivals and all kinds of art, so that there was something for everyone, as well as a chance to be seen regardless of who you are or what you were doing. Everybody got a chance, regardless of whether they brought in an audience of two or an audience of two hundred. That was what was so great about it. It placed opportunity at the centre of everything. There was an open-door policy, which is so far removed from the elitist way a lot of theatres are run. It gave the fringes of society a stage smack, bang in centre of Glasgow. It quite literally felt like the centre-stage of Scotland sometimes, with a passing trade that was the envy of every other venue in the city. To me, that was the paradoxical beauty of the place. The seats filled themselves and the young artists blossomed as a result.

KIRSTIN McLEAN *(Actor, Arches Award for Stage Directors winner 2004)*
A place to try and fail, or try and succeed. The space to investigate, to contemplate, experiment, make a mess, find my voice, try on other voices, fuck it all up, start again… all of which is so important for the early stages in any artist's career. And the wonderful thing was, you were never alone. There was always a hoard of others rehearsing

simultaneously and we offered support, critique and conversation to each other. One such artist was Adrian Howells who was usually there or thereabouts and while producing profoundly moving work of his own, he was always able to be generous and incisive when being an outside eye for others. And of course, we all learned from each other's work. (We perpetually asked each other: is it good to pause and acknowledge when a train passes noisily overhead, or just ignore it?) Anyway, amongst us, we made many great things, and of course, many terrible things too. To paraphrase Adrian, it was all allowed.

NIALL WALKER

I first met Adrian when he was doing *Adrienne's Dirty Laundry Experience*, and I went into the downstairs dressing rooms and here he was with his bleached blonde hair, and of course he was dressed for the show, which was wearing a pink blouse and then what you call a tabard – which is one of those blue things that cleaners wear. And he had big clip-on earrings and all this make-up on and everything, and I said to him, 'I hope you don't mind me saying this, but you look just like Pat Butcher.' From *EastEnders*. He was kind of completely mortified, but also thought it was hilarious. And he told his friends, and they called him Pat until the day he died, basically. They just called him Pat, that became his name. I remember seeing [that] first show, and just thinking it was hilarious. You know, it was just so funny but also thought-provoking. Most of his work – whether it was that one or *An Audience with Adrienne* or *Adrienne's Salon* – he always did that thing where it was fun and camp and all the rest of it, but then he'd throw in something really quite dark or thought-provoking at the end. When he did *An Audience with Adrienne*, and it was all very audience interactive fun, jokey, and all the rest of it, and then it ended with him just completely stripping naked, and showing us that he was a man, and then getting dressed in his normal clothes.

He seemed to have made Glasgow a home, certainly a cultural home. I suppose it's interesting that The Arches, being a massive building, became synonymous with one-to-one theatre works! Because there was quite a lot of that, actually, that happened at The

Arches, and that's what he was known for – or intimate work. So it's interesting, because actually, in many ways, in another world The Arches would have been about big… and it did have its large promenade shows and all the rest of it, and it was known for that in a way, but actually it became just as known for its intimate either one-on-one or small group work and all the rest of it.

NESHLA CAPLAN *(Box office assistant then manager, 2006–2009)*
I've got so many great memories from my time at The Arches. A cheeky bonus of working there was getting to see previews. One I'll never forget was my one-to-one with the incredible Adrian Howells: *14 Stations of the Life and History of Adrian Howells*. It was just me and him, going on this promenade journey through this massive cavernous space. What he managed to do was extraordinary, he made every 'station' feel tiny, so incredibly intimate that I got totally lost in his moments of confession. Lost with him in a building that until that moment I thought I knew so well.

LJ FINDLAY-WALSH
Adrian is entirely entwined with The Arches story. He wasn't just an associate artist. He embodied how to redefine what's possible in terms of an associate artist, or an artist-in-residence. Because he didn't just come and reside, he affected the culture of the building. When Adrian came on board, The Arches became much more 'Adrian'. So it was less about how we did things, and more about what he could show us about how he worked.

And then, of course, Adrian came in and affected our every-day. Adrian would come into the office, and there was no way you would ignore him. He carved out space to….relate, chat, have a laugh. There's not anyone else who could come in there and ask me to down tools in terms of what I was doing, because we always worked at such a pace, but Adrian changed the pace of work when he was about, for good. I think we could all learn from that.

So yeah, Adrian coming in with the cakes and drink trolley, dressed up, offering us cake and tea. Coming in to discuss his love life. That

was an important part of the day to day of what it meant to have an artist-in-residence, as it turned out!

NIALL WALKER

I mean, bloody hell, you never met anyone who made you feel so loved and welcomed and warm as Adrian did. Anyone he met, he'd make them feel special. So yeah, it's incredible.

He was just such a great person to have around. My favourite memories of Adrian are him arriving in The Arches' office. You would know when he came in the door, even when you couldn't see him. Like, because my desk was around the corner, but you just knew when he came in the room. Because immediately it was just like, *(big, enthusiastic voice)*, 'Hello!' Whether it was to the cleaners, or Mark, or to anyone, he gave them 100 per cent, and the mood just completely lifted.

JACKIE WYLIE

There's all that international work, and then the other bits I was really proud of was when the arts programme came together with other elements of the programme. Some of my best memories are of Adrian Howells' restaurant takeover. If I was to go back and think of all the things I loved, I don't know if I would be, 'Oh it was DEREVO and Akhe doing a spectacular thing...' In a way, I think I was probably most proud of Adrian tottering around the Café Bar selling gammon and pineapple.

LJ FINDLAY-WALSH

And also, the beautiful thing I remember about Adrian is when we were doing *May I Have the Pleasure*...us all sitting in the corner of The Arches office, and Adrian just lay bare his artistic process to everybody. Everyone was going to be part of the decision making, and the questioning, and helping him get to where he needed to be with the piece. It wasn't a closed shop...that wasn't the place we were meant to be having the conversations...you know, usually you would be down in the studio and you would demarcate the time. But Adrian just brought the work into the everyday. And it didn't matter who you

were – you were part of it, if you were present! You were coming in to talk about whether that was the right title for the show. You know – who should he dance with at the end? All of these things.

NIALL WALKER

When he did *Adrienne: The Great Depression* – it was an Arches-affiliated show, but it was in a hotel room at the Brunswick Hotel. It's tough for me to think back on, because what I experienced in that hotel room in the Brunswick... It was an audience of three. And you walked into this hotel room, it was basically like... stinking, clothes strewn everywhere, bed a mess... and he's just like lying on the bed, completely out of it. And then eventually he wakes, and talks to you, and talks about his depression. And he's in kind of post-drag... you know, he's had make-up on and it's all a mess.

But it's tough because... that's exactly what I experienced, the morning [in 2014] that Lucy [Gaizley] and I found Adrian dead on his bed. We walked into his own room, and it was like that. Except he was lying there and he didn't get up and perform a show. He just stayed there.

It immediately made me think it was like déjà vu – this is reality imitating fiction. Except, of course, *Adrienne: The Great Depression* wasn't fiction because it was all about his own depression, so it's all these blurred lines and stuff.

I think we were very lucky to have him, basically. I think Glasgow was lucky to have him, I don't think it was just The Arches that had him. He was involved with a lot of things up here.

GEORGE MACKENNEY *(Front of house staff, duty manager, operations manager 2005–2015)*

I still find myself thinking, 'What actually happened there?' But isn't it strange that there is sometimes comfort in accepting the fact that not everything can be accepted? Perhaps that is the inevitable conclusion of what the brilliant and fabulous Adrian Howells used to say: 'It's all allowed.'

Remembering Adrian is a beautiful thing. Away from the somewhat indulgent reflections on The Arches as some sort of trip-like metaphor for life and how it manifests, it is the memories of people that I accept warmly into my heart. There were literally millions of them, with different lives, loves, experiences and tastes. What emerges most strongly from the 'space-between' are the people I met there who remain in my life. They are now family and that makes every moment worth it.

TIM CROUCH

It feels like The Arches invented relaxed performances before they were a thing. The space responded to relaxation. The transaction between audience and stage felt porous and generous and real... In the spirit of Adrian, it was all allowed. At The Arches, it felt like everything was allowed.

The last time I was there was in April 2014 for Adrian Howells' memorial. After the most heartbreaking event in the University chapel and bluebells thrown into the Kelvin, we all bundled back to The Arches to drink and dance our sorrow away.

JACKIE WYLIE

The Arches and the arts programme, and actually all of the corporate programme, the club programme – it was like the alchemy of the impossible. Especially now, having had different experiences of putting on theatre, looking back... the extraordinary nature of what was actually achieved within the resources that we had... it was some kind of mystical... I don't know, those conditions... I suppose alchemy is everybody's personal energy.

The fact that we couldn't quite unify as a team, around the fact that we were all alchemists of the impossible, is quite a sad thing to me, in a way. You can look back on all these extraordinary things that happened, but at the time we couldn't quite all see that we were all driven by the same thing.

MARK ANDERSON

Rob as Technical Manager did his best to accommodate everybody. He was so great, he was a sweetheart – he didn't ever want to let anyone down. Likewise Front of House, of course, you know – it took the buy-in of everybody, and that spirit… 'Yeah, we might be arguing, but we're a family here, let's make it work. Let's do our best to make it work.'

JACKIE WYLIE

The reason we were all so close as a family was because we were doing things that normal people would be like, 'that is not possible to do', within the timeframe and the budget. The bonds were to do with believing that something could happen. And also, this sense of being together in one space where the values were understood – the values being about community, in the sense of everybody being accepted and included.

But also, as a family, we had fights, let's not put rose-tinted glasses on the whole thing. There was so much conflict around scheduling and priorities and the whole thing about the clubbing generating the income that fuelled the art, so there needed to be more clubs: if you think about the paradox of it in logical terms… the clubs were necessary to fuel the business model but the more clubs there were, the less art could happen. Even though the purpose of the clubs was to make the art possible! That is a business model that is so fragile, actually, because it's so inherently complex.

ROB WATSON

As I say, there was a turning point for me where it would be that alleviation of pressure – or the realisation of the alleviation of pressure, rather than euphoria. Because we did it, and nothing happened, and we were alright. So it was the euphoric relief that we've just managed to do it by the bones, rather than the euphoric high of being able to add extra bits… you know, put the cherry on top of the cake. We just managed to get the cake baked and get it out to people, rather than being able to do something really, really special. It was perceived as special by those who got it, but for us that was the frustration… that

the cake was always warm as it went out. And that was a kind of hard part of it. But again, there was no awareness of that in the Tuesday meeting – Mark Anderson was always like, 'That was great, that was brilliant, we can do that again.'

Which is where we then really had to start playing the health and safety card. And that was it. It felt shit, but I think it was just what you had to do. And I had to start saying to them in those meetings, 'I don't think we can do that safely.' And Mark was like, 'Come on, why are you being like that?' And I was like, 'Because I don't, I don't think we can do it safely. That's the point of this. I get that you want as much in here as possible.' But Mark wasn't looking at the artistic benefits of what we're doing from Jackie's side, and Jackie's not looking at the financial benefits of what we're doing from Mark's side. And that's where it felt disparate, that's where it felt like a disparate organisation rather than that understanding that it's all punters – it's everybody that's getting an Arches experience when they come through the door. Which should have been the crowning glory of what we did, you know?

But there is that part of me that also thinks the nature of what we did then is what created it. If we were a bit more reserved or conservative about what we chose to put in – then would we still have that great volume, would we still have these stories to tell people?

BRIAN REYNOLDS *(Music programme manager, 2008–2012)*
More could and should have been done to reduce departmental tensions across the whole place and I've tried to apply those lessons to my own company. I remember at one point it seemed to me like LJ and I were being set against each other. Which was upsetting – I don't think those responsible knew how strong our relationship was. It's even stronger now. I didn't need my events to happen – any venue of that scale should have in employment a booker as hungry as I was. What we required was an effective system to analyse the options available and for somebody to make executive decisions about what was to happen and what – regrettably – couldn't. There was usually no perfect outcome given the options but the process we had wasn't fit for purpose and as an organisation we were resistant to change. My

emotions can be read like a book and I do have the ability to negatively affect the mood of a room if I'm not happy about something. I'm more aware of that now but probably only slightly better at managing it. Jackie and LJ, on the other hand, are some of the coolest people I know and manage to handle extremely difficult situations with care, respect, diligence and grace. They are seriously tough women. I've always truly admired them.

Then there was the night of the Faithless Sound System. A genuine nightmare production transforming a 27-room Russian theatre production into a Faithless gig/club for 2,300 people. Wild. I don't miss wrestling with other departments for use of spaces! Our Ronnie [Phipps – assistant technical manager] had promised the Russian team they could use the stage and we just had to run with it.

THE LIST, 5th Nov 2009, Issue 643, feature 'Natural Limits', by Kelly Apter
'As partnerships go, it couldn't be more perfect. One of Scotland's most unusual and atmospheric venues effectively handing over the keys to two of the world's most unconventional theatre companies. What the performance will look like is still anyone's guess, but one thing's for sure, when DEREVO and Akhe start running wild around The Arches, it won't be dull.'

KIRSTIN BAILLIE (*Front of house staff, 2009–2015*)
I loved when theatre companies would take over the full building and use every room as a set, each room connected by a theme but on their own, a vast and intimate world awaited. One time each room was turned into a different segment of the female brain. Punters would make their way around the building opening doors into the unknown; I remember one woman gaffer taped to the wall.

ROB WATSON
I had taken a couple of days off, Ronnie was assistant tech manager at the time. I had said to Ronnie, 'Arch 2 is Faithless, regardless. Arch 2 needs totally earmarked for Faithless. So we can build it during the day. That gives us Friday and Saturday during the day to build their

show, get everything they need in place. DEREVO and Akhe can have the rest of the building and the basement.' I came back from a couple of days off, and Ronnie said that Jackie had browbeaten him into using Arch 2: 'They need Arch 2, we've promised them Arch 2... so DEREVO are getting Arch 2.' And I was like, 'Fuck, this is going to push us behind.'

So they got it, they built that big multi-door thing with the platform in Arch 3 west. And this is the...mismanagement is a bad word to use, I suppose... but the struggle with it, as the place lay bare over Thursday, Friday, Saturday during the day, there was nobody in, because we were waiting for the DEREVO show at night.

MARK ANDERSON
I was there! I absolutely loved DEREVO, they definitely provided two or three of the best shows I ever saw at The Arches, the productions were just gorgeous. But that night lives really strongly in my memory because that was on a knife edge as... could that be done? And we weren't just talking about a small club night, it was Faithless, one of the biggest dance acts around at the time.

DAVID BRATCHPIECE
DEREVO had built all these massive doors throughout Arch 3. I think that was the first time I was looking at something going, 'We can't do this, there is no way we can turn this around in time.' Under Rob's direction, as soon as the last audience member had walked out, all these people descended on the stage...

BRIAN REYNOLDS
I think we had thirty crew on it. In real time, the changeover looked like a sped-up video.

ROB WATSON
In a bid to get ahead, we'd set up the monitor desk in Arch 2. And I had asked Kev White to mark up the channels in accordance to what Faithless had. So he marked up the desk – you know – kick snare, hats, overhead, blah blah blah. He failed to realise that channel 12 was dead

on the multicore. So there was no signal passing through channel 12. Channel 12 was taped up on the multicore stage box, he'd marked up the desk, so every channel from 12 onwards was one out – it was 12 into 13, 13 into 14, and so on. We were sitting trying it, going, 'Nope, nope, nope.'

Rick Pope, he was the engineer. He's Jamiroquai's engineer as well. So they're getting pissed off – he was sitting going, 'This is fucked, what's going on? Find the fucking channels.'

And [then] Chris came up and said, 'We're at capacity, we're at 812 in Arches 5 and 6. People have been queueing outside for an hour. We need to open up. We need to open.' And Rick Pope was going, 'Well, I'm not getting the band up until you find these channels.' And the tour manager was going, 'What the fuck is going on? This isn't cool.'

BRIAN REYNOLDS

We almost nailed it except one incorrect patch swapping Channel 5 out for Channel 6 and causing a forty-five-minute delay while they identified the issue. Uuuuurrghghhhhhhhh. Huge crowds outside. Arch 5 and 6 at capacity and a huge pressure to open the doors before it was ready.

ROB WATSON

And at that point, or just after it, I remember clearly Sister Bliss went up on stage with a DVM 1000, which we'd hired from a place called Soundcare in Liverpool. It was a kind of DVD mixer. She was like, 'This isn't working. It's not taking any of the visuals, it's not taking any of the disks.'

And at that moment I was like, 'I could just bolt. I could just run down the lane and run away, I'll just go!'

The solution was to get the two bits of uncovered Heras between the middle bar and Arch 3, and open up to that part of the building.

I put Kev Eadie on the monitors, and he was like, 'There's nothing in 12, there's your problem.' So Kev got that sorted. Scott McDonald,

my nemesis for so many years, was like, 'Sister Bliss, I'll do it. What do you need me to do? Just give me a list.' So he sat down with Sister Bliss going, 'Right, track one intro, track two…' and he took over all the DVD stuff.

And that was it, the gig fucking went okay!

BRIAN REYNOLDS
That was stressful though it was a great night. The agent was genuinely furious with me!

DAVID BRATCHPIECE
When Faithless finally took to the stage, Maxi Jazz bumped his head on the way up and for a second I thought the gig was ruined! After all that! But he was fine, total pro, went up and stormed the gig.

ROB WATSON
And even with the punters – they were getting to see something that they wouldn't normally see. Normally we had drapes to cover everything happening backstage. The drapes were open at this one and they'd seen people running about going mad trying to get it all ready. They were up at the fences going, 'Waaaah!'

MARK ANDERSON
And yeah, it was remarkable. And that embodied the spirit of the team at The Arches. I got involved. I was there for the DEREVO show, and I was there to make sure we got it turned around in time, and I stayed for the Faithless show, and it was brilliant.

I actually get wee shivers thinking of that night, and how amazing it was. And then I'm starting to get angry thinking… how the fuck was that allowed to stop.

ROB WATSON
I do have another theory in terms of the alleviation of pressure. When you're working towards what seems to be an almost unachievable goal – ie, a one-hour turnaround from DEREVO into Faithless – the

pressure is on, and that makes you work harder. It doesn't necessarily make you work any better or safer, but it does make you work harder. And the achievement of that goal – when you get the doors open – and this is one of the things that was kind of hard to temper or quantify… because when you did it, 'Fuck, we got it, we're done here' …and the alleviation of pressure meant that it was almost euphoric.

KIERAN HURLEY

Working there when it was really busy was obviously hard work as well. The queues were mental, the folk were mental. As well as that slightly more chaotic aspect of it, there was a really well-oiled machine that was the best place in Scotland for running mass events full of absolutely munted people. And that showed. Like, security knew what they were doing. Front of house staff, cloakroom staff knew what they were doing in terms of clearing out massive crowds of people. You know, crowd control, informal crowd control, stepping out and directing people where to go and that. It was a really well-oiled team of professionals, but it was also staffed by people that really liked to party. And that showed, you know? It was both of those things at once.

Working the really busy nights was all dependent on the character of the night. You just got much sounder chat at Inside Out and Colours and Pressure than you did at Death Disco. That was simply the case.

KIRSTIN BAILLIE

Working in the cloakroom was always a laugh, apart from the MWI masses returning with no tickets, only animated jaws to point us in the direction of their jackets. Stuck in a small space with five other people, it's hard not to form a bond. We could guess how much tips we were going to get by what club night it was. I looked forward to working Colours nights the most, they were the most generous.

KIERAN HURLEY

For, say, Inside Out, a lot of these people aren't from Glasgow – they're from East Kilbride or they're from further out still and they're getting the train in and they're getting a hotel and it's like they've really saved

up for this one night, and it's the one big thing of the month and they're going to absolutely blow out but everyone they meet is going to have a brilliant night as well, and they're going to spend all their money. And that has been the decision that has been made. Whereas it's much less like that if you live in Garnethill and you're nineteen years old, do you know what I mean? The archetypal punter at Death Disco was a nineteen-year-old art student who's taken pills for the second time in his life, and is absolutely flying and is disgusted at you for not knowing where his coat is, even though it's him that's lost his ticket, and his face is all gurning. Whereas at Pressure or Inside Out, you've got a hardened pill-head who has taken eight times the drugs of that art school student, and who is in absolutely every bit of a state of crisis because he's not got his jacket and he doesn't know where his mates are and doesn't know how to get home, but he's just like, 'That's alright! I'll chat to you! Cloakroom guy, sound as fuck. I'll chat to him!' And that's his response to the situation. So the character of each different night was entirely different.

To be honest I actually think, in retrospect, that's part of what got me more into going to Pressure than going to Death Disco. Because Death Disco was marketed at people like me – arty, studenty folk. And I think it gave you a sober perspective on what these two different scenes were, that made one of them much more appealing than the other, I think.

My interest in UK rave as a cultural moment was something that I developed and I grew through at The Arches; it was absolutely inspired by clubbing, which was my generation's articulation of that subculture. There was something about how the 'Kill the Bill' scene spawned the kind of party protest movement and Reclaim the Streets and all of that kind of thing, and it sort of like influenced the culture and shape of direct action and anti-capitalist activism for generations after that. I'd had a successful show [his CATS Award-winning solo work *Hitch*, in 2009] and Jackie and LJ had asked me what I wanted to do next. And I said, 'I've got this idea for doing a show about raving.'

LYN GARDNER *(Theatre critic) [Taken from The Guardian, Edinburgh Festival Fringe Review, Mon 20 August 2012]*

Kieran Hurley's layered coming-of-age story *Beats* [uses] sound and video to hark back to life in the small Scottish town of Livingston in 1994, the rave scene across the UK and forward to the student protests about cuts and tuition fees on London's Millbank in the winter of 2010. It is a deceptively simple show, but one that's always making connections, not least between the idea of running riot and the mad delirium of dancing. Does each generation have to find its own way of protesting? Why do we keep having to fight the same battles? How can you really understand your history when it's written by the victors? How might the youthful energies of raves best be harnessed?

Given its noisy subject, this is a surprisingly quiet show – albeit fierce. Sitting at a table, Hurley gently tells the story of 15-year-old Johno [and] his sad, worn-down mum. The mills have closed, the battles have been lost, but one day Johno heads out of town to a rave – his first. Maybe also his last, because the 1994 Criminal Justice and Order Act made it illegal for people to gather to hear "amplified music which is wholly or predominantly characterised by the emission of a succession of repetitive beats". DJ Johnny Whoop is on hand throughout the show to ensure that is exactly what we are doing… What makes the evening more than just another growing-up monologue, like so many on the fringe, is the layering and the questions that hang in the air. What does community really mean? How can we really care for each other? Most crucially, it prods at the links between freedom of hearts and minds and the freedom to gather in public spaces. It asks whether we want to live in a society where it is illegal to dance, and questions whether dancing alone is ever enough.

KIERAN HURLEY

There's a ladder there, that doesn't exist for people anymore. Where I did a Scratch night as part of a big student company, and then that same big student company did an Arches Live, that meant I was known to the building. I was in a place where I could then do an Arches Live as a solo thing for my first full credit. And then that went well, so I

could apply for [The Arches' biggest theatre award] Platform 18 for *Beats*. Platform 18 went well and was already designed to introduce me to other venues, other new work venues beyond The Arches – to The Traverse, to the Fringe. And it did that. So, I then had a UK tourable level show, that one of the artistic directors at The Bush in London saw and liked at the Fringe and wanted it for his first ever Radar Festival. Straight out of that, we're taking it down to The Bush in the same year. So I'm getting my first thing on in London. It was only on for three days at The Bush, but one of the people that saw it there was Brian Welsh, who had, independently of meeting me, had decided that he had wanted to get out of telly and back into film and make a feature film about the rave scene in Scotland… when he saw *Beats* in London, which he wouldn't have done otherwise. And so he contacted me about adapting it into a film.

That's like an industry connected ladder over five years. From student to making a feature film. [The film adaptation of *Beats* premiered in 2019.] That is completely impossible without The Arches. Like, just completely impossible. I've described it before as a series of chance incidents that were good luck. It is that, but it's also a consequence of a resource and a strategically considered ladder for career development for young artists. And a building to provide a home to it. And, like… that doesn't exist now. And that's mental, if you think about the people that could go on that ladder, that are not, because it doesn't exist. I'm very very fortunate to be of a generation of people who were the last in the door for that, I think. And I don't know… I'd be doing something else otherwise. Without a shadow of a doubt.

DAVID BRATCHPIECE

By this point we had a new midweek club, Octopussy. It was a student club and had a bouncy castle, a wee chapel for joke marriage ceremonies and a swimming pool, which was actually a giant paddling pool. Drunk students swimming and bouncing on a castle is quite an odd thing when you had come up through dark-edged techno nights like Slam, like I had.

Octopussy started small but grew quickly, and was eventually the biggest student night in town, especially the Halloween ones, which were utterly mental. One time we had to split up a fight between a Ninja Turtle and a Tellytubby. I think the Tellytubby won, which is surprising. I wasn't a fan of the music personally, but Johnny Whoop, Arches techy stalwart who had worked with Kieran on Beats, always closed it and did brilliant sets – like, it would be chart tunes earlier on and then Whoop would come up and play Tiga and Green Velvet and all that.

It was always a tricky turnaround getting the place ready for Octo… sometimes theatre customers would be going into the studio and we'd be outside frantically filling up the pool with maintenance Graham [Gunn], an absolutely brilliant guy. And the theatre crowd were like, 'What in the name of fuck…' On one of my very last shifts, I got thrown into the pool by the security team. I didn't mind though, it was funny. I just nicked a T-shirt from lost property and stuck that on instead.

NIALL WALKER
I struggled a lot when Octopussy came along for that reason, to be honest – I was never a big fan. But again, it all seemed to be about making money by that point. It was like, okay it's making money so it's great. And I was like, No it's not – it's lots of people getting absolutely hammered and running around in their pants, it's just stupid.

DAVID BRATCHPIECE
So yeah, Octo was kind of a different crowd for the Arches, with its own challenges. Some brilliant nights, but a feeling amongst some of the longer serving Arches staff that it represented the shift going on both in club culture, and The Arches itself.

By the 2010s, things were getting harder in the club as a manager. Drugs were changing, things were getting a lot more unsafe. It's a whole different discussion but drug laws in Britain are archaic and they don't make sense. Younger people were coming in – and we were

really strict on the door – but it's no secret that The Arches was the club people came to get to mad with it.

I could see a new generation of clubbers coming through, and they'd maybe have banged a couple of pills in the queue, were fine going through the doors but then full-on collapsing when they got inside. Increasingly seeing some horrific things in the first aid room. For the whole history of the club people have always taken pills, but they'd always been a bit more able to look after themselves. The states that we were seeing people getting into was something new. We were thinking, This is a different thing.

NIALL WALKER
You could definitely see eras in the clubbing world changing for sure, and I think by 2010 all clubbers were interested in was seeing a big name like Calvin Harris or Sasha or whoever on the bill.

DAVID BRATCHPIECE
Alien War came back in, in 2008 and 2012 – it was Gary running it again. This time it took place in the basement – half the basement had been done up in the refurb, but there was still a nice spooky derelict bit at the back. It was hugely popular – I reckon a lot of the crowd must have been the children of the folk who went to the first one! Great show and great actors, but I think a lot of the veterans from the first one felt it lacked the sheer terror they felt back then. Maybe coming in through the Café Bar rather than the grotty Midland Street entrance contributed to that, or maybe it was just acid blood tinted spectacles, so to speak.

JACKIE WYLIE
Nic Green was upstairs trying to do a live art piece and she could hear the machine guns! Do you remember the machine gun fire used to ricochet through the kids shows! But actually, it was such an impossible thing, really, because the model meant that *Alien War* did have to happen, because if there was alchemy of the impossible in making stuff happen, and there was also extraordinary resilience in

the team, because [of] being able to hold the fact that an *Alien War* show could interrupt a theatre show.

KIRSTIN BAILLIE

I stood in as a plant for *Alien War* when an actor phoned in sick last minute. I had to act as a member of the public, taking part in the tour and when we got stuck in a staged elevator, an alien grabbed me and I had to scream and shout as I got dragged away into the darkness. Just an average day working in The Arches!

The energy reverberating around the building from the National Review of Live Art, artists rehearsing their weird and wonderful art, the bustle from the bar, techies marching around the building with a sense of urgency similar to MI5, managers conversing through radios, DJs I loved arriving, gigantic speakers being rolled out to which tunes would pour out from later. The steady descent into minimal techno. I knew I belonged.

I couldn't tell you most of the actors' names or theatre companies that I've witnessed throughout my time. I've seen hundreds of shows and when I think about them, they all blend together like a lucid dream montage which I'm pretty sure was half the artist's intent. A woman slapping people with fish, people braiding hair into plants, a lady in a dark room with a Miss Piggy mask on, shaving her legs erotically and very slowly. I've seen burlesque routines frozen, while groups of people sketched tasselled nipples; *[2001:] A Space Odyssey* screening with an alternative techno soundtrack; a show about a plastic bag accompanied by feral dream-like visuals – I'm sitting crying in the front row bawling my eyes out and when the lights come on, I turn to the audience and realise I'm the only one crying.

I remember standing beside a regular theatregoer, belting out David Bowie's 'Life on Mars?', accompanied by a gospel choir. I hold the man's face dear in my heart but like the shows and performers, his name is lost in the cracks of the brickwork; we held hands as we sang with the choir and then after, we nodded politely, not quite knowing what to say to each other. I remember a WWF-style immersive wrestling match and *Whatever Gets You Through the Night*, a

wonderful Glesga musical by Cora Bissett, where the audience sat on old subway seats while we were graced by a ballet dancer dancing to songs about chips and cheese. I've seen John Cooper Clarke orate deep into the main arch and Peter Hook from New Order talk for hours about his time running The Hacienda. I've witnessed performers climbing ladders to peel vegetables at Death Disco while clubbers mingled and winched to the beat, while carrot peelings – like trippy confetti – fell on horny clavicles.

I especially loved to see them hired for corporate events, when the crowd couldn't comprehend what they were witnessing and didn't know how to react; people adrift from their comfort zone forced to float for a while in the queasy unknown. That's what The Arches did best, it allowed worlds to overlap; theatre spilling sometimes intentionally, sometimes by accident, over into club nights or people having a quiet drink in the foyer bemused by live art that's radiating through the glass entrance from the main arch. A group of young lads, waiting for *Alien War* to start, take a glimpse into a rehearsal room for an Al Seed performance.

MARK ANDERSON

My most memorable moment, actually, is a horror story. It was Cora Bissett's show – *Whatever Gets You Through The Night* [2010]. A fantastic piece of site-specific theatre, and again, The Arches was so good at that. It was a cracker... it was one of the best pieces of theatre, I think, that we put on. Musically, it was astonishing. But this was a classic example of having our cake and eating it too. That show was housed in Arch 5 and 6, because at the time we needed the top arches for corporate events, hires, and it was manageable, because the theatre was going to be finishing at ten o'clock, let's say... and corporate events would often start later than that, or whatever it might be. Certainly, there might have been a club due in later. But that particular night, we had done a corporate hire for the top arches, to what was sold to our corporate team as an 'Irish Folk' night – folk bands. And I remember sitting in the show, and it was quite near the end of the show, but obviously that by its nature is getting towards the denouement of

the wonderful piece of theatre we're all witnessing, and I could start to hear what sounded like singing, you know – football chanting. Actually, when I first heard it, I wondered whether it wasn't part of the soundtrack to the show, because someone walking down Union Street in Aberdeen was one of the storylines, but as it got louder and louder the reality dawned, it was horrific. I thought, 'Oh god, don't tell me that's this folk night thing.'

We were going to open the doors to the hire, but they'd agreed there was going to be no music until the theatre had finished. But this sounded like football chanting. And it seemed to get louder and louder, and I could see the front of house staff getting agitated, and I had to get out of my seat and shoot off up the back corridor. And once you got out in the corridor you could hear it. And ultimately, what had happened was, the corporate events department had been sold what was effectively Irish Republican sympathisers doing a fundraising night for the provos!

And it was a fucking shambles. They were drunk before they came in, so once the doors opened there was hundreds of these eejits, and the music hadn't started but they were tanked up, and they were in the middle bar… Of course, we had the doors closed, but the doors, although we had replaced them in the recent years prior to that, you know, they were never going to keep out the noise of hundreds of men singing at the top of their voices. And it was an embarrassment… I felt terrible for Jackie, I felt terrible for Cora… In fact Cora was with me out in the corridor and I honestly can't remember who was on that night, the duty manager, but trying to get them to be quiet… it wasn't going to happen. So that absolutely stands out, and I wince thinking about it.

JACKIE WYLIE

Oh, the closing night of *Whatever Gets You Through The Night* – just trying to put a really good face on it like, 'Yup, this is The Arches, this is absolutely what happens.' The enormous resilience to contain all of that, and only with retrospect do you realise that that was the beauty of it and it wasn't something to be worried about. Actually, that is not

a good example of that because it's politically suspect that we had that programmed! But *Alien War* clashing with the Christmas show is not actually something that we needed to worry about, in a way. I mean, obviously children may have been scarred for the rest of their lives by the inherent violence within the basement of The Arches! Ha! But really there was something about all of that which was actually okay... which is just the benefit of hindsight.

BLAIR SUTHERLAND

I was never part of the front of house until 2006, then I took over managing that whole department. And then we had to become so much tighter with our policies and procedures – we had to have a lot more meetings. All the boring stuff. Who wants to sit through health and safety meetings every quarter, let alone every month, you know? It's the stuff that goes on behind the scenes that maybe people don't know about The Arches.

IAIN 'BONEY' CLARK

See the other thing about The Arches that really sticks in my mind – the bouncers. The bouncers were all brand new. They never gave anybody a hard time. They were never aggressive with you... Don't get me wrong, there was some people that got flung out every now and again, there always is, but I always remember the bouncers being absolutely brilliant with everybody. And everybody liked the bouncers.

With the bouncers in there, you felt safe. I think if you had something in there, they would give you a warning. Take it off you, and that came back to bite them in the bum. And if somebody did take a bad turn, the bouncers were always there to help them, because they were all well trained.

So although the club was quite mental, it was quite a safe club at the same time. People felt safe going there.

DAVID BRATCHPIECE

After years of working there, Lisa and Nina had become the joint heads of security. It was very unusual for two women to run a large security team like that, but it was important, I think.

NINA MILLER

It was the during the transition from [security firms] Rocksteady to Security Scotland. The two head stewards that were there at that point were going with G4s, so obviously we saw the opportunity to not be managed by guys again – because we had the experience and the knowledge. So we literally had a meeting with Mark [Thorburn] and James [Glackin, co-directors of Security Scotland], and just said, 'This is what we do, this is what we know. This is what we can offer you. We highly recommend you put us in charge, rather than bringing in two of your own people.'

LISA DUNIGAN *(Steward, then joint head of security, 2003–2015)*
We typed it all out, and asked for a meeting with them. And we also put, 'What will you do for us?' Because we were making that decision at the same time [as], 'Do we stay or do we go?'

So we literally asked for this meeting with these two guys that we had never met before. And we turned up – these two lesbians with all these sheets of paper, like interviewing them almost. It was like, 'We'll decide if we want to stay and work for you.'

NINA MILLER

Yeah, that's the attitude we had. We desperately wanted it, but we were like, 'We can't show any form of desperation. We need to be like, Yeah, it's in your best interest to put us in charge.'

But yeah, we outlined our terms and conditions, told them what we could offer. I think they were probably a bit taken aback, particularly by two women coming to them with that type of proposal. I don't think they'd ever had female head stewards in their business before. They were quite new – obviously they had both done a lot of security themselves, and come across women, but I think we were the first in Scotland, to run particularly a superclub.

It probably did break the mould a bit – two women saying, 'We don't need the big guys, we can control three thousand people a night, just with a team of people that can use their brain and their mouth –'

LISA DUNIGAN
– and that cared. We wanted to teach people.

NINA MILLER
Because we loved it so much. It was a case of, 'You don't work here unless you love it.'

BLAIR SUTHERLAND
The Best Bar None Awards, which was set up to really highlight the good work that the late-night economy and the pub trade does on Glasgow, with regards to perfect serves and safety and all that – that was vital, I thought. Because we were partly funded by Glasgow City Council. The awards were core funded by [street safety team] Safer City Centre.

We got the Best Bar None award overall gold six years in a row, and then we got Lifetime Achievement, because I think basically we were devaluing the sort of social side of the award – the award was all about who was doing the best socially, and running the safest venues, and because we won it every year, everybody else in the city was getting a bit pissed off with it, you know?

I spoke to the people that ran it, they were all legal authorities in the council, and they said, 'Look, we're going to give you a lifetime achievement award, Blair.' And I said, 'Well, I'm really pleased with that.' Not [for] me, but for The Arches. And I said, 'I think it's only fair that we step down as being in the club category next year and we go into a specialist category. Because I think that for Glasgow it's an important thing.'

I don't know whether it's still running, because I'm out of that side of the trade. But I think it was great. Imagine The Arches – the club that had the most notoriety, but it was the safest. And to be awarded that, to be judged, by members of the licencing police, building control, Glasgow City Council and the Fire Wardens, and still awarded the best by a long shot. And maybe this added fuel to the fire in the later days.

For the whole team, that were working there on a Saturday night, listening to what we've trained them to do, I knew that it made a difference. I think it was one of the best accolades [and] it reflected on the whole of The Arches, as much as it was based on the licence part, it gave a great bit of marketing, to the theatre, corporate, everything. It gave it a good bit of recognition. I was so proud. Probably one of my proudest points of it all. And as much as I was the face of it, it was all the team that made it possible.

It got tough towards the end. That's the tough time. But the pressure… the whole licencing side of it changed big time. When the new Police Scotland took over from just Strathclyde Police, there was a whole Scottish Forum as opposed to just one Strathclyde Police, so – I'm just talking about the Retail side of things – we had a great relationship with the authorities. And that helped us actually, even on the theatre side, because some of the theatre stuff was 'out there', you know! So, they understood the line between art and licencing. If we were just an arts venue, we would have no issue, but we were a licenced arts venue as well. So, we had to make sure that it didn't create bad press, because that would then hit the licencing side. So that's what took up a lot of, probably, my last ten years, or certainly last five years – constantly battling with licencing.

6

2013–2015

How Can You Have A Day Without A Night?

'Shocking news – a real act of cultural vandalism which will damage Glasgow's reputation worldwide.' – Theatre critic and political commentator Joyce McMillan on the closure of The Arches

ROB WATSON

The risk aversion theory is always what I thought about with The Arches – the more padding that you put on a wall, the faster people will run into that wall because they want that perception of risk, that's the whole point of it. The best example of risk aversion theory is the car – if you want to prevent car accidents, eradicate them completely, you get rid of side impact system, get rid of airbags, get rid of seatbelts and you put a six-inch spike on the steering wheel. Because the dangers are palpable there. Whereas everything that we did was to try and mitigate and to prevent that as much as possible. When I say mitigate, there's two sides to that – there's us protecting the people in the place, and us trying to protect the reputation, or heal the reputation that the venue had. And that's something that we fought from the outside as well. Which is weird, because again, looking back on it now, when I was technical manager, it felt as though our duty was to say, 'It's not a drug venue. That's not what we're trying to be.' And that felt a big push in terms of what we were trying to achieve. In The Arches everything felt nuanced and considered. Because we had a really broad church of people who loved it and appreciated it, but at the same time we obviously had to make sure that the perception of The Arches wasn't going to get damaged.

GEORGE MACKENNEY

It is how we accept something for what it is that affords us the power to own our experiences. The Arches provided the risks, the hazards and the space for people to grow: to seize an experience and wrestle with it; to dream while awake; to have a day and a night mould into one; to be exhausted and satisfied; to laugh and to cry; and to do these things all at once. It was so deafeningly quiet when you walked round the building, locking it up after consecutive days of marvellous mayhem. Club follows theatre, follows rehearsals, follows food, follows drink, follows conference, follows two hours' sleep, follows soundcheck, follows a forming queue, follows... follows... well, I think you get the idea. When there was a moment of quiet, you thought, 'What the fuck just happened here?'

DAVID BRATCHPIECE

I left The Arches in 2013, after fifteen years. On my last day there, I took a final walk round the building by myself, just looking at the bricks. There was a theatre company rehearsing in Arch 5, and their music – 'Somewhere Over The Rainbow' – was kind of gently reverberating off the walls; it was beautiful and it was perfect. Why did I go? Lots of reasons, it was just my time. I was getting older. The scene was changing. The crowds were changing.

LISA DUNIGAN

I think I felt the people were changing. The punters. It wasn't The Arches that changed, it was the people that came and what they expected, and how they thought they could act. And the culture. You take it back to the 90s, and you would have people that would be able to tell you who that DJ was, what track, how many beats per minute, when they last played, who they collaborated with. And then when things like the website 'Don't Stay In' came in, and people started changing – it got more commercial and picture-orientated, and it was all about who had the best-looking picture of the night. And then that transformed into the folk that are out there now, that just wanted to go on a night out, get fucked up, didn't care how they were doing it, when they were doing it, what the consequences of them doing it

were. There were no friends that went out and looked after each other the way they used to. You know, you could go out as a group of friends and be like, 'Just you slow down and calm down', whereas they were just like, 'Let's just go and get fucked up', and that fed into the music which morphed into the club which morphed into a lot of the hassle and ultimately a lot of the incidents.

NINA MILLER
Yeah. It became a very entitled generation of punter. They all knew their rights, daddy was a lawyer. It became social network-orientated, and we would get an absolute tanking on social media – particularly me at one point. It was trolling, when you look back on it. It upset a lot of members of staff. We got obsessed with reading it after every club, and then we had to be like, 'Right, we cannae. We'll never go back to do the job.' But the generation became more entitled: 'We can say whatever we want, we can do whatever we want.'

Up until about four or five years before the end, you had a very set crowd per night. So, your Pressure lot would not go to Inside Out, would not go to Death Disco. You know – there was a very set structure. And then, we noticed, doing the queue, the same punters coming. And then, I think, promoters changed – and they weren't so much about the exclusivity of their night and who they wanted there, it was more, 'We want to make cash. So… don't knock them back. We know they're not regulars, but let them in, because we want the money.' And that's when things changed, I think promoters became more kind of financially orientated as well, and that broke down the difference between the crowds. And before you know it… I remember speaking to punters, particularly over like Easter weekend, where we would have three or four completely different nights, and by the fourth night I'd seen them every single night. Whereas previously that never happened.

RICKY MAGOWAN
The EDM thing came, and Americanised everything, everything was bigger. So one minute we had those DJs playing in the club, next minute they're getting £100,000 to do a gig in America. And then at

that time, LiveNation and others, they bought into a lot of festivals, so they spent about ten billion pounds in America buying into this thing. And everybody went there. And that was it.

JULIE McEWAN
The other thing was the cost to try to even get them to come to the UK, because their fees were so attractive elsewhere round the world, it was hard to get a hold of them.

NINA MILLER
It lost sight of what it was, I always think – towards the end it was monopolised by Colours – not to take anything away from Colours because they're good friends and they run brilliant nights – but, it became a Colours club.

LISA DUNIGAN
Ricky kept it going. If Ricky didn't put on the things he did, there wouldn't have been anything coming in.

NINA MILLER
And that was The Arches' fault. Because that shouldn't have needed to happen. But it did just become about numbers and money. Lost sight of its roots. 'It's alternative, it's out there, it's forward thinking, it's new music…' it lost all of that.

RICKY MAGOWAN
The thing that irks me a wee bit is that some people say that [hardcore trance event] GBX sent the place downwards a bit – bear in mind that it ended up with Slam, back doing more things at the Sub Club. Inside Out finished. We've got every fucking Saturday, and the place was on its arse. Our remit was to get as many people in there as we could to make money for the venue. That's the cold hard fact about it.

JULIE McEWAN
The diversity of the audiences as well… at that time you couldn't sustain bringing 2,000 people every week. The bubble had burst. So

for one promoter like Ricky to be able to tap into all those audiences – like hardstyle one week, then house and then GBX or whatever – is pretty unique.

Everybody was just trying to keep it afloat… that's all we cared about at the end. We didn't want the place to shut down. We didn't exactly see what was coming round the corner.

BBC NEWS, 13th February 2014
Regane MacColl, from Duntocher, West Dunbartonshire, became ill at Glasgow's Arches club on Saturday 1st February.

She died at the city's Royal Infirmary in the early hours of Sunday morning.

MARK ANDERSON
I'll never forget it.

I used to go to bed on a weekend with my phone on the side, hoping it wouldn't ring. Because if it rang in the middle of the night, you knew there was an issue. And it didn't ring that often, but it did ring a handful of times. And that struck fear into me. That was really not a very pleasant part of the job, but it came with the territory.

So that particular night, I'll never ever forget it, because I was actually on holiday. I was skiing in Switzerland. We'd just arrived on the Saturday, and early on the Sunday morning… bearing in mind that I was an hour ahead of the UK… my phone went off at… it might have been seven in the morning, Swiss time. And I saw that it was [Operations Manager] John Quinn's number. And my heart absolutely sank. I knew that would be 6am UK time. The fact I was on holiday… he wouldn't have phoned me unless… I can't tell you, I was having palpitations. And then of course the news came through and I knew in my heart of hearts then, that actually that was probably the end of The Arches.

NINA MILLER
We couldn't have made it any safer. I worked with her mum's best friend. And I broke down in work on the Monday, and was talking to her about it. I just remember sobbing, and saying, 'We

did everything we could, we did our best.' And she was like, 'They know that. The family know that.' But the media didn't. The social media certainly didn't.

MARK ANDERSON
By the time I got back everything had gathered apace and we had to go through all the licencing board hearings. It just went from bad to worse.

THE HERALD, 15th May, 2015, by Gerry Braiden
One of Scotland's most prestigious arts venues is facing near certain closure after licensing chiefs shut its controversial nightclub operation.

The move against The Arches follows the latest complaints against the venue by Police Scotland, which said there were "potentially lethal and profound consequences" unless instances of drug misuse and disorder were addressed.

It is the third time in just over a year the police have tried to shut the venue.

JOSEPH BLYTHE (*Press officer, 2013–2014*)
I strongly recall waking up to a phone call from Niall in the morning warning me that there had been an incident at the venue over the weekend. I didn't quite grasp how serious things were until I went into the office.

We very quickly had to adapt to the sheer volume of media coverage and enquiries we were dealing with – and plenty of it wouldn't come through us. I remember seeing broadcast reporters filming packages outside the Midland Street entrance without having asked us for any input or comment, and tabloid reporters cold-calling the Café Bar and the box office to ask random members of the staff questions about the incident, about the club nights, drug taking in the venue... There was a meeting called with all the staff to tell everyone that they needed to not respond to anyone trying to get information out of them, to be on their toes for any questions coming their way. It was quite intense.

I also really wanted to be thorough in documenting and keeping track of as much of the coverage as possible – it felt like it was important to do so. We didn't have any kind of media monitoring, beyond relying on Google Alerts, and at the time you couldn't quite account for all news coverage ending up online immediately, so I remember having to go up to Central Station every day to buy stacks of newspapers, which I'd sit and go through at my desk. It's still the hardest time I've had in my professional career so far.

There was a lot of frustration about a lot of the coverage amongst the staff. A sense that the media were getting facts wrong and overselling misconceptions. I remember someone telling me that even details like the type of pills involved were being incorrectly reported – I vaguely recall the media turning the Mortal Kombat pill thing into a bit of a crusade. It was tough, because the reality was that, however safe the staff made the club spaces, however tough searches at the door became, there wasn't a way to stop people who wanted to from taking any drugs before coming to the venue. I think that fed into the frustration, a feeling that the venue and the staff were being made scapegoats for something that was largely out of their control, despite all the hard work being done.

I remember being told that Police Scotland were using the case and the media pressure as an excuse to come down hard on the venue – that previous cases and other occasions had resulted in a sense that the police had it in for The Arches. Everyone was very aware of the venue's financial situation – that the loss of the club nights and gigs would effectively put paid to the place as a whole, and people's jobs along with that, and so the sense of media pressure adding to the situation was hard for folk.

LISA DUNIGAN
It was an agenda.

One night a drunk woman had fallen on the dancefloor, and the stewards, when they attended, weren't sure if she had banged her head. So the stewards, as a precaution, we called an ambulance. And it turned out that she hadn't banged her head, but because the

ambulance was called, the police came down at the same time, and then that's when the senior officer came in saying, 'You've lost control.' They were going around stamping on bottles, hoping to find a glass bottle, because everything obviously had to be plastic.

NINA MILLER
After Regane's death, they'd given us a ten-point checklist: 'You must do this, this and this.'

[A list of recommendations, including the improvement of CCTV, and the handing over of any confiscated substance, no matter how small, to authorities.]

And it was almost like: You've had your knuckles rapped, you're sailing close to the wind. Here's a support document, if you do these things, things will be alright. So we were like, 'Hmmm, okay.' But you can't say no. We did the things, and it was played back during the licencing hearings: 'Well, you did this, this and this.' And I remember looking at Lisa and being like, 'But, they told us to do that.'

LISA DUNIGAN
They set us up, basically. And I remember going into the licencing hearing and one of them said, 'Don't worry, it'll all be over today.' That was her words.

THE GUARDIAN, 10th June, 2015, by @guardianmusic
One of Glasgow's best loved venues looks likely to have to close. The Arches is to go into administration, following the decision of the city's licensing authorities to force it to close at midnight following police complaints about disorder, including drug use, at the venue.

Patrick Harvie, Scottish Green MSP for Glasgow, said: "I'm so sorry for the staff of The Arches and for the entirely avoidable loss to the city's cultural and social life. This is a venue which gave so much to Glasgow's arts community and to our reputation for great nightlife.

'It's also a venue which put consistent effort into addressing public safety issues, and was rightly recognised for having done so. The failure of our society's drugs laws cannot be laid at their door, and moving drug use from this venue to one less used to dealing with these issues will do nothing for public safety.'

THE GUARDIAN, 10th June 2015, by Lyn Gardner

The Arches in Glasgow has gone into administration following the withdrawal of its late licence. The news is a significant blow to British theatre and performance, and to Glasgow's reputation as a city that has always seemed to understand better than many others that it defines itself through the culture it makes and that it sends out across the rest of the UK and the world. Joyce McMillan, the influential theatre critic of the *Scotsman*, has described the loss of the Arches as 'cultural vandalism'.

It is. The loss will not just be to Glasgow itself and the other Scottish cultural institutions that it feeds so regularly, but the whole of the UK theatre and performance ecology. Its tentacles spread out far and wide. For many English, Welsh and Northern Irish artists it is the place that they call home north of the border. Major international artists including Gob Squad and Ann Liv Young perform there too.

But the traffic is always two-way. The Arches does more than invite and host. It has supported brilliant artists such as the late Adrian Howells reach their potential both as artists and mentors, and nurtured wave after wave of young artists, many emerging from the Royal Scottish Conservatoire's influential contemporary performance practice course. It has done it with a generosity and a beady eye for the radical and distinctive that has helped them fly. People like Nic Green, Rosana Cade, Kieran Hurley, Gary McNair, Pete McMaster and Rob Drummond. Many of those working in live art and performance across the UK got their earliest work seen via the National Review of Live Art, which made its home there for many years, or via the Behaviour or Arches Live programmes. The Arches was one of the reasons that in recent years Glasgow has become a magnet for young performance-makers; many of those who forge careers there take the

work on to festivals and theatres across the world. It is as significant as Battersea Arts Centre, in London, in the way it nurtures tomorrow.

The great irony is that at a time when the government is always calling upon artists and arts organisations to look beyond subsidy and be more entrepreneurial, it is the Arches' commercial business model – in which the club side of the business supported the art – that has resulted in this disaster. The Arches simply does not receive enough subsidy to keep supporting artists and presenting their work.

If there is no way back, the loss will be felt for years to come. No wonder there is such grief in Glasgow and across British theatre tonight.

GLASGOW EVENING TIMES, 20th May 2015, by Victoria Brenan
Following a meeting of its executive team, The Arches said the cut to its operation, effectively shutting its nightclub, would have 'a devastating effect on the future of the venue'.

It comes as a petition against the closure surpasses the 30,000 mark, with leading Scottish playwrights writing of the 'potentially devastating' results of Glasgow licensing board's decision to curb the hours following police complaints of drug misuse and disorder.

An open letter on behalf of the Scottish Society of Playwrights (SSP), whose council members include the Makar Liz Lochhead as well as Davey Anderson, Kieran Hurley and chair Nicola McCartney, among others, said the Glasgow club and arts venue holds a 'vital place in Scottish culture.'

BBC NEWS, 27th May 2015
Thousands of people signed a petition in protest at the decision, while more than 400 cultural figures – including novelist Irvine Welsh and members of Mogwai, Belle & Sebastian and Franz Ferdinand – put their signatures to a letter criticising the move.

LJ FINDLAY-WALSH
There was also a whole host of international peers, festivals, venues and arts funders from across the globe that signed the petition and said how important it was for The Arches to stay open. And that was

really heartening – although it didn't work, as an end of the episode it was really nice to see how well loved and how well thought of that organisation was. Not just in a grassroots way – which was the most important thing – everybody in Glasgow, whether you were a clubber or an artist or a student wanted it to stay open, but so did these big established names all over the world.

RICKY MAGOWAN

It was a witch hunt, wasn't it. They were damned if they did and damned if they didn't. And to do everything they did to make it the safest place in the UK, to then get that used against them and lose the licence is fucking ridiculous. You just need to look at the last few months in Manchester – the Hacienda had the biggest problem in the UK, but still the city of Manchester opens its arms to that place because they knew the benefits of it, they knew the historical aspects of what was happening in there.

NINA MILLER

I remember the very last Easter weekend. The police had basically said to us, 'If you open, we will shut you down, and you will be arrested.'

And we were standing in the office, and we were all talking about it, and everybody was looking at each other, and it was a bit like going into battle and knowing you were going to get shot. Everybody was just like, 'Fuck it. If this is going to happen, let's just fucking do it.' I'm getting goosebumps even talking about it. The atmosphere that night, doing the briefing. It was like, 'Guys, you're on your toes. You're ultra-professional, but you take no shit. Because this could be...'

You know, we had to say to people in the briefing, 'Are you prepared to get lifted?' And of course, the team were like, 'Yep. Absolutely prepared.'

And I remember standing with Blair, and me and him just looked at each other, and I went, 'Shoulder to shoulder?' And he said, 'Oh aye.' And then we went out of that room, and that was it.

LJ FINDLAY–WALSH

Dark Behaviour was the last event. The idea was to curate a club night that also included live art and performance. That sounds so simple, but it was special – there was visual artists involved who would create installation work, so you had actual aesthetically installations within dancefloors. I think the first Dark Behaviour coincided with me being pregnant and the last Dark Behaviour coincided with Jackie being pregnant, so in my reminiscing about it…I remember being able to stand back and survey this beautiful madness with a mixture of pride and wonder rather than being fully in it.

Actually, there's an amazing trailer of the last Dark Behaviour. I had suggested that we just put it out after the fact, but the party looked so outrageous and so out of control – as every great party should – that we thought that it wouldn't do the legacy of The Arches any good, everything still felt so raw, so we didn't send it out. But it should go out now, who cares? Everyone should know. It was wonderful.

Yeah, it was a beautiful way to end.

MARK ANDERSON

It's kind of sad, in a way, that ultimately what really fuelled The Arches finances was drink. Over 50 per cent of our income came from bars. So, that's the way it was. We were still held up as a beacon of self-sustainability by the Arts Council and then Creative Scotland, and it was great because we were able to do it.

What I don't think I'll ever forgive Creative Scotland for is that they abandoned us. In our hour of need. And Glasgow City Council. You know, collectively, they bottled it. Those meetings that I had to go to, with Creative Scotland and Glasgow City Council, and Gordon Kennedy, who was our chair at the time, and Jackie – you know, they were soul-destroying. You could just sense that they didn't want to support us. And I can't forgive them for that. Because… they could have supported us. It was great when they were able to hold us up: you know, I was at plenty of Creative Scotland and Arts Council meetings, huge meetings with all the arts estate around Scotland, where we were mentioned, and everyone was told, 'You all have to be more self-sustainable, funding isn't available the way it was, look at what The Arches do.' Of course,

most organisations didn't have the space that we had to be able to put those types of events on, certainly not the clubs… but at the same time, they loved it, and we were internationally renowned, you know – we were a real kind of touchstone for them, if you like.

JACKIE WYLIE

I was on maternity leave but came in for the meetings at the end and I remember the emotion of the board. I remember Gordon having to tell everybody about the administration process, and I had little baby Stella and I was still breastfeeding, so my baby was with me and there was a meeting – all the awful meetings happened in The Playroom.

MARK ANDERSON

When it came to it, they could have supported us. And we could have done away with all the clubs that added the risk into the organisation. If they, between them, had upped the subsidy, and supported what was a world-beating arts programme… we could have kept the corporate events. We were internationally renowned for corporate events because these international conferences were coming and people were going back to every corner of the globe and raving about this venue. The music programme took care of itself. It was the clubs.

So, if they had plugged the gap, then The Arches would still be going today. It would have required subsidy, but ultimately they still would have been supporting, as our business card said, 'the coolest arts venue in the world'. And it could have remained as such. We could have evolved. Jackie might have moved on, I might have moved on, but The Arches could still have existed.

ANDY ARNOLD

Basically nothing was done by Creative Scotland, who were completely useless at the time, and the council… they had a meeting in the council offices, to find out what could be done. I'll never forget that meeting. Jackie was at it, and various people who used the place. And it was being chaired by Janet Archer from Creative Scotland. I thought we should go: 'Right, what's the strategy, what are we going to do?' And

she said, 'Before we do that, let's go round the room and see what The Arches means to everybody.' It was a two-hour meeting, it couldn't be any longer than two hours. So they went round and everyone was like, 'Well, what it means to me…' and blah blah blah and I thought, 'For fuck's sake'. And then it was almost time up at the end of that. And I said, 'Well, at least can Jackie have some money to do some sort of feasibility study on what could be the way forward?', you know, so there's something there. And that was agreed, but then Janet said she was interested in a press release. In other words, we make a statement. It was a PR stunt. There was no real desire to do anything. You're talking about peanuts relatively, for a major Scottish arts venue, a few hundred grand just to keep it going while things were sorted out. And instead, they wound up, administrators with unseemly haste sold everything, and that was the end of that.

JACKIE WYLIE

My energy was focused on finding resources for the arts programme to carry on. And that's a really difficult thing to talk about, because at that time there was a huge duality which was – at what point did we have to let go of the building, and move on with the arts programme, and how to do that with integrity and authenticity, and actually how to do the right thing. And also, I had a tiny baby, and when you have a tiny baby it's really difficult to know what the right thing to do is anyway, but at what point did I have to try and imagine that the arts programme could go on out with the building, because that was the only option

ANDY ARNOLD

I always thought The Arches would have a future, though, because as long as you've got a place where you have a licence for two thousand people to go and enjoy themselves, you're onto a winner, you know. But it would have to change. And when they did lose their late-night licence, people used to say to me, 'Do you think that's the end of The Arches?' and I'd say, 'Well, no, because it's a fully equipped place, it's got a licence for two thousand people, and it gets 450 grand or whatever in subsidy so why should it?' [But] the idea of trying to find a way to get back into that building wasn't really dealt with in a realistic way, I

don't think. So that was that, and that was the end of it. Because once you close the place, it's very difficult to get it open again

They needed to completely change the way they were thinking, and they couldn't. They just kept clubs till midnight and whatever, and trying to keep the same stuff. It would have meant brutal cuts. We were on nothing, paying out staff at the beginning, and it needed to go back to a small staff, slimmed right down, just go back to basics. And it would have managed just with the subsidy, because the subsidy would have carried on being paid. Pay the rent, pay the bills, keep your head down, and build up again. But instead, it was trying to keep forty full-time staff and all the rest going, and it just didn't financially add up. So it went under.

NIALL WALKER

We talked a lot about other things. You know, one of the other things many of us suggested was a street food market and all the rest of it. But it's hard when you're in a building like that, which has for so long been relying on the clubbing programme to think, 'How could anything else possibly bring in that kind of money.' So I wouldn't criticise the commercial end of the building for not doing that themselves. There didn't seem to be an alternative model, really.

JACKIE WYLIE

I suppose the thing that is unresolved for me is – to what extent there was a kind of police and corrupt establishment decision that The Arches had to go.

There's that hotel that exists on the front of the building now, which feels like an absolute affront to me… in some ways it's like progress, or those things that we feel we can't be in control of… there's a feeling of powerlessness against that kind of gentrification. But there's something about the whole thing that's so troubling.

BLAIR SUTHERLAND

When they knocked down the building out of the back of the café, of Arch 1 and Arch 2, to create Motel One, there was a lot of politics there because… who's going to stay in a hotel where there's a club?

And if they've granted a building warrant for that, that's a red flag, you know? There were certainly issues with reports of licencing that we had trouble with. For any staff that had to deal with that, we had to deal with it on a daily basis in there. It was not nice.

DAVE CLARKE
It was such a blight on Glasgow's culture for the police to have such a say in whether it survived or not. I found an Article on Resident Advisor, written by a journalist called Ray Phipps. Which was talking about the head of Police Scotland that was instrumental in this 'zero tolerance' policy. It brought it all back, the anger that you felt at the time.

STUART McMILLAN
I think the police are probably more used to dealing with guys that own nightclubs that are not as transparent, or not as forthcoming with things that will inherently go against them in the licencing courts. Whereas I feel that The Arches' compliance with them was inherently...

ORDE MEIKLE
Used against them.

STUART McMILLAN
Used against them, and became part of the downfall, unfortunately.

MARK ANDERSON
We did our best, we won a lot of awards, we did everything we could. But when you are up against the dark forces of Police Scotland, and the tyrant chief constable we had at the time... he had it in for us.

BLAIR SUTHERLAND
That was a lot of hard, really personal mental difficulty for a lot of people who worked there, to deal with. Our hearts went out, and they still do. I'm not saying there's not a day goes by, but I think everybody who worked there that night... we didn't do anything

wrong. We've got all these policies and procedures in place. And I think a lot of people know that. But it was... a right kick, man. Know what I mean? Doesn't matter what was right or wrong or if it was an accident or if it was meant, it was so tough to deal with. For the whole company, from the top down.

And since then, I think we were really fighting a bit of a losing battle. From 2014 onwards. Which is sad to say now, but everybody gave it their all. And we didn't do anything wrong since then either, so why'd it shut? I got taken to court after, when The Arches was all shut – they tried to take my personal licence off me. And it got flung out, got found not guilty. Because we had every policy and every procedure in place. So it kind of asks that question, 'Why did The Arches lose its licence?' If I didn't lose my licence, and I'm the guy in charge of The Arches, why did it lose its licence?

I'm not trying to be flippant about it. It's just, historically or hypothetically as you look back, authorities have agendas, and they do work together. And it's sad to say that, if they're powerful enough, we won't win. And we didn't win that one. We won enough that we probably won enough to piss them off.

MARK ANDERSON
I hate to think of the loss to not just Glasgow...certainly Glasgow, I mean there isn't a person in Glasgow that didn't know of The Arches. But internationally, the loss to the arts scene in Scotland is unmeasurable. And they blew it. They had the chance, and for whatever reason they... and they continue to support organisations that plough on doing this and that... rather than seeing The Arches as a leading light of Scottish art. It's a shame.

And you can quote me on that!

JACKIE WYLIE
I think the thing that is really impossible to reconcile is the building, and the loss of a physical, subcultural space. And maybe there's something about the world just now and our inherent desire

to gather at the moment. Can you imagine going to The Arches…
oh my goodness me, can you even begin to think… actually just to
walk into The Arches and feel that feeling?

NIALL WALKER

Because when Andy started it up, he just had the Midland Street
entrance, a scabby old arch, and a scabby little theatre. So that could
have survived just as it was, maybe with Creative Scotland funding
or Scottish Arts Council funding or whatever. But the clubber guys
came in, and created a monster basically. And it was brilliant…
bloody hell, it sustained for a long time. I'm not being critical by
saying that I could tell there was no future in the building by 2013.
Loads of venues never last that long, especially clubs for goodness'
sake. I mean, Studio 54 was only open for six years or something –
and only three of them were the sort of legendary years. The Arches
is a huge success story, and should always be talked about as that,
because it was a long time it ran for. Death Disco ran for ten years.
Bloody hell, hardly any club nights run that long. And look at Slam,
Colours and Pressure and everything. It's incredible. Absolutely
incredible what that building and organisation achieved. But there's
a time for everything.

And, in a way, when I heard that it was closing and everyone
was like, 'Oh my god, The Arches is closing', I was a bit like – well,
it's time. It just is. I mean, I was there holding a placard up – 'save
The Arches' – outside the council, don't get me wrong. Because I
didn't like how it closed. I didn't like how it closed as a result of the
council and their shitty, completely anachronistic licencing laws
designed by old buffoons who have no idea what they're talking
about. Talk about old white male privilege! It's just completely
sickening, that Glasgow City Council close venues the way they
do, or force them to close down because of the restrictions they
impose on them or whatever.

But at the same time, despite it being the licencing thing, that was
the final nail in the coffin for The Arches, I could still tell that it was
going to be hard for it to survive culturally, because of the way that

club culture was going. If it was running now, the club nights would be like the stupid Bungo's Bingo nights and ABBA nights and all this kind of shit, because that's what people go to. And I'm just like – The Arches is not quite right for that. It would feel wrong.

BLAIR SUTHERLAND

You've got to remember that, right at the beginning, it was a wee Glasgow company. Then it became worldwide renowned. Not just the club – that's well documented – but look at New Territories, and the National Review of Live Art and even just some of the recognition it got for small theatre… I mean, I think one of the first theatre shows I worked at The Arches was Raindog [Theatre Company] and it was with Robert Carlyle and various other artists that were performing in there. And you think… those guys that were performing there in 2012 might have went on to do the same things… loads of famous people… they would be quite comfortable just to come to The Arches, even just to support Andy and the team, or Jackie and the team, because it gave them an avenue, you know.

CARL COX

I was very honoured to be asked to become a patron of The Arches. It was a very honourable thing, to be able to give up something like that to me. But I always felt, in my heart, that I always gave The Arches and everyone involved in it, you know, the punters and the staff, something to feel proud about. I felt proud about it, being there. And any time I speak about being in Glasgow and playing at The Arches I always talk about it with passion and affinity, with the love of having been there. I think it was clear that no matter who played there, I was definitely somebody who really appreciated what the staff did, what the management did, what the promoters did, what the DJs played, that basically made that place what it was. And that's the legacy of what it is. The Arches.

NIALL WALKER

I would have never been working in the arts if I hadn't gone there. But I wouldn't have experienced some of the most amazing eye-opening performances and eye-widening clubbing!

And they weren't all at The Arches… I've experienced clubbing and theatre all around the world, as a result of working at The Arches. It's changed everything for me, culturally, as a person.

And pretty much all of my friends – like, at my wedding I remember looking around the room and 80 per cent of my friends that were there, I knew through The Arches. Either because I had worked with them there, or I had met them there, or met them through someone who had worked there. Like, it's this big old tree of people that had come from there.

God, I feel so lucky that I was part of something like that.

TIM CROUCH

The least pretentious venue I ever played. And the most exciting. Glasgow is a poorer place without it.

STEPHEN McCOLE

I performed there, I partied there, I DJ'd there, I met the mother of my children there, I made life-long friendships and always felt welcomed and safe there. The Arches is part of me and I am a small part of its story. It was much more than one of the best clubs in the world – it was the beating heart of a massive artistic community!

What has happened to our Arches is nothing short of cultural elitist vandalism.

KIRSTIN McLEAN

Ah, the cultural significance was massive. The Arches represented complete artistic freedom (while not always offering complete financial freedom). It was a place where, if you had an idea for a piece, you were given space and time and a bit of technical support to rehearse and stage it, and a brilliant bar space for post-show analysis with any number of other performers. For local artists this was a godsend, and I don't think I realised how lucky I was to have this place. A place to try and fail, or try and succeed.

GEORGE MACKENNEY

When The Arches closed down, the music stopped, and nothing followed on. All that was left were some bricks, heaped over a space, where a twenty-five-year party had happened. Without people, it was mouldy and cold.

It was an honour and a privilege to be there. That, I can fully accept.

JACKIE WYLIE

There was a community of artists, who I would absolutely stand by as being the most exciting artists in Scotland – and what's interesting to me is that they are all now the mature artists – when I think about all of them breaking new ground then... they are now *the artists*, do you know what I mean? And at NTS, they continue to be really, really exciting. So after the closure I spent some time... it sounds corporate, but *consulting* with those artists felt really important. In a way, Take Me Somewhere was co-created by the input of those artists because we spent time talking about what the form might be of the programme if the building didn't exist, and the thing that rose to the top was the idea of festival. And actually the thing that The Arches did so brilliantly in the arts programme was festival – I guess the definition of festival being around celebration. The Arches was celebrating life, celebrating art.

RICHARD GADD

What did I do in The Arches? I did everything. That was the beauty of the space. It catered to almost every single artistic and human need. I did comedy gigs, theatre, went to nightclubs (pretty sure I even swam in one). I witnessed some of the most shocking and engrossing performance art the country has to offer. I still have the image of a man in a strap-on dildo, fucking a stuffed goat seared into my memory. And that is probably one of the tamer examples! I acted in a show about wrestling, which is still to this day some of the most fun I have ever had on a project. I temped for a bit in the office and every day had to convince the security there that I wasn't a trespasser. I filmed short films, rehearsed plays, got drunk in the restaurant. Froze my tits off in a 'holding cell' at 2am when a bouncer decided I was being too rowdy

for the rowdiest club in Glasgow. I stole a good number of salt and pepper shakers from the restaurant. Every time I stepped in there, it felt new and exciting. I can still almost smell and feel it all these years later. The warm lighting and the warmer staff. The sound of the train rushing by. It felt special every time you stepped inside that building and my university experience would have been less than, had it not been around.

NATALIE O' DONOGHUE (*Events bar staff, 2008–2015*)
What made The Arches so exciting to work in was the variety of events you got to experience. You would be working a mixture of club nights, gigs, children's pantomime, performance art, corporate events, whisky festivals, and shifts in the cafe bar. The artists that performed in the venue always seemed to understand what a special place The Arches was, and that energy came across in the performances. Even if a gig or club night wasn't to my own taste you couldn't deny that the atmosphere was electric. The cultural significance of The Arches is huge for Scotland – for both artists and audiences. Due to the nature of the programming, it was a venue that audiences attended quite literally for decades and that loyalty is part of what made it so unique.

ANDY MACKENZIE
Surviving nearly seven years working there and countless more as a punter, I am still surprised that I actually have the cognitive ability to remember my own name, let alone a fucking anecdote!

We were driven by the arts, driven by the music and most importantly driven by the people of Glasgow. It was a fuck you to the establishment, a fuck you to draconian policing and a fuck you to the council and government who didn't and still don't see the importance of funding the arts.

The cunts got us in the end, but fuck me, it was wild whilst it lasted!

In all seriousness though, there really are so, so many pivotal moments, that I really don't know where to start. So I won't. All I can say is thank you to each and every one of you beautiful, beautiful

people and thank you to The Arches – you are and will always be my spiritual home.

KIRSTIN BAILLIE

The Arches was the only place I know where your manager would brief you about the Christmas pantomime shift at 10am and then sixteen hours later the same manager would nod and smile at the sight of you, the employee turned punter, tuned to the moon and beyond, scrambling for marbles along with the other luminous zoomers, who've taken a break from the tunes to marinate along the submarine corridor, to gather brain cells and bearings before weaving their way to a different room through the big sweaty glorious maze that was The Arches.

NEIL BRATCHPIECE *(Events bar staff, 2000-2007)*

What made The Arches especially unique was the sheer variety of events going on simultaneously. It was not unusual for me to work two nights in a row into the early hours of the morning having my eardrums pounded by beats and bellowing punters, then go in on a Sunday afternoon to make sure people had enough tea for a burlesque life drawing class.

MIRANDA RALSTON *(Arches PR 2005, finance assistant 2005-2011)*

I met my fiancé and most of my best pals there. One of my first days as an intern, I saw this lassie – the other intern – and I thought she's too cool for me but I thought, fuck it, and the very first words to her I said were, 'Do you like Madonna, I'm going to the concert, do you want to come?' Fast forward ten years and I'm a bridesmaid at her wedding and that's the first line in my speech. And that is the magic of The Arches, it's pals for life.

I walked down the stairs to the Café Bar one day, and saw this guy who turned out to be the tech manager's nephew and looking back was probably love at first sight, and twelve years later we're still together and engaged. And again...that is the magic of The Arches.

NESHLA CAPLAN

Working late was always my favourite time – aye, the stuff in the office needed to get done but I always felt The Arches liked a long lie, took its time to dress (very) well in the afternoon and came alive at night. Walking from Arch to Arch when you have theatre mixing in with the dancing, when it was full of all kinds of life, is hard to describe. But I'd say 'proud' gets close. Proud of each department pulling together to make the magic.

BRIAN REYNOLDS

Some of my fondest memories about the place are hanging out in the Café Bar, eating and drinking wine and going to see brilliant and challenging theatre shows with a really lovely group of staff. I miss that a lot. I'm really glad of my time there.

RICKY MAGOWAN

We've all got lifelong friends that we made within those railway arches.

EDDIE CASSIDY *(Clubber)*

Even in that queue you could tell it was different to the other clubs – the queue had a better atmosphere than the inside of most clubs! That's one thing that was totally different about the place, there was no need to dress up, yes – folk did, but it had more the feel of a house party than a nightclub, far more relaxed and laid back. A house party where you know everyone and everyone is your pal – the constant alertness to potential imminent casual violence, you just didn't have in The Arches. For some reason everyone seemed to be in a great mood, on some sort of massive high. Ahem.

RONA PROUDFOOT *(Clubber)*

I've often lamented that one night, we were all in The Arches for the last time together and didn't know it. I cannae even remember what night it was but I wish I'd partied harder, spent less time gabbing in the bogs to strangers and didn't leave early in order to get a cab…

LOUISE STEWART *(Box office and front of house staff, 2008–2015)*
The venue was special, no doubt, with its dramatic brick curved structure and chilling atmospheric basements holding up this amazing arts institution, but the real thing keeping it all together, I believe, was the people.

JACQUI REID
The people that worked there made The Arches so special. I genuinely believe everyone that worked there felt so blessed to be a part of it. Everyone cared and wanted to put on an amazing show. People that worked there knew how to have a good party. This good energy rubbed off and the atmosphere inside the building felt like magic – I hate how cheesy that sounds but it's true!

CAT HEPBURN *(Box office and café bar staff, 2010–2015)*
I think what made the place special was the combination of the rounded brick walls, the boundary pushing art and superclub – it was a multi-purpose venue but the opposite of broad. At least at the start. It really did feel crushing when we shut. We were a family.

JACKIE WYLIE
The family thing was like a combination of it being so challenging and also the fact that you were in something that had a genuine heart and soul.
 There was definitely something amazing about it. Definitely.

ANDY ARNOLD
I had intended, actually… originally, for when I died… there was sort of like a Lenin's Tomb, a mausoleum in The Arches. Sealed off, but having glass ends so you could look in. And see my coffin there in the middle, you know. Maybe it's still a possibility, actually. Still got my face on the glass there, on the door.

The Arches closed its doors for the final time on the 15th June 2015.

7

Bits And Pieces:

Some Favourite Memories From The People Who Made The Arches

NATALIE O' DONOGHUE

One particular standout moment for me working behind the bar was during a particularly sweaty, packed-out club night when a customer approached the bar with an item of lost property. A prosthetic arm that he'd found lying on the dance floor. During Halloween weekend you would often find discarded wigs, shreds of costumes and other novelty items but that was my one and only misplaced limb over the years.

NEIL BRATCHPIECE

I have many sweet memories from my time in The Arches, not least getting to perform several shows in the same venue I cacked my pants in running from aliens when I was a child. I hosted one of the last ever shows there, a Glasgow Comedy Festival show pitting rappers against comedians in rap battles, which was almost as horrific as anything HR Giger ever dreamed up. I also once smoked a J with De La Soul in their dressing room, which strangely enough they recounted as their least favourite memory of the place.

DAVID BRATCHPIECE

My dad [Mark] was a stand-up, my wee brother [Neil] is a stand-up, and so am I. So in 2003 we decided to do a show together for the first

time, in The Arches. It ended up so busy that people were sitting on that stone floor, and had some record bar sales for that type of event. But that's just because our pals came through from Motherwell.

KEITH BRUCE

There was the annual – for a few years – Fol de Rols, an alternative cabaret and variety evening in aid of the charity Enable, which included music, magic, comedy and, on one occasion, a posse of arts administrators choreographed by Marisa Zanotti to the music of Beck's 'Loser'.

Another memorably short-lived club night was the initiative of *The Herald*'s Thinking Popster, David Belcher, and myself. With a soundtrack of soul classics (probably, who remembers now?) it was called Shake'n'Vac and Belcher persuaded a male member of the acting posse to pose naked for a publicity shot, with the handle of a Hoover Junior strategically placed to obscure his genitals.

CAT HEPBURN

One Sunday, a girl in her twenties in skimpy clothes traipsed into the Box Office to collect her jacket that she'd left in the cloakroom at one of the club nights. She was accompanied by two big guys, they'd clearly been partying all night. We got chatting and the girl admitted to us she was going back to Millport – her walk of shame involved a ferry – can you imagine?!

LOUISE STEWART

I was at The Arches for the theatre and the gigs. I was never into the club nights. It just isn't my scene. However, I got it. I understood why. There were nights where you'd walk into the club and immediately be covered in a thin, moist layer of two thousand punters' worth of sweat. It was disgusting but kind of awesome. That clammy lamination was pure exhilaration and effort. The punters were committed to their club nights. Still gave me the boak, though. At one particularly soggy club night I bumped into three generations of women from the same family. Granny, mother and daughter. All in pink tutus and white vests. All steaming but loving it and loving each other.

NESHLA CAPLAN

Working in the Box Office in The Arches required a fair amount of acting. Depending on the day of the week/time of year we had different invisible hats. We had such an eclectic audience demographic. Pressure Fridays were the head down, tunes on, process each sale on fast repeat – so busy but so much fun. For our festivals, we got to spend time with our customers, helping them navigate how to manage the many brilliant things they wanted to see. There is something special about being at the start of someone's journey, [and] the Box Office is the place where the transaction takes place. People parting with hard-earned pennies in the hope of feeling something. In The Arches that was extra special. Handing over a little piece of card that was an entry to a wonderland.

ANGIE KOORBANALLY (Bar, front of house and box office staff, 2004–2009, founder of Nightwalk 2010)

It was always a goal to put on my own event in the Arches. And in 2010 Nightwalk was born. Nightwalk was the first regular fashion event in the venue. It was a fashion show with a twist. Unlike most fashion shows, Nightwalk took place at night, featured several fashion designers' collections, from street-wear to avant-garde, menswear to jewellery, and was set in a club environment with DJs, spectacular lighting and big screens. The catwalk was huge and we recruited a very diverse group of models. The catwalk show was also bookended with flamboyant performance art including drag queens and fire breathing. All of the fashion designers were local independent businesses, and the idea was to give them more exposure in a fresh and contemporary way. The first event was a success and we went on to hold eight more shows, twice a year until 2014. Many designers went on to achieve great success in their carriers. I like to think Nightwalk helped them a little along the way.

I also met my partner Scott McDonald in The Arches – he and I worked on Nightwalk together and we are still together today.

SCOTT McDONALD *(Lighting and visuals freelancer 1991–2015)*
Was lucky enough to be involved with the first ever 'club' gigs in The Arches in 1991 while working at the time with the legendary lighting/ projection company Scottish Luminaries (aka artists Ronnie Heeps/ Dr Robert Gibb).

These were the Pussypower/Angus Farqhuar-promoted 'Blast-Off' gigs with Terry & Jason DJing, Angus and Test Department drumming, amongst many other strange things going on including fantastic giant puppets on the dancefloor courtesy of local artist Jim Logan. These gigs were seminal and were proof of concept that The Arches could be used as a viable club space, ultimately changing the trajectory of the fledgling venue for years to come and putting it on the road to becoming the most exciting club venue in the city, if not Scotland, if not the UK, if not the entire world.

Best Arches memory? The police raiding Slam, the crowd chanting 'get tae fuck' then Slam dropped 'Positive Education' and the place went absolutely berserk. Off the chart berserk.

I'll never forget the energy released at that moment.

KIRSTIN McLEAN
My partner and I like to reminisce about one of our first dates, back in 2009. I brought him to some evening of performance art or other at The Arches, which being a fairly straight-laced actor was not his natural habitat. We'd just seen something he couldn't get his head around (and neither could I to be honest). We were having a drink deciding whether to go home or catch the one durational piece that was still going. I urged him to see it: 'Not all this kind of work is like that, you know, let's just go in.' So in we went. To see a totally naked man have a massive bag of water burst over his head, drenching him completely. Since then, my partner is convinced that yes, all 'this kind of work' is indeed, just 'like that'.

TAMSIN AUSTIN
The White Stripes played, to a very small crowd. It was like me and my dad. It was because they were doing the Beat Room, but they couldn't

get to the recording, so they decided they were going to come and stage a bit of the Beat Room the day before or something. I think the White Stripes were maybe playing at King Tut's or something.

But there was this funny situation where we had to stage a little White Stripes gig in the first arch. And it was basically just the staff. I remember my dad was up staying, so he came as well. So yeah, it was the most bizarre thing. And I was becoming a massive fan of the White Stripes at the time, so it was a pretty big deal actually – and after that, I was a huge fan of theirs. And I think back, and think, 'Oh my god, the White Stripes did a private gig for me and my dad and the staff at The Arches.'

IAIN 'BONEY' CLARK

I was DJing in The Arches. And I got a bit lairy, a bit drunk and boisterous. And I got thrown out. The bouncer was like, 'Right, you're oot.' And I was like, 'I'm DJing!' And he goes, 'I don't give a fuck. You're oot.'

And so they actually put me out. I was standing at the door, and they wouldn't let me back in to get my records. So I had to get my girlfriend at the time, now my wife, Suzy – she had to go back in and get my records, bring my records back out the door.

So I had my big metal record box, and I sat it down at the side of me. And I was like, 'Fuck's sake, I cannae believe I've just been flung out.' And I turned around, and my records aren't there. And I'm like, 'Where the fuck is my records?'

And then walking down the street towards McDonald's, there's this old fucking tramp walking away with my records. He's fucking walked past me, picked the records up and walked on. So I ended up fucking fighting with this guy, trying to get my records back.

LISA DUNIGAN

One of my funniest was – her out of The Gossip. Beth Ditto. Me having to lift her over the barrier on my own. I thought I was going to die. She jumped out into the crowd and I've never seen so much fear. And they quickly fed her back, and she was in an all-in-one silver lycra cycling

shorts suit. Legs akimbo. Coming towards me. So there wasn't much left to the imagination.

And Tony [Brown, assistant head steward] tried to help, we went onto the mojo barrier to lift her over, and she was like, 'No, just the girl!' And I was like, 'Nooooo!' As I was trying to lift her over the barrier on my own. It almost killed me.

There was a time when there was a fight that had broken out between people from [neighbouring homeless shelter] the Wayside Club, and they were kicking each other's heads in at the top of the street. And it ended up where I was like, 'Uuuurgh, I need to go up.'

And I was tending to the guy in the middle of the road, his head was burst open. And all I heard was, 'Do you need a hand?' And I turned round, and it was Macaulay Culkin. And I was like, 'What's happening?'

DAVID BRATCHPIECE
I need to give a shout out to all the cleaners and maintenance staff from The Arches over the years… Roseanne, Georgina, big George, wee Jinty, Graham and his son. All of them are legends in their own right and The Arches just wouldn't have happened without them. And of course the main man, big Charlie, the toilet attendant. With that familiar bellowing catchphrase – 'Wash your hands!' – turns out he was ahead of his time. Everyone called him Charlie but his real name was Sylvester. Felt like everyone in Glasgow knew Sylvester, and loved him. And rightly so.

JULIE McEWAN
Eric Prydz was coming to Scotland for the first time, and he was coming from Sweden. And he didn't like flying. So we booked him on a ferry.

RICKY MAGOWAN
Naw, Julie booked him on a fucking ferry.

JULIE McEWAN

I booked him on a ferry. But I'd never booked anybody on a ferry, or anybody from Sweden before.

RICKY MAGOWAN

Bear in mind, this is before he had an agent or anything. I tracked him down. He didn't have an agent, didn't have a manager, didn't have fuck all. His big track had just come out, and this is before the big Internet thing. So we tracked him down before anybody.

JULIE McEWAN

So he gets here, and on that particular weekend there was no hotels in Glasgow and the closest place was the Avonbridge in Hamilton. We had to put him out there. So I went out to pick him and his two pals up in my wee Peugeot 206 – incidentally, a couple of weeks later Boney pulled the door right off it – so I went and picked them up, and he gets in the back with one of his pals, and one got in the front. And the guy in the front gave me his business card and he said, 'I'm going to be a massive producer.' And I was like, 'Aye, right, whatever.' And it was Sebastian Ingrosso, from the [superstar DJ/production trio] Swedish House Mafia. I just remember being in the front of my wee Peugeot 206 and thinking, 'That's a rubbish name for anybody.'

But when we got to The Arches, he was the headliner and David Guetta was the warm-up. David Guetta's agent, Maria May, had asked Ricky to put Guetta on as a favour. And when he did go on, he was really nervous, he was terrified about going out on the decks and nobody enjoying his set. And Ricky was so melted he actually stood and watched his full warm-up set. So he thinks that Ricky took time to listen to his music and what he was playing, and he's absolutely loved Ricky from then on.

WILLIAM DANIEL

My favourite memory of the venue was the BBC Radio 1 Essential Mix night back in 2008. It was an awesome night that was one of the busiest I can ever remember. One of my best friends and fellow

resident DJ Barry Connell got the opportunity to record his first ever Essential Mix for that night. It was one of the best Inside Out events ever and is still spoken about to this day. It's also one of my saddest memories because, shortly after this mix was aired, he unfortunately passed away from acute meningitis. I still miss him today.

KIRSTIN BAILLIE

My most distinct memory of the National Review of Live Art was Ian Smith. A newbie to all this, I didn't know who he was and then there he was, in the foyer – an exhilarating force of nature, his palpable delivery had me and everyone in the room in a collective, joyous swoon. I loved each time he returned to The Arches along with his interactive theatre company Mischief La-Bas; actors hired to cause mayhem for events dressed up as nuns, air hostesses, the elderly, always silly and fun to unsuspecting punters. I especially loved to see them hired for corporate events, when the crowd couldn't comprehend what they were witnessing and didn't know how to react; people adrift from their comfort zone forced to float for a while in the queasy unknown. That's what The Arches did best, it allowed worlds to overlap; theatre spilling sometimes intentionally, sometimes by accident, over into club nights or people having a quiet drink in the foyer bemused by live art that's radiating through the glass entrance from the main arch.

MIRANDA RALSTON

A favourite memory as a punter is the buzz of the queue and not knowing whether you would get in or not. Then getting in and spending most of the night in the toilets talking to your NBR (new best random), and the indistinguishable buzz of the hand-dryers became a part of the tunes. And the sound of the fire alarm which sounded so much like part of the tunes that no one would leave!

SIMON FOY

I can remember when we had a night in summer, and it was a four o'clock finish. There didn't seem to be that many police around at times. And somebody opened up the boot of their car, and the doors, and they had… I think I left at about half six or something, and there

was maybe around four or five hundred people on Midland Street dancing away. And it was a brilliant atmosphere. I think the police probably came around but were just like, 'They're just having a bit of fun.' You'd get a few impromptu things like that which stand out.

JULIE McEWAN

It's the bass inside, too. See, walking up... I can still remember every single time, whether I was going to work, or I'd been out all night and I was going to work again, or whatever was happening... the bass from walking under The Arches... Your whole body was like 'Wow!'... and you can't describe that if you've never been. Before you even went in it, as an employee, or you were going for a night out, you just had to turn that corner and hear it, and you were there. That was where it started for your night. It was just amazing.

Remember the night the guy brought his car, or a van, and after the club everyone was outside?

RICKY McGOWAN

Yup. After Sasha and Digweed. It was Tony Gordon. Banging it right out, and there was about a thousand people there for about an hour after the club. It was fucking brilliant. That was the Sasha and Digweed Easter weekend gig.

JULIE McEWAN

That was amazing, that was a buzz.

There's so many great nights. There's so many good memories, and I think as a group of people that worked together as well... we might not see people now, but we had great relationships and friendships, and people that you still fondly think of. And that's unique in a sense itself. And even all the friends you made on the dancefloor, or over years. I'm just so grateful.

Appendix One (More Tune):

A Playlist of Some Arches Anthems

Slam / Pressure:

Slam: Positive Education	*(Soma Quality Recordings, 1993)*
Green Velvet: Flash	*(Yeti Records, 1995)*
Jeff Mills: The Bells	*(Purpose Maker, 1997)*
Laurent Garner: Crispy Bacon	*(F Communications, 1997)*
Scott Grooves: Mothership Reconnection (Daft Punk mix)	*(Soma Quality Recordings, 1998)*
Dave Clarke: Before I Was So Rudely Interrupted	*(iCrunch, 2000)*
Funk D'Void: Diabla:	*(Soma Quality Recordings, 2001)*
Silicone Soul: Right On	*(Soma Quality Recordings, 2001)*
Vitalic: La Rock 01	*(Citizen Records, 2001)*
Envoy: Dark Manoeuvres	*(Soma Quality Recordings, 2013)*

Colours / Streetrave:

Farley Jackmaster Funk: Love Can't Turn Around	*(EMI, 1986)*
Frankie Knuckles: Your Love	*(Btech, 1989)*
Alison Limerick: Where Love Lives	*(Arista, 1990)*
Leftfield: Not Forgotten	*(Outer Rhythm, 1990)*
Source ft Candi Staton: You've Got the Love	*(ZYX Music, 1990)*
Bizarre Inc: Playing With Knives	*(Torso Dance, 1991)*
Shades of Rhythm: Sound of Eden	*(ZTT, 1991)*
Felix: Don't You Want Me	*(Hooj Choons, 1992)*

Inner City: Pennies from Heaven	*(Virgin, 1992)*
Paul Van Dyk: For an Angel	*(MFS, 1994)*

Inside Out / Freefall:

Mauro Picotto: Lizard	*(Masterpiece, 1997)*
Humate: Love Stimulation (Oliver Lieb Clubmix)	*(Deviant Records, 1998)*
Corvin Dalek: Pounds & Penz	*(Intergroove, 1999)*
Sasha: Xpander	*(Deconstruction, 1999)*
William Orbit: Barber's Adagio For Strings (Ferry Corsten Mix)	*(WEA, 1999)*
DJ Elite: That Fuct Camera	*(White Label, 2001)*
Simon Foy: InsideOut	*(BXR, 2001)*
Tiesto: Traffic	*(Nebula, 2003)*
Marcel Woods: Advanced	*(High Contrast Recordings, 2005)*
Sander Van Doorn: Riff	*(Roxy Records, 2007)*

Death Disco:

Miss Kittin and The Hacker: Frank Sinatra	*(International DeeJay Gigolo, 1998)*
Zombie Nation: Kernkraft 400	*(International DeeJay Gigolo, 1999)*
Freefall: Skydive	*(Superfly, 2000)*
Mylo: Drop The Pressure	*(Breastfed, 2004)*
Tiga: You Gonna Want Me	*(Different [PIAS] Recordings, 2005)*
Gossip: Standing In The Way of Control (Soulwax Nite Version)	*(BackYard Recordings, 2006)*
Justice vs Simian: We Are Your Friends	*(Ed Banger Records, 2006)*
Justice: Waters of Nazareth (Erol Alkan Remix)	*(Ed Banger Records, 2006)*

Simian Mobile Disco: Hustler	*(Interscope Records, 2007)*
Erol Alkan & Boys Noize: Waves	*(Boys Noize Records, 2009)*

And Also:

Massive Attack: Unfinished Sympathy	*(Wild Bunch, 1991)*
Billy Ray Martin: Your Loving Arms	*(Magnet / Warner Music, 1994)*
Faithless: Insomnia	*(BMG, 1995)*
Josh Wink: Higher State of Consciousness	*(Strictly Rhythm, 1995)*
Arab Strap: The First Big Weekend	*(Chemikal Underground, 1996)*
Daft Punk: Da Funk	*(Virgin, 1996)*
The White Stripes: Seven Nation Army	*(XL, 2003)*
Easy Star All Stars: The Great Gig in the Sky	*(Easy Star Records, 2003)*
Linus Loves: Stand Back	*(Breastfed, 2003)*
Franz Ferdinand: Take Me Out	*(Domino, 2004)*

And let's not forget the Scottish National Anthem…..

Artemesia: Bits + Pieces	*(Hooj Choons, 1995)*

With thanks to all The Arches clubbers and DJs for their input into the playlist!

Huge thanks go to:

Niall Walker, for the overall aesthetic of this book, ongoing support and the contribution of essential photos and memories.

Tiernan Kelly and Mark Anderson for supplying essential background material.

Murray Robertson and everyone at The List, for providing an essential archive to help us keep our dates in order.

Bartosz Madejski, Paul Cameron, Lori Frater, Angie Dight, Cara Stewart and Rory Olcayto for supplying or taking pictures.

And everyone who contributed memories or sat through long Zoom interviews with us. We're only sorry we couldn't fit every story in there.